beginner's guide
to digital painting in

Photoshop® Elements

3DTOTALPUBLISHING

beginner's guide
to digital painting in

Photoshop® Elements

3DTOTAL**PUBLISHING**

3DTOTAL PUBLISHING

Correspondence: publishing@3dtotal.com
Website: www.3dtotalpublishing.com

First published in the United Kingdom, 2014, by 3dtotal Publishing.
3dtotal.com Ltd, 29 Foregate Street, Worcester WR1 1DS, United Kingdom.

Soft cover ISBN: 978-1909414099
Printing and binding: Everbest Printing (China)
www.everbest.com

Visit **www.3dtotalpublishing.com** for a complete list of available book titles.

Junior editor: Jenny Newell
Managing editor: Lynette Clee
Lead designer: Imogen Williams
Designers: Matthew Lewis, Aryan Pishneshin, Joe Cartwright
Proofreaders: Melanie Smith, Adam J. Smith

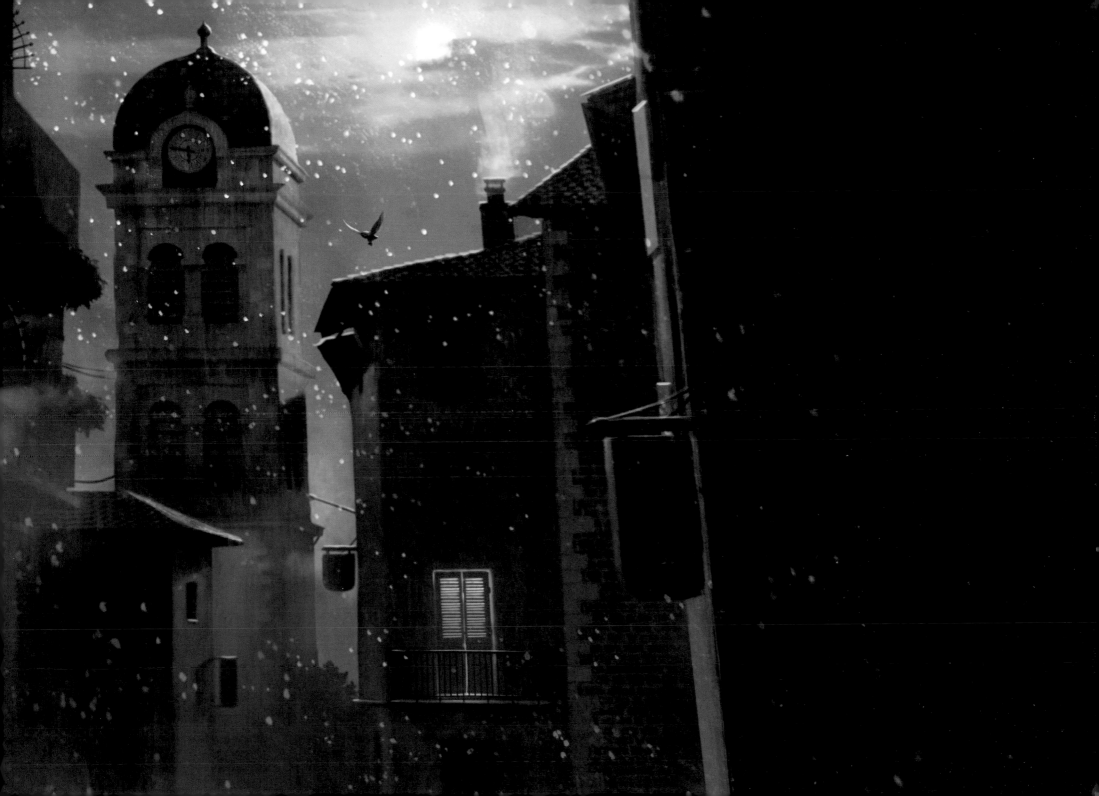

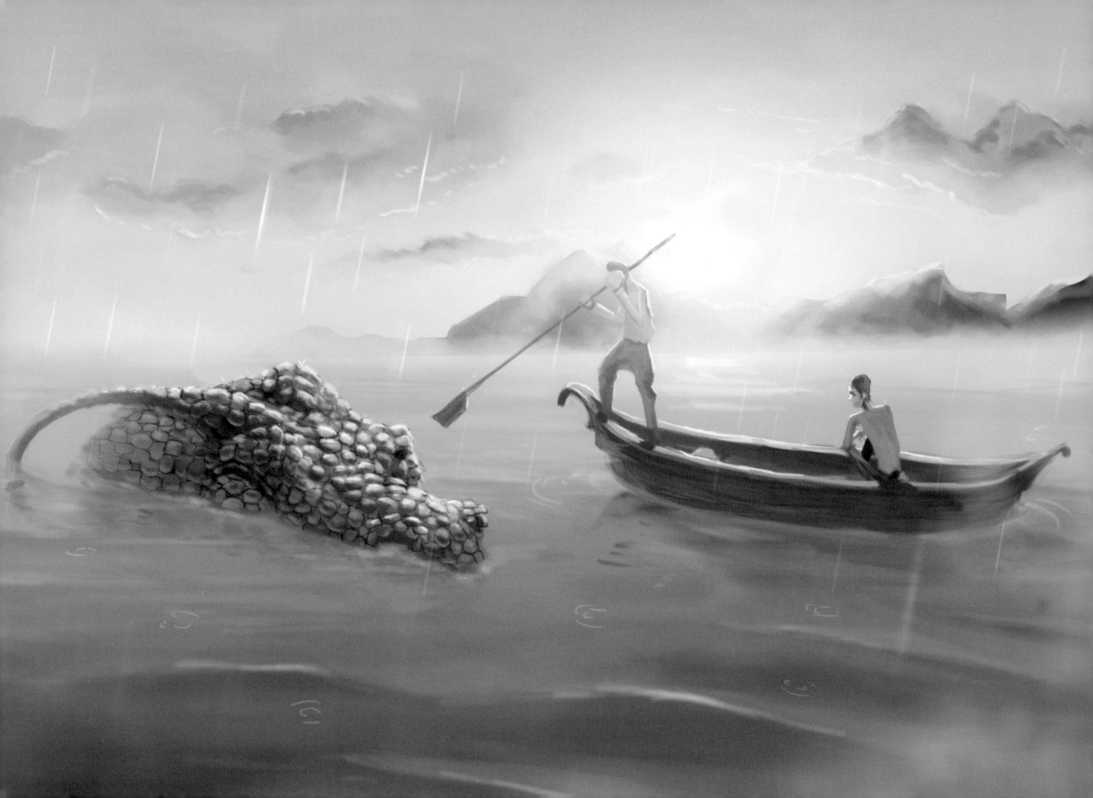

Contents

Beginner's guide to digital painting in Photoshop Elements

Introduction

As a beginner artist, casting your eye over the latest digital images on top CG websites can be pretty daunting. With the huge number of incredible 2D examples online and in books, it's difficult to know where to begin your own creative development, and scrolling through online tutorials and image breakdowns can be fairly unfruitful too – especially if you're new to the digital art scene and have difficulty telling the difference between a pixel and a plug-in.

As a company specializing in teaching the latest and greatest software techniques, we spent some time considering the best tools and skills a beginner artist should possess, and compiled them together in this all-new, comprehensive beginner's guide to Photoshop Elements. As a slimmed-down version of the full Photoshop, Elements has a far better-focused set of functions and a simplified interface, which allows you, as a beginner artist, to truly hone your creative skill set.

To guide you through your creative learning, we have gathered a range of skilled digital artists to take you through all the basic elements you need to consider when starting out as a digital creative.

To start you off, Rich Tilbury gives us a comprehensive overview of the standard Photoshop Elements interface. From useful tips on getting and setting up your first Wacom tablet, through to tweaking the settings in the Photoshop Elements software to begin the painting process, Rich covers everything you'll need to know about finding your way around the software.

From there, with your basic software knowledge established, digital artist Christopher Peters gives an all-inclusive overview of the basic techniques in art theory. Using standard pointers on how light and color, perspective, and composition are expressed in a 2D digital space, Christopher also reveals a number of handy tips on using these techniques to create certain scenes, emotions or narratives in your own work.

To help you refine your style even further, seven established digital artists, including Concept Artist Eric Spray and Illustrator/Art Director David Smit, reveal the processes behind seven different art styles to adopt when creating an image. In addition to providing extraordinary and inspiring Photoshop Elements creations, our seven artists also divulge, in great detail, the key methods behind their processes; making this a veritable mine of techniques that you can adapt to fit your own budding artistic style.

From those incredible full project overviews, our guide then draws on the above art theory and interface information to offer an invaluable encyclopedia-style section on how to create popular textures in your own work. From dragon scales, to moonlight, to trees, to rain, these top texture tips are designed to allow you to practice and apply a wide range of convincing finishes on the features in your images.

Finally, our breakdown gallery demonstrates a practical application of all the tips covered in the previous chapters. We challenged 11 artists to create an image incorporating the Photoshop Elements software, basic art theory, and the texture finishes. Our 11 artists, including Tommy Kinnerup, Bram 'Boco'

Sels, and Carlos Cabrera, did not disappoint. Each artist used a selection of the textures, and added a little of their own style, imagination, and flair to produce a glorious gallery of images to inspire you in your own creations.

All in all, this title promises to be an excellent guide for anyone taking their first steps into the digital painting world.

Jenny Newell, Junior Editor, 3dtotal Publishing

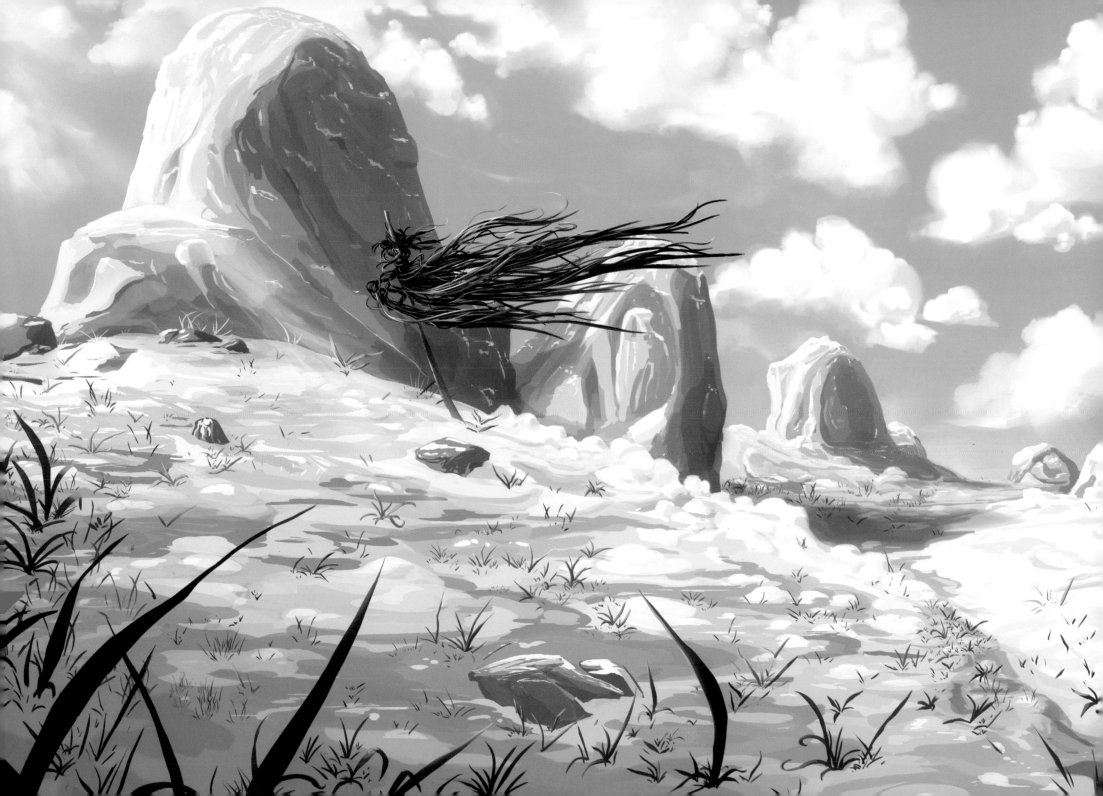

Fit on :
Actual :
Print Siz

Zoom In
Zoom O

Right click to access

ensions: 49.8M

th: 4962 pixels

Height: 3507 pixels

Document Size:

idth: 20 inches

: 14.135 inches

248.1 pixels/in...

Introduction to the Photoshop Elements interface

Work through the layout and standard functions available on the Photoshop Elements interface

Opening a new arts-based software package for the first time is often a confusing experience, particularly if you're new to practicing art in a digital form.

To ease you into setting up and working with your new software, Rich Tilbury gives a comprehensive breakdown of the main tools and functions available on the Photoshop Elements interface. Starting with those first moments with your new Wacom tablet, to setting up your canvas, Rich guides you smoothly through each of the panels and basic functions in your Photoshop Elements software and reveals key, universally applicable art and software-related tips along the way.

Introduction to the Photoshop Elements interface

by Rich Tilbury

Step 1

Wacom: Your tablet and tools

Anyone serious about digital painting will need to invest in a decent graphics tablet. Wacom produces a wide range of graphics arts tablets that are suitable for both casual users and professional artists alike.

For the novice artist, or more advanced artists who prefer to use a simpler machine, I recommend investing in a graphics tablet from the Bamboo product range, which keeps costs at a minimum and yet is still more than adequate for your needs.

The cheapest product here costs around £40 to £50 (GBP) and is more than worth it as an invaluable asset for any self-respecting artist.

Your tablet will ship with a software installation disk which will guide you through the setup process. When opening the box you will discover two key components: the tablet and the stylus. If you purchase the simplest tablet it will consist of nothing more than an A5-sized drawing surface. More expensive tablets will incorporate Express Keys but these are not a necessity and exist simply as a workflow aid. The stylus will resemble the one shown in image

01, which has a button at the top constituting an eraser and a button along the shaft which can be customized to work with the mouse buttons or shortcut keys within the software. I prefer selecting the Eraser tool within Photoshop Elements in conjunction with the nib as opposed to turning the stylus upside down and using the built-in Eraser, but this is a personal preference.

Step 2

Setting up your tablet properties

You will need to set up the tablet properties before you can begin working. The two key settings to work with here are: the pressure

sensitivity of the stylus – this will determine how much your hand weight will affect the impact of your brushstrokes; and the mapping – this helps to ensure that your tablet area corresponds correctly to your screen area.

Image 02 shows two examples of the types of dialog boxes you will see when adjusting the properties. On the left you can see a box relating to the sensitivity of the stylus tip with a slider bar along the top to allow a quick setting. As you press the stylus tip on the tablet the degree of pressure is measured along the Current Pressure bar.

Eraser

Assignable buttons

Pen tip

▲ Your stylus and its key components

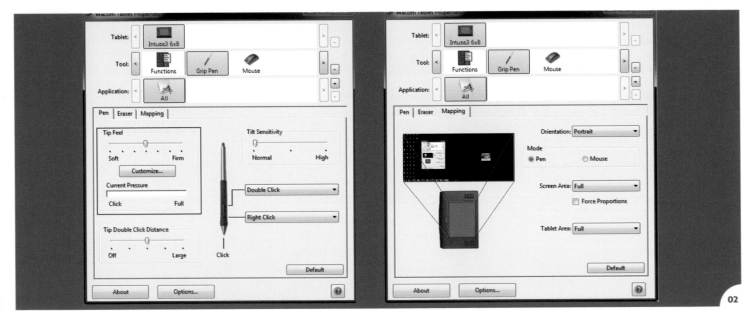

▲ Adjusting the pressure and mapping of your Wacom

▲ Advanced settings in your Wacom properties

▲ The welcome screen for Photoshop Elements

Step 3

Setting up more tablet properties

If you wish to fine-tune the pressure settings you can click on the Customize button. This will open a new settings window that allows you to refine the pressure of your stylus by way of a control point along a line (image 03). Opposite this is a test area where you can gauge the pen pressure after making any adjustments.

Using a graphics tablet may require some getting used to if you are new to the principle – but it is an invaluable tool for any digital artist.

Step 4

Introduction to the interface

When you start up the software, you will be greeted with a welcome screen that gives you the choice of two options. We shall be working within the Photo Editor throughout this book but you can swap between the two options at any point during your workflow.

Organizer is primarily a way of cataloging photos and arranging them in a library, while the Editor is where you will create digital paintings and manipulate documents.

Step 5

The Editor

When Photoshop Elements Editor mode opens, you will be faced with a screen that resembles image 05. You will notice a number

of tools and panels around the edge of your window, many of which can be accessed by shortcut keys, which are shown in parenthesis when you hold the cursor over them.

1. Menu bar: The menu bar opens a list of commands that are available for modifying your image, some of which are accessible via panels when open.

2. Toolbox: The left-hand toolbox is an area you will use continuously as it is where you will find the main painting tools. This is something we shall deal with in more detail in the next chapter.

3. Taskbar: Along the lower edge we find the Taskbar, which displays commonly used tasks as a series of buttons. It is also a way of showing or hiding panels and switching between the Editor and the Organizer modes.

4. Panel bar/bin: The right-hand side of the window houses the Panel bin, which is where information and toolsets appear for associated panels when opened.

5. Workspace: This is the active image area, where you will work on your painting.

6. Tool Options bar: The Tool Options bar is where context-sensitive functions appear for selected tools. This can be toggled on or off via the Tool Options button on the Taskbar.

▲ The basic panels and menu bars available in Photoshop Elements

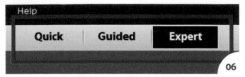

06

▲ The three editing modes in the bar across the top

Step 6
Quick, Guided, and Expert modes

There are three tabs below the Menu bar: Quick, Guided, and Expert. These tabs correspond to the three different editing modes, each with their own set of tools and panels. As this book focuses on digital painting however, we shall be required to work within Expert mode for the most part. This mode allows us full use of all available tools.

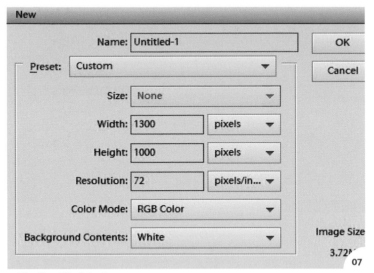

07

▲ The New File dialog box

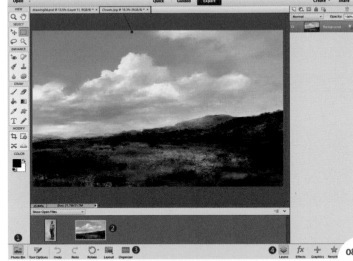

08

▲ Managing your open images using the tabs and task bars

Step 7
Opening a new file

To open a new document, click on the small arrow and scroll down to New Blank File. You can also go to the Menu bar and select File > Open or File > New > Blank File.

When you open a new file you will be prompted by a dialog box allowing you to specify the size and resolution of the document.

Assuming you have opened an image file you will notice that it occupies the main workspace. Sometimes you may wish to have more than one file open at a time but if you try this you will find that only one is visible by default.

Step 8
Managing images

At the top of this workspace you will see two tabs named 'drawing04' and 'Clouds' (image 08). These correspond to the two open images. Simply click on the tabs to switch between these.

You can also view the open documents if you click on the Photo Bin button along the lower tool bar (1). This will display the open documents along the Tool Options bar with the active one highlighted in blue (2). If you wish to revert back to Tool Options, just click on the Tool Options button. The buttons along the right-hand side of the Taskbar correspond with panels that are visible in the Panel bin. In

this instance, the Layers panel is selected and therefore visible (4), despite there being only one apparent layer, named 'Background'.

It is worth mentioning at this point that if you want to switch to the Organizer then you can do so by clicking on the Organizer button along the Taskbar (3). You can revert back to Editor mode by clicking on the Editor button in its place.

Step 9
Column layout

If you wish to view multiple images, just click the Layout button along the Taskbar and choose one of the available options. Here, I have selected the All Column layout option, which

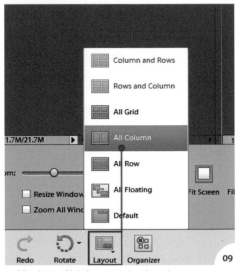

09

▲ Allowing multiple images to be viewed

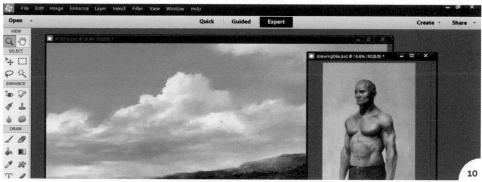

▲ Making your workspace larger by removing the Panel bin

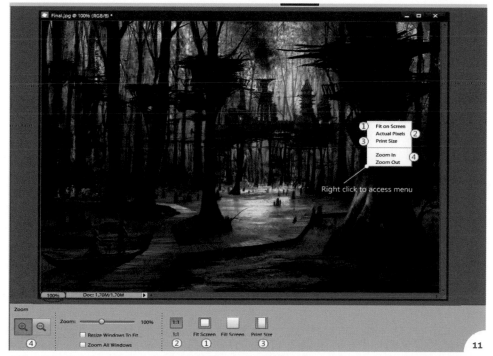

Right click to access menu

① Fit on Screen
② Actual Pixels
③ Print Size
④ Zoom In
 Zoom Out

▲ How to locate and use the zoom function (numbers show right-click options and their corresponding Tool Options)

will arrange the documents in a vertical format within the workspace. This allows you to snap your documents into an easily accessible layout.

Step 10
All Floating layout

A layout mode that you may find yourself using regularly is All Floating, which you can see between All Row and Default. This enables you to detach the images from their dock and move or resize them freely within the workspace.
If this button is inactive then go to the Menu bar and select Edit > Preferences > General, and ensure that the checkbox named 'Allow Floating Documents' in Expert Mode is ticked.

Another way of implementing this is to go to the Menu bar and select Window > Images > Float All in Windows. You can see in image 10 that the two documents are laid out in separate tabs that can be freely moved around the workspace.

You may also notice that the workspace looks larger as a result of removing the Panel bin, something that can be done by unticking the label towards the bottom of the Window menu. This menu essentially controls which windows or panels are visible, and if you look towards the top you can see Tools, which is ticked to indicate that the Toolbox is visible on the left.

We could, in theory, hide the Window menu mentioned above, along with the Tool Options,

therefore creating a large workspace with nothing more than the Menu bar and Taskbar evident, although this would prove impractical.

Step 11
The Zoom and Hand functions

It is perhaps worth mentioning at this point the two very useful tools you can find at the top of the Toolbox under View; namely the Zoom and Hand tools.

The Zoom function is particularly useful. If, for example, the image is larger than your screen you will not be able to see the entire canvas at full size and hence will need to zoom out. It is also very useful to work on your image at a reduced size from time to time, so you don't lose sight of the overall composition.

Image 11 shows a canvas at full size which you can see fits within the work area; if it was twice the resolution though, it wouldn't fit. Because the example image is at full size, it shows as 100% below the document, but if we zoom out this value will change.

To zoom in or out, you can either right-click on your image to reveal the sub-menu, or use the + and − tools below your workspace in the Tool Options bar.

The Hand tool simply allows you to pan across regions of your canvas while zoomed in.

Step 12
Resolution and image size

When you create a new document or blank file you will be prompted by a dialog box similar to that shown in image 12. Here you can name your file and set the image size and resolution.

A digital image is measured in pixels along the width and height – these determine the size of the file. Here for example, the image is 1300 pixels wide by 1000 pixels high. These dimensions do not refer to the physical size of the pixels but instead relate purely to the quantity in the image; so the size of a pixel is not fixed but rather is dependent on the resolution.

The resolution is measured by the number of pixels per square inch (ppi), with an increasing number of pixels equating to a higher resolution and increased quality. For example if we have an image that is 50 × 35 pixels with a resolution of 10 ppi, this would effectively mean that each inch of the image would be composed of 100 pixels (10 × 10).

Therefore 50 pixels wide at 10 ppi is equal to 5 inches (50 divided by 10) while the height would be 3.5 inches (35 divided by 10).

Step 13
Working with pixels

Go to Image > Resize > Image Size to check the size of your image. In image

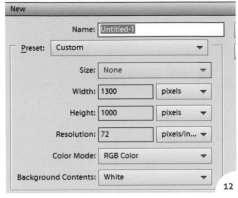

▲ Working out the image size and resolution

13 you can see how these calculations relate to the image size in the dialog box. The pixel dimensions are 50 × 35 and the corresponding document size is shown below in inches, with the resolution below that.

As you can see, the image clearly shows each pixel – this is because the resolution is low (10 ppi). When you alter the resolution in Photoshop Elements, the width and height is automatically calculated but the pixel dimensions and file size will remain consistent.

Step 14
Choosing an image size

An example of this can be seen in image 14. You'll notice that the original image has been resized to a resolution of 20 ppi (upper right) compared to 10 (upper left). The lower image has been resized once again but this

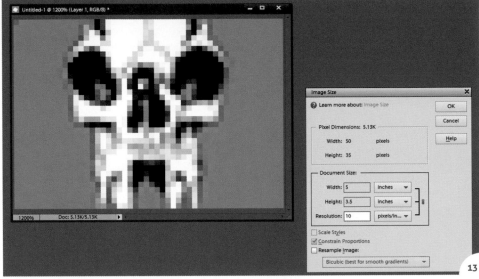

▲ Clearly defining the pixels in a low resolution image

time to 72 ppi. You will notice that as the resolution increases, the size of the image decreases (the effect of smaller pixels). This demonstrates the relativity of pixel size.

The pixel dimensions remain at 50 × 35 but importantly the clarity and definition improve, resulting in a less pixelated image.

Choosing the resolution for your image will depend almost entirely on what you intend your image to be used for, but a good rule of thumb is that if you only ever wish to view it on a computer, 72 ppi or 96 ppi is more than adequate (depending on the

quality of your working monitor). However, if you intend to print your work then 300 ppi is generally the required resolution.

If you ever want to quickly check your image size you can left-click on the tab just above the Tool Options bar, labeled 'Doc'. This will reveal a gray information box as shown in image 14, which gives a brief breakdown of the key technical information.

❝ RGB is the standard color mode and is best left untouched unless you want to work in black and white ❞

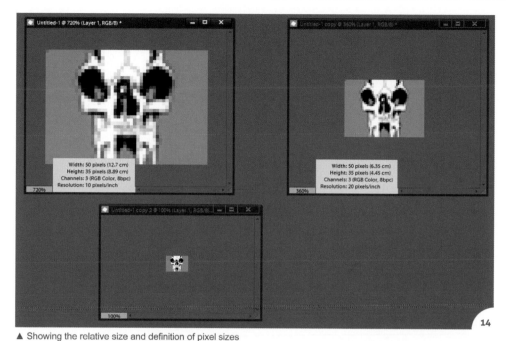

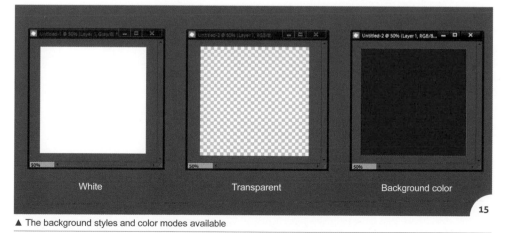

▲ Showing the relative size and definition of pixel sizes

14

White Transparent Background color

15

▲ The background styles and color modes available

Step 15

Color mode and background content

As well as setting the size and resolution of a new document, you will notice that you also have the option of determining the Color Mode and Background Contents.

RGB is the standard color mode and is best left untouched unless you want to work in black and white, in which case you can select Grayscale. The other option is Bitmap which reduces the image to one of two values (black or white), although I have never needed to use this mode and for the purposes of this book it will not be necessary.

The remaining option specifies what type of background you begin with. These options can range from white, transparent, to whatever background color is selected in your image.

Image 15 shows the three various modes and how the background color relates to that chosen at the base of the Toolbox under Color.

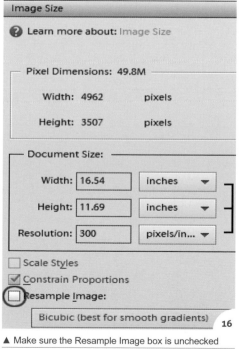

16

▲ Make sure the Resample Image box is unchecked

Step 16

Resizing your image I

There are times when you may need to resize your image either for print or web purposes. To do this, go to the Menu bar and select Image > Resize > Image Size, which will bring up the dialog box shown in image 16. This shows the pixel dimensions and document size of the image currently open and selected.

If your image is for a print publication, you first need a minimum resolution of 300 ppi. As long as your intended size is smaller or equal to the Document Size then the procedure is fairly straightforward.

Start by ensuring the Resample Image box is unchecked in the lower left-hand corner of the window, and then enter either the new width or height dimension in the corresponding boxes.

Step 17
Resizing your image II
First you need to ensure that you have entered either the height or width dimension in the appropriate box.

Now you can see that the original width was 16.54 inches but has now been reduced to 12 inches. The amounts are automatically adjusted to fit the right proportion.

You will notice how this has also altered the height but, more to the point, has increased the resolution to 413.5 ppi (image 17). As this is greater than 300 ppi (the ideal print quality), we can hit OK and proceed with the printing.

Step 18
Scaling up your image I
If we wish to scale up the image for print, the process is a little more complicated. As before, you need to make sure that the Resample Image box is unchecked and then enter the desired width or height value. This time we will increase the width from 16.54 to 20 inches, which now brings the resolution below 300 ppi to 248.1 ppi.

Step 19
Scaling up your image II
The next step requires checking the Resample Image box which unlinks the resolution from the width and height, and making sure that the Constrain Proportions option is also checked. You can see the location of the checkboxes in image 19. You need to ensure that both boxes are checked before proceeding.

Step 20
Scaling up your image III
You can now enter 300 as the resolution of your image in the Resolution box under Document

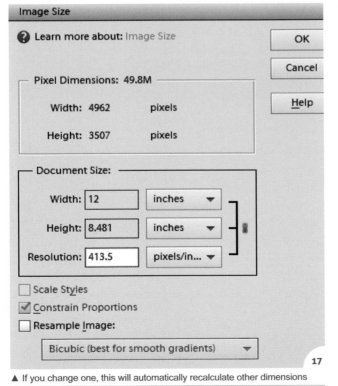

▲ If you change one, this will automatically recalculate other dimensions

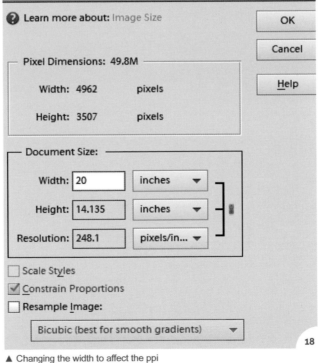

▲ Changing the width to affect the ppi

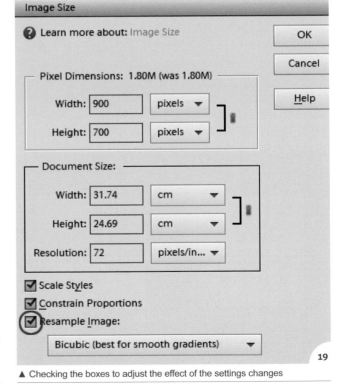

▲ Checking the boxes to adjust the effect of the settings changes

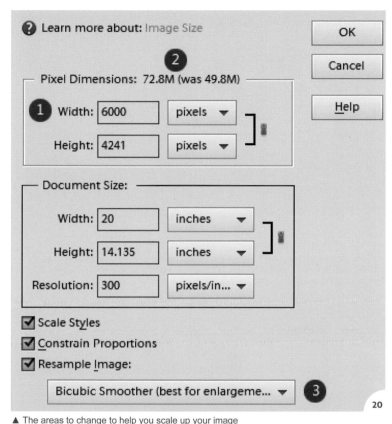

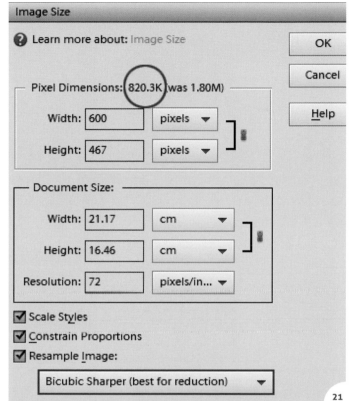

▲ The areas to change to help you scale up your image

▲ Reducing the size of your image by changing pixel dimensions

▲ Select the right Bicubic function

the document size, we will now need to change the actual pixel dimensions.

First, check the Resample Image box and Constrain Proportions box. Remove the Pixel Dimensions at the top of the window that are currently set to 900 × 700 and enter the desired width (600 in this case). You will notice the height value change, and the new file size will have changed from 1.8 MB to 820.3 KB.

Step 22
Scaling down your image II
One final thing to do before hitting OK is to select the Bicubic Sharper option from the drop-down menu (not highlighted in this image).

The Bicubic Sharper option is the best choice when reducing the number of pixels.

If you wish to upsize an image then the process is exactly the same, except that you need to select Bicubic Smoother options instead of Bicubic Sharper.

Size (image 20). Notice how the document size remains at 20 × 14.135 but the Pixel Dimensions have increased to 6000 × 4241 (1).

Alongside the Pixel Dimensions label is the file size. As you can now see, it has changed from 49.8 MB to 72.8 MB due to the increased resolution of the image (2).

❝ Sometimes you may wish to reduce the size of an image if you intend to upload it to the internet for example ❞

The final step is to choose Bicubic Smoother from the drop-down list at the bottom of the dialog box (3). This allows

you to choose the best method for upsizing your image. Finally, after checking all of the above settings, you can click OK.

Step 21
Scaling down your image I
The process for scaling down an image is a little different. As opposed to altering

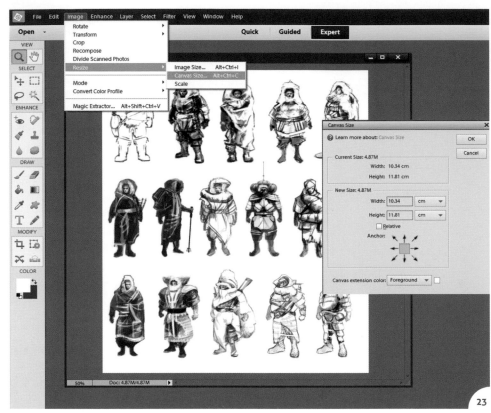

▲ Select Canvas Size from the Image menu

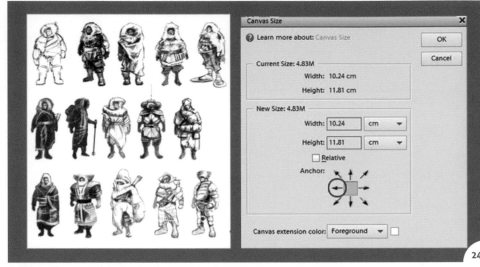

▲ Choose the appropriate direction for your extension

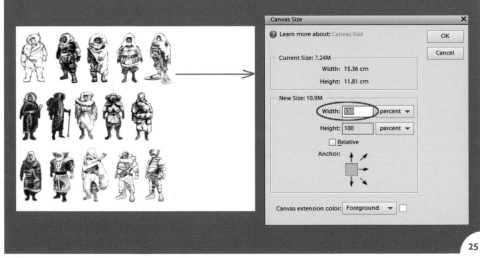

▲ Extending the canvas by percentage may be easier

Step 23

Canvas size

One of the advantages of working digitally over working with traditional techniques is that we can alter the size and ratio of our canvas at any point. You may often find, as I do, that during the painting process you feel the need to extend your canvas either horizontally, vertically or indeed in both directions, in order to include a new idea or change the crop or composition of the scene.

❝ We can resize the canvas within Photoshop Elements by going to the Menu bar and selecting Image > Resize > Canvas Size ❞

In image 23 you can see an example sheet of characters on a document that we are going to resize, along with the drop-down menu, and the resultant dialog box on the right-hand side.

Let's assume that we wish to draw some additional characters. What we wish to do is extend the canvas horizontally in order to increase the number of characters along the three rows.

We can now resize the canvas within Photoshop Elements by going up to the Menu bar and selecting from the list: Image > Resize > Canvas Size.

" I only want to extend the canvas to the right, so it is necessary to deselect the left arrow on the Anchor box "

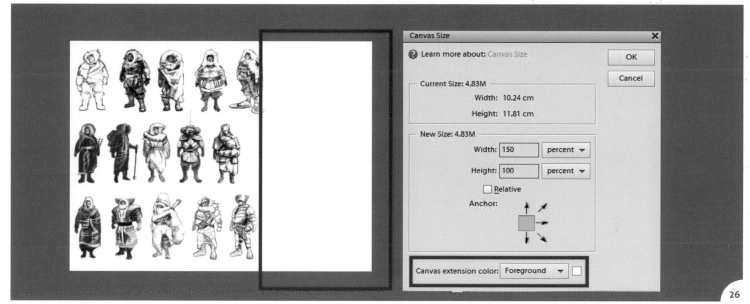

▲ Choosing the foreground color of your extension

26

Step 24
Resizing your canvas: direction
In this instance, I only want to extend the canvas to the right, so it is necessary to deselect the left arrow on the Anchor box (ringed in red in image 24). If I wanted to extend it the other way as well, I would select the opposite arrow and it would extend the canvas in that direction, too. You can choose more than one arrow if you need to extend the canvas in more than one direction. Simply select as many arrows as you need.

Step 25
Resizing your canvas: percentages
Next to the Width and Height settings, we can see drop-down boxes which correspond to the unit of measurement (centimeters in this case). This is where you enter the new value to extend your canvas, which can be done on either axis.

If you wish to alter the height remember to amend the Height value and click on one of the vertical arrows on the Anchor box.

I find using a percentage is easiest and as I want the canvas to be half as wide again, I enter

150% in the Width box, as seen in image 25. When I enter the new dimension it will extend the canvas by 50-percent in the desired direction (see red arrow). If I wanted the canvas to be twice as wide, I would enter a value of 200%.

Step 26
Resizing your canvas: color canvas
Note that the color of the canvas extension is white, which is set by the lower drop-down box labeled 'Foreground' (image 26).

There are numerous options here but if you set the foreground color in your Toolbox

beforehand, then choosing this option will yield the most appropriate background color.

Step 27
Conclusion
This concludes an overview of the key areas and tools within Photoshop Elements. Hopefully by now you should be familiar and confident with the interface and how to navigate through its menus and toolbars.

The next step will be to focus on those areas integral to the painting process and examine some commonly used tools and approaches.

Introduction to painting tools in Photoshop Elements

Learn how to use the tools in Photoshop Elements to create your own digital painting

Having set up your hardware and explored the various tools and functions available in Photoshop Elements, it's time to start digitally painting!

In this second chapter on digital painting in Photoshop Elements, Rich Tilbury uses an example scene to break down the best methods you can use to create your own landscape digital painting. Using his own picturesque mountain scene example, Rich runs through the complete process of image creation, while methodically presenting and explaining each of the key tools and settings as his image develops.

You'll encounter a variety of different tools, from gradient fills to custom brushes, and learn how to apply each of these within your own work.

Introduction to painting tools in Photoshop Elements
by Rich Tilbury

We shall now take a look at some of the tools you will likely use when painting, as well as some of the more common menu functions. So far we have dealt with a number of technical aspects that are undoubtedly important but perhaps less interesting than some of the more creative topics associated with the painting process.

Step 1
Setting up your background
Start by opening a new document: File > New > Blank File. Set the width to 800, height to 650 and the resolution to 72. Despite being a small file it is more than adequate for our needs.

Go to the Foreground/Background color at the bottom of the Toolbox on the left-hand side and double-click on the foreground box to open a window, as seen in image 01. Set the RGB values to 141, 101, and 31, respectively, and then click OK. Now switch to the background color and set the RGB values to 202, 230, and 252. You should now have a warm brown as a foreground color and a pale blue as a background color.

> **Gradient tools can be used for both coloring and shading tasks using specific selection areas, or in this case as a way of establishing an overall color scheme**

Step 2
The Gradient tool
We are now going to employ the Gradient tool to fill our canvas with a blend between these two colors. This is used to fade out a single color to white or black, and also to create a smooth transition between two or more colors.

Gradient tools can be used for both coloring and shading tasks using specific selection areas, or in this case as a way of establishing an overall color scheme.

So to create a gradient, first select the Gradient tool from the toolbox. Now look along the Tool Options bar along the bottom panel, where you will see a window similar to the one in image 02, showing a thumbnail of the color scheme (on the left) along with the different types of gradient style on the far right. Ensure you have Linear selected; the Mode is Normal and Opacity is 100%.

Step 3
Changing gradient options
There are numerous gradients at your disposal within the options for this tool. If you click on the thumbnail it will open up a window accessing the options (image 03). Usually you will only ever need to use the Foreground to Background or Foreground to Transparent presets (the two upper-left thumbnails), though there are more complex gradient styles available.

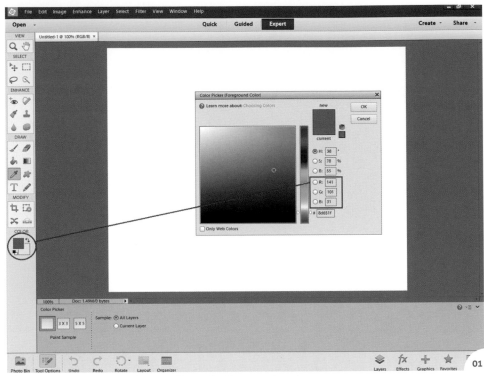
▲ The result of clicking on the foreground box and setting your color values

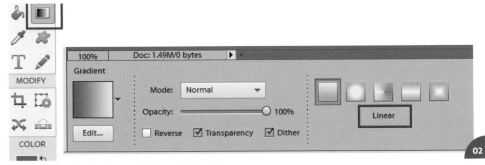
▲ The Gradient tool and some of the available settings

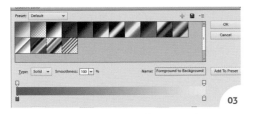

▲ More presets available for the Gradient tool

Step 4
Creating a gradient

With the Gradient tool selected, drag from the bottom edge of the canvas up to about half way.

You should now see a smooth gradient from the brown through to the blue. If the blue and brown are reversed then click the Undo button along the Taskbar and then click on the arrow icon next to the foreground/background color tabs to swap them around, and then redo the task.

Step 5
The Lasso tool

This will form the basic color for the ground and sky but in order for it to make more sense we will add in a distant mountain range, courtesy of

the Lasso tool. You will find this tool in the upper section of the Toolbox under the Select panel.

I first draw a selection area roughly along the horizon line. In order to create a straight line you need to hold down the Shift key while dragging out the Lasso tool.

You can swap between the three Lasso tools in the Tool Options bar across the bottom. You can choose from the standard Lasso, Polygonal Lasso, and Magnetic Lasso. The standard

version traces the motion of the mouse or stylus and works as freehand. The Polygonal one draws in straight lines only, whereas the Magnetic Lasso is capable of selecting an area from a less than accurate tracing. You can use these according to your needs.

In this instance I choose to use the Polygonal Lasso to create the mountain scene. Once you have started to draw, you will need to bring the Lasso back to its original starting point in order to close the selection area.

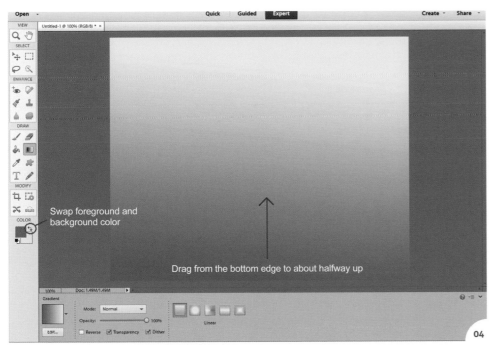

▲ Creating the right gradient with the Gradient tool

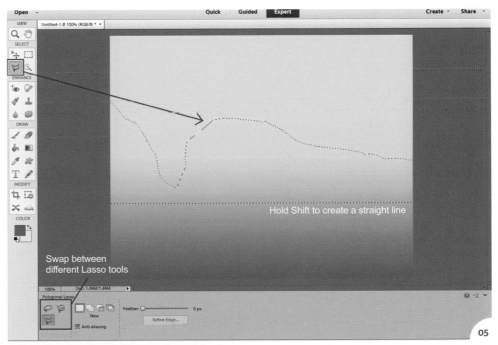

▲ Using the Lasso tool to add a distant mountain range

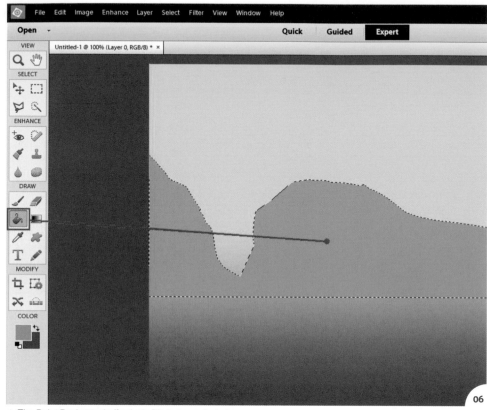

▲ The Paint Bucket tool effectively fills in any selected area

▲ Selecting areas of the foreground with the Lasso tool

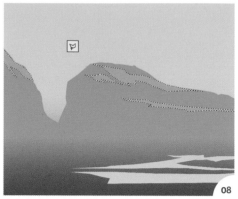

▲ Selecting areas of the mountain lit by the sun

Step 6
Blocking in areas

In order to block in the mountains, I opt to use the Paint Bucket tool, which I use to fill in areas with either a flat color or a designated pattern.

You will find it in the Draw panel of the Toolbox, just under the Paintbrush icon.

With the selection area active, ensure that you have an appropriate color set in the foreground on your Color swatches, and then select the Paint Bucket tool. Then simply click within the selection area made with your Lasso tool, and repeat for each section until the whole region you want to fill, is filled. You can also repeat this with different color fills.

Step 7
Creating foreground detail

We can use the Lasso tool to create foreground detail and help define the ground plane.

First, create some shapes that resemble those in this image, and then fill with a pale green/yellow (I use the values: R223, G216, B174).

In order to create multiple selection areas you will need to momentarily hold down the Shift key when starting a new one, otherwise the active area will be deselected. If you wish to subtract from an active area, hold down the Alt key instead.

Alternatively you can select the Add or Subtract icons along the Tool Options bar. This tool can be more difficult to control and so may require a few attempts before you get the result you

want. If you are after a more organic shape, however, then this can prove effective.

Step 8
Selecting highlights

We shall now go back to the Polygonal Lasso and create some selection areas across the mountain range that will correspond with the sunlit regions.

I have assumed that the sun is somewhere to the right of the image and so will cast shadows to the left.

Step 9
Choosing a color

In order to choose the right color we are going to take advantage of the Color Picker, which can be found below the Paint Bucket tool in the Draw section of the Toolbox. This

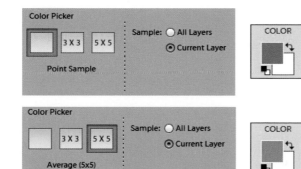

▲ Different options available when using the Color Picker tool

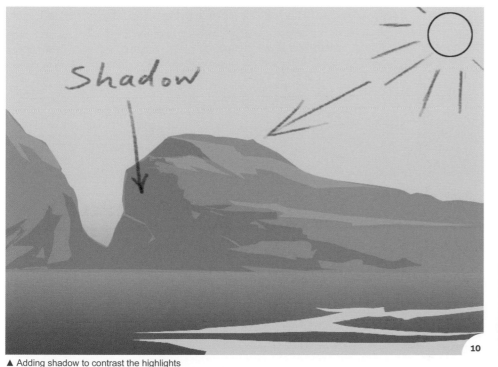

▲ Adding shadow to contrast the highlights

tool samples colors from your canvas which then sets a new foreground or background color. If it is a color that you will use regularly then it can always be saved as a Swatch, something we shall look at later in this chapter.

The Tool Options bar shows settings that determine the size of the area that is sampled. With the Color Picker you can sample a single pixel or an average color from either a 3 × 3 or 5 × 5 pixel area. This image shows the Color Picker over the central pixel on the far left and a choice of two sampling options in the center. The upper one is sampling this single pixel whereas the lower setting is sampling the complete area of 25 pixels before calculating an average. This has a bearing on the sampled color, which is why the foreground color is lighter from the 5 × 5 selection area – it incorporates the lightest pixels along the top edge.

In order to select an appropriate color for the mountain highlights we shall use the Color

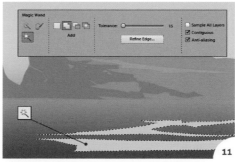

▲ Effects available with the Magic Wand tool

Picker to set the mountain range as our foreground color, and then open the window shown in Step 1 by clicking on the foreground color swatch. Using this as a guide, select a color that is slightly lighter and click OK.

The Paint Bucket tool can now be used to fill in the selected areas in the last step.

Step 10
Creating shadow

Now that there are some highlights it follows that we will need some shadows. These can be achieved using the same procedure, except this time we shall select a slightly darker color.

Be careful to adhere to your chosen light source (previously stated as being at the right of the picture) and place the shadows accordingly.

Step 11
The Magic Wand tool

We are now going to add some contrast to the foreground by way of a darker gradient. In order not to obliterate the pale yellow pattern created in Step 7, I will need to mask off this area because we are still working with a single layer. Layers are something we shall discuss in more detail later on but for now we will stick to using one.

The way to mask off an area is to first select the pattern and then invert the selection so that the

active region incorporates the area surrounding it. A tool you will frequently use and which is perfect for this scenario is the Magic Wand.

The Magic Wand tool icon resembles a magician's wand, and can be found next to the Lasso tool in the Select panel on the left-hand side of the interface.

It is essentially a selection tool with three variations depending on your preference. You will see the three options available along the Tool Options bar, each with its own set of sub-options. There are advantages to all

three, depending on the situation, and the associated options allow for numerous tweaks, but the general differences are as follows:

1. The Quick Selection tool permits you to click and drag an approximate area and then automatically detects a boundary.

2. The Selection Brush allows you to paint in a selection area, but perhaps more crucially integrates a mask mode. This overlays a semi-opaque color across the canvas, giving you the option to paint out areas you don't want to include.

3. The Magic Wand selects an area of a similar color range and is best suited to regions where the color variation is minimal.

You may find that using a combination of all three proves the most efficient way of creating accurate selection areas but I often find that the mask mode is the best way of refining an area after having first used one of the other methods.

Step 12
Using the Magic Wand tool

As we have clearly defined areas of flat color in our image we can use the Magic Wand,

▲ Selecting areas outside of the pattern

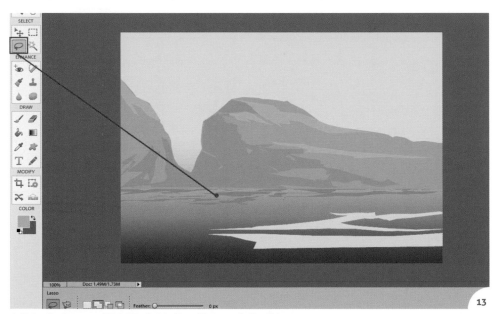

▲ Using the Lasso and Paint Bucket tool to add shapes in the distance

▲ Using the Lasso and Paint Bucket tools to add more blocks of color and detail to the landscape

so after selecting it, click on the pattern. If your selection area does not closely match the pattern then turn down the Tolerance (20 should be sufficient in this case). This setting affects the range of colors, thus a lower value selects a narrower range and vice versa.

Because I have two separate areas to select, I ensure that Add is highlighted within the Tool Options bar.

As we wish to affect the area outside the pattern we now need to invert the selection area. We do this by going to the Menu Bar and choosing Select > Inverse or Shift+Ctrl+I (image 12).

With this done we can now drag a Foreground to Transparent Gradient from the bottom edge up to the top of the pattern, using a reddish brown (R110, G64, B14). Make sure the Mode is Normal and the gradient is set to Linear along the Tool Options bar.

Step 13
Creating perspective
We are now going to add a random pattern along the horizon line in front of the mountains to help create a sense of perspective.

I use the Lasso tool to ensure a more organic feel to the marks, and draw out some shapes stretching along a thin portion of the distant

plain, before filling in with the Paint Bucket tool using a gray-blue (R107, G149, B175).

Not only do these shapes emphasize the perspective but they also help to blend the mountains with the ground plane.

Step 14
Building more detail
Using the same technique we will now build on the level of detail by adding further areas of color using the selection tools and the Paint Bucket.

This time I shall use a dull green (R115, G122, B114), which is slightly darker as we want to increase the contrast as we near the foreground.

Step 15
Using layers
So far we have been restricted to one layer but very often it is advisable to work on several, especially if the image is complex or you want to experiment with the composition or color scheme during the process.

Layers are a way of dividing an image into separate components as well as controlling not only the opacity but how they interact with one another. They can also contain transparent areas which allow those underneath to be clearly visible. Think of them as a sketch pad with each sheet of paper corresponding

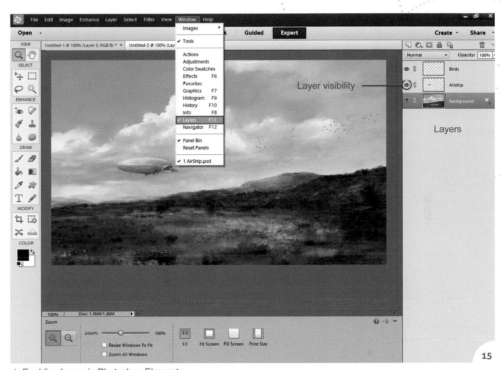

▲ Enabling layers in Photoshop Elements

to a separate layer which can incorporate both opaque and transparent regions.

The more layers you include in a file, the bigger that file becomes. However, once any editing is complete, layers can be merged to reduce the file size.

In order to add a layer you first need to access the Layers panel which can

either be done through the Menu bar via Window > Layers or by clicking on the Layers button below the Panel bin.

Once open you will see the layers at the top of the panel. If you only have one to begin with, it will be labeled 'Background'. This is always locked (so you won't be able to edit it), and is indicated as so by a small padlock icon beside the label.

Step 16
Working with layers

In order to create a new layer, click on the uppermost left icon in the Layers panel, resembling a folded sheet of paper. A new layer will now appear above the background labeled 'Layer 1'. If you wish to rename it, right-click on it and select Rename Layer.

If you wish to delete a layer, select the layer and then click on the garbage icon in the upper right. If you want to hide a layer, then click on the small eye icon to the left of the thumbnail which will then place a red line through it and render it invisible. Clicking on it a second time will unhide it.

In image 16 you can see that there are three layers altogether with the actively selected one highlighted in blue. There is a landscape on the Background layer and two others that correspond to an airship and flock of birds. Because the airship and birds are on separate layers we can move them independently as well as edit them in a number of ways without affecting the landscape, which is a great advantage.

I decide to relocate the airship over to the right by first selecting its layer and then using the Move tool (Select panel in the Toolbox). You will also notice that I move the flock of birds, which as you can imagine

would have been far more complicated if they were part of the Background layer.

Step 17
Moving objects in layers

Because layers enable us to move elements we also need to consider the pictorial space in a third dimension. We can move the airship left and right but what if we wanted to move it nearer to the viewer or have it receded?

There is also the issue of changing its orientation; for example we may wish to try it at a slightly oblique angle. Obviously these issues will affect its scale and proportion but fortunately Photoshop Elements has a useful tool that is perfectly suited to the task: the Transform tool. This is found along the Menu Bar under Image > Transform > Free Transform.

Step 18
Transform tool

When active, the following settings are available along the Tool Options bar, with a bounding box appearing around the editable component. This bounding box incorporates control points or handles that are used to manipulate the object in the directions indicated.

If you place the cursor inside the corner points it reveals a scaling operation (diagonal arrow), whereas outside of the bounding box it controls a rotation (curved arrow). If you want

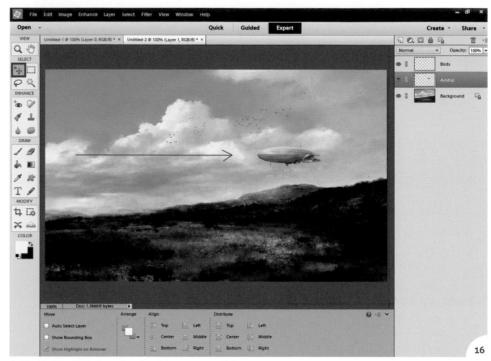

▲ Moving the airship is easier when it is on a separate layer

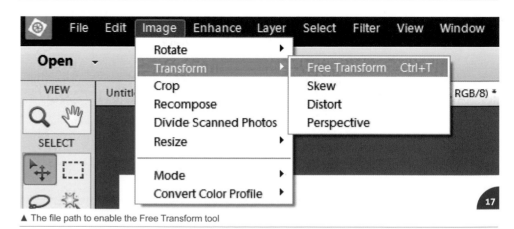

▲ The file path to enable the Free Transform tool

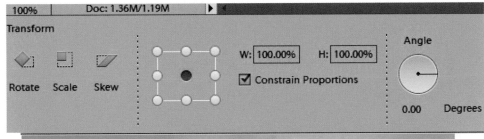

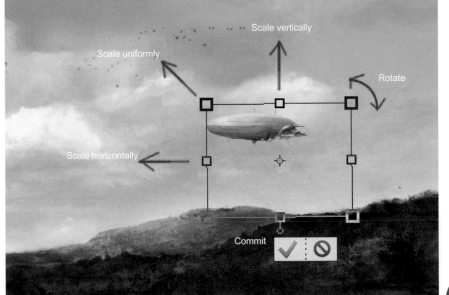

▲ Functions available with the Transform tool

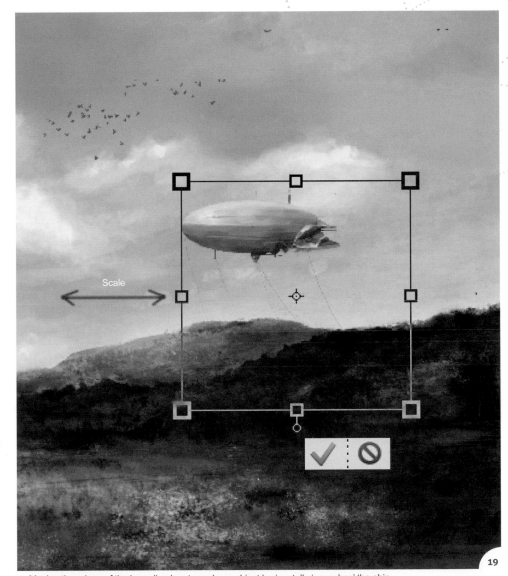

▲ Moving the edges of the bounding box to scale an object horizontally 'squashes' the ship

to scale uniformly then ensure that Constrain Proportions is checked within the options bar.

Once you're happy, click on the Commit button (green arrow) or alternatively cancel it using the neighboring button.

Step 19
Scaling one axis

Scaling along a single axis squashes the object either horizontally or vertically. As you can see, the ship here has been 'squashed' during the horizontal scaling process.

Step 20
Rotating an object

When rotating, you have the option of designating the location of the axis point. You can select this from the small diagram in the Tool Options bar, which has each of the nine points corresponding to those on the Bounding box.

Step 21
Opacity

If we scaled the airship uniformly so that it looked further away, then we may want to reduce the layer opacity slightly to account for the atmospheric perspective.

Strictly speaking, this is not the correct way of reducing the contrast but it is acceptable as the airship is a similar color to the background and we only need to reduce the opacity by about 25%.

Step 22
Extreme distortion

So far all of the editing has been done via Free Transform but we also have the option of using Skew, Distort and Perspective for more extreme distortion.

We can create the illusion of rotating an object slightly through minimal scaling (as seen in Step 19) but if, for example, we wanted to turn the airship 30 degrees or so then we would be better off using a combination of the above.

You will notice that I add a highlight along the bow of the ship and amend the rear fins as these no longer conform to the revised angle.

As a rule, more amendments tally with greater distortion, which is often why 2D artists incorporate 3D into their process to allow a greater ease of experimentation.

Step 23
Adding more detail

Going back to our original landscape we shall now add some further detail in the foreground. I advise adding detail on a separate layer so you can experiment with the shapes and composition without having to redo the background if you don't like the changes.

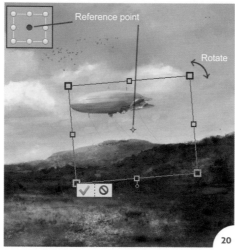

▲ Rotating using pivots on the bounding box

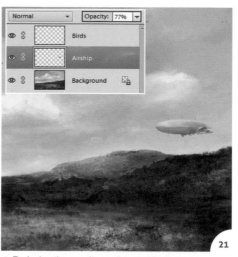

▲ Reducing the opacity on distant objects

▲ Revising the detail to fix a scaled image

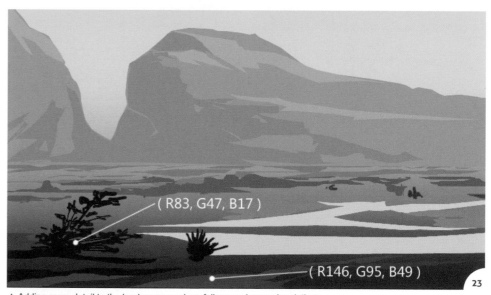

(R83, G47, B17)

(R146, G95, B49)

▲ Adding more detail to the landscape, such as foliage and ground variations

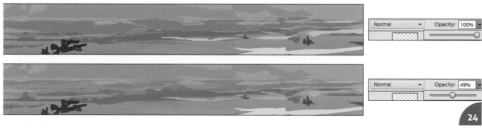

▲ Using Opacity to create a better transition between the ground and mountain base

Image 23 shows this additional detail in the form of some shrubs and patterning across the ground plane with their accompanying RGB values.

Step 24
Layers to smooth obvious lines
We will now add a layer to soften the transition between the ground plane and the distant mountains.

Using the Lasso tool once more, I trace an array of shapes along the horizon line and fill them in with a color similar to the mountains. I then reduce the Opacity to around 50% (depending on the exact color), which helps create a smoother gradient between the foreground and the background.

Step 25
Layer blending modes
One of the key advantages of using layers is the ability to change their blending mode,

which affects how they interact with those located below them in the Layers panel.

Each of these scenes in image 25 comprise of a gray background and two separate rectangles. You can see how the four example blending modes change the relationships between the two rectangles. You'll find that this is something that can be exploited with digital media to great effect in your own images.

Step 26
Overlay blending mode
With these modes in mind, we shall add a further layer and add some detail in the foreground area. This time though, we will select Overlay as our blending mode.

Image 26 shows the dark green band on a new layer set to 'Normal' (top image) and the result of setting it to 'Overlay' (lower image). You can see how the color has now changed and is more closely attuned to the surrounding hue.

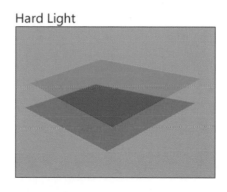
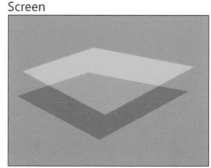

▲ Examples of the different blending modes available

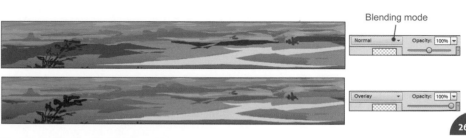

▲ The effects of the Overlay blending mode

Step 27
Adding more layers
We can continue adding layer upon layer in order to add details such as these and experiment with the blending modes, trying out various color schemes and levels of transparency. The main restriction is file size and an increasing complexity, but the number of levels you work with is ultimately up to you. I advise flattening layers periodically and working with as few as possible in order to minimize these issues.

Image 27 shows the final version of the image with its accompanying five layers.

The two additional layers incorporate a gradient lightening the lower half of the sky alongside some minor detail in the middle distance, including a small shrub and pale band of color.

Step 28
Benefits of using layers
The great thing about layers is that we can keep adding new ones to create variations as opposed to re-painting. Image 28 shows the scene with two further layers at the top of the palette, creating a different mood and lighting condition. We can switch between the two color schemes quickly and easily if needed.

Apart from the Undo function, this is perhaps one of the greatest advantages of working

digitally – we can revert back to a part of the painting process as well as being able to divide the image into components.

Step 29
Using brushes
We are now going to try and replicate our painting using Photoshop Elements' brushes: the heart of a digital-painting package.

Brushes are accessed from the Draw section of the Toolbox. After selecting the Brush tool you will see a number of parameters along the Tool Options bar. There are two slider bars where you can control the size of the brush as well as its opacity.

The sample brushstrokes in image 29 use a variety of sizes and opacity levels, both of which are self-explanatory. To the right of the bar you will see the Mode label, which is identical to the Layer blending modes except that it correlates with the brush and not the layer.

Step 30
Brush Presets
The small arrow to the right of the Brush label opens the Brush Presets menu, where you can choose from a variety of brushes. You will see a window allowing you to scroll through the library. There are a number of libraries that can be accessed from the top menu next to the Brush label – Default Brushes in this case (image 30).

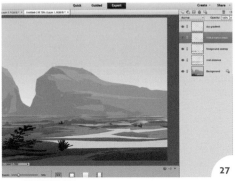 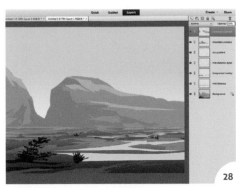

▲ The final version of the image with added layers ▲ Changing the mood or lighting conditions with layers

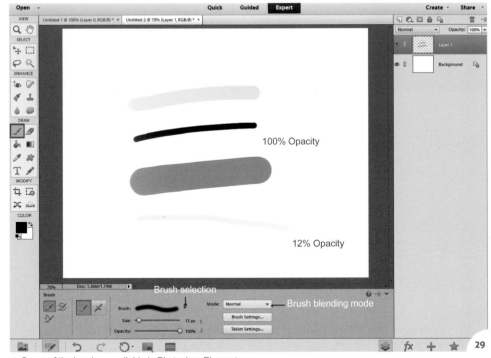

100% Opacity

12% Opacity

Brush selection

Brush blending mode

▲ Some of the brushes available in Photoshop Elements

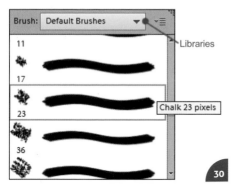

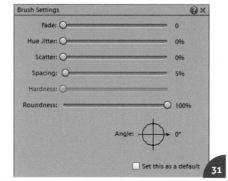

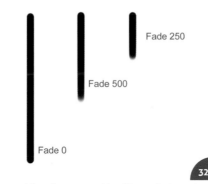

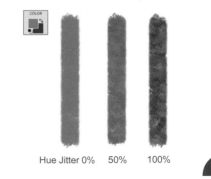

▲ Brush Presets available in the Default Brushes menu

▲ The Brush Settings window and setting options

▲ Some of the effects created by different Fade settings

▲ Using the Hue Jitter option to mix colors

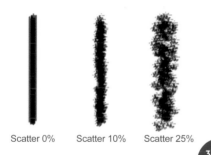

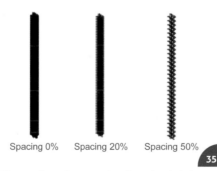

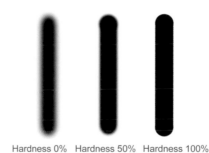

▲ The Scatter option can break up your brush tip

▲ The spacing option spreads out your brushstroke

▲ The Hardness setting blurs or sharpens the strokes

Step 31
Brush Settings

With each brush there is a choice of settings at your disposal. These can be found by pressing the Brush Settings button.

Brushes can also be modified through the Tablet Settings drop-down menu, lending yet another level of control. We will discuss these options in turn.

Step 32
Brush Settings: Fade

The list is headed by Fade, which determines the rate at which paint depletes from your brush. Higher numbers correspond to a more loaded brush, although 0 represents no fading at all (unlimited paint). The brush size will also have a bearing on this so settings will need to be tweaked accordingly.

Step 33
Brush Settings: Hue Jitter

Hue Jitter is something I rarely employ, but it can nevertheless prove valuable. It essentially mixes the background and foreground colors within the brushstroke, as seen in image 33.

You'll find that using a higher percentage results in more of an equal mix in the brushstroke.

Step 34
Brush Settings: Scatter

Scatter effectively breaks up the brushstroke into a pattern that reveals the shape of the brush tip. The higher the percentage, the more increased the scattering.

Step 35
Brush Settings: Spacing

Following Scatter is Spacing, which spreads out the brush marks in a stroke. Higher numbers will create a less consistent stroke.

Step 36
Brush Settings: Hardness and Roundness

Below Spacing is the Hardness setting which varies the edge of the brushstroke from soft to hard, depending on the position of the slider.

The final setting in this menu controls the Roundness of the brush tip, and so as you

move the slider from 100% (fully round) down to 0%, the circular brush shape becomes increasingly elliptical until it eventually assumes the shape of a thin line.

Step 37
Tablet Settings
The other important parameters are the Tablet Settings, where you can change how the graphics tablet influences your brushstrokes. These are similar to the brush presets but allow the settings to be applied to each and every brush that supports them once selected.

When using a graphics tablet it is common for you to want to be able to control the opacity for a great many brushes, and so enabling this function here can prove useful. Whether you wish to enable the remaining functions is subjective and depends on the situation.

❝ Use the bracket keys to the left of the Return key in order to alter the size of the brush ❞

Step 38
Painting with the Chalk brush
For this tutorial I shall restrict myself to the Chalk brush, which you can find about halfway down the library list, under Default Brushes.

Using the initial painting as a guide, I begin replicating the foreground section on a single layer. While painting, it is useful to sample colors from your image with the Color Picker tool in order to vary the hue and tonal range. A good shortcut is to hold down the Alt key when using the brush, which makes the process more fluent.

Another handy tip is to use the bracket keys to the left of the Return key in order to alter the size of the brush.

Step 39
Experimenting with settings
By enabling Opacity within the Tablet Settings we can lay down semi-opaque brushstrokes akin to watercolor washes. This allows us to mix color on the canvas, which gives us a certain freedom to experiment with color and try different combinations, as well as being able to create both hard- and soft-edged passages.

Image 39 shows how, by varying the opacity, we can create a range of marks. We can then create fully opaque areas by sampling the semi-opaque washes.

Step 40
Painting objects
You can structure this version of the painting in a similar way by using layers to isolate different components, or use a single layer as I have done. In order to create the horizon I use a semi-opaque wash and then sample it to create a soft transition.

When using brushes, try to vary the types of marks you make and consider how both soft- and hard-edged strokes can be used to describe different materials/objects, as well as create focal points and spatial depth.

For example, clouds may require both soft and hard edges, while architectural scenes will demand crisper lines. Of course, rules can always be broken, but it is always worth

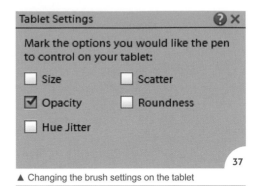

▲ Changing the brush settings on the tablet

▲ Using the Chalk brush to add in shapes and detail

▲ Creating different effects by varying the brush settings

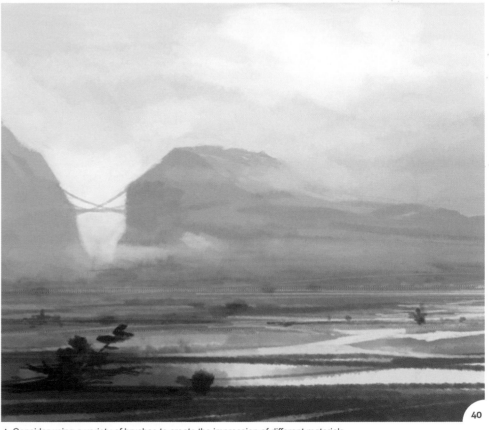

▲ Consider using a variety of brushes to create the impression of different materials

considering how you apply the brushstrokes and the impact this has on the overall image.

Image 40 shows the final version of the image, which, as you can see, has a very different quality to the first one. The outline of the background hills varies between a soft and hard edge to show the interference of clouds, which can also be seen drifting above the horizon.

The entire image was painted using only the Chalk brush, but you could add an array of texture to your scene by varying the types of brushes you use.

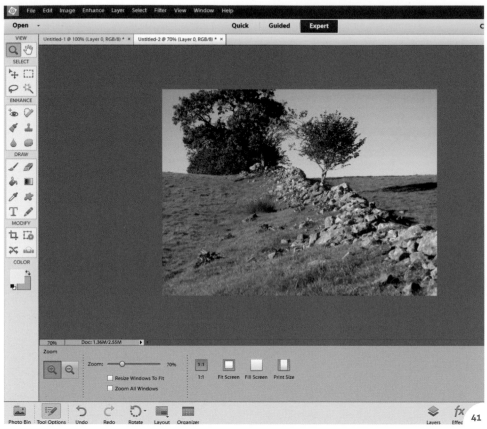

▲ Extracting the image of a shrub to use as a custom brush

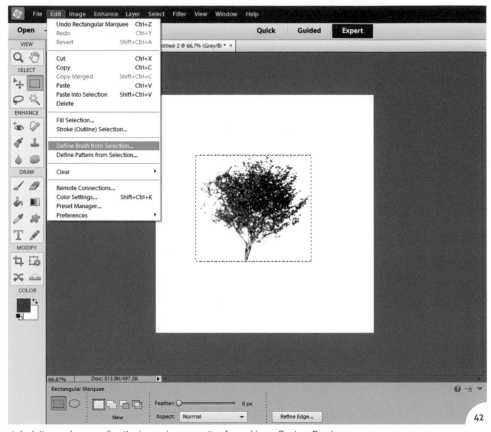

▲ Isolating and grayscaling the image in preparation for making a Custom Brush

> **❝ One of the most powerful aspects about the Photoshop software range, with regard to digital painting, is its ability to create and save custom-made brushes ❞**

Step 41
Custom Brushes

One of the most powerful aspects about the Photoshop software range, with regard to digital painting, is its ability to create and save custom-made brushes. With this function, you are able to create and refine your own texture brushes.

Let's say, for example, that we wanted to add a number of trees across our landscape but didn't want to paint each one individually. We could paint a single tree and then use this to create a brush, or alternatively we can find a photo from which to extract a brush. I looked for a suitable image and found

the one in image 41. This was particularly appropriate because it has a plain background and therefore makes it easier to extract.

Using the Magic Wand, I select the sky around the small shrub and then incorporate the rest of the canvas using the Marquee

Brush: Default Brushes

100

75

45

352

▲ Naming your brush and finding it in the Brush menu

tool. Once done, I invert the selection area to encapsulate just the shrub and then copy and paste it into a new layer (Ctrl+C then Ctrl+V).

Step 42
Creating a custom brush

With the shrub on a new layer, I desaturate it, as the color information is not important compared to the silhouette. This can be done by going to Image > Mode > Grayscale. Image 42 shows this stage of the process, with the shrub pasted onto a white background and flattened into a single layer. You may wish to scale down the image as a large brush can be more intensive to use, but this is dependent on your chosen file size and hardware situation.

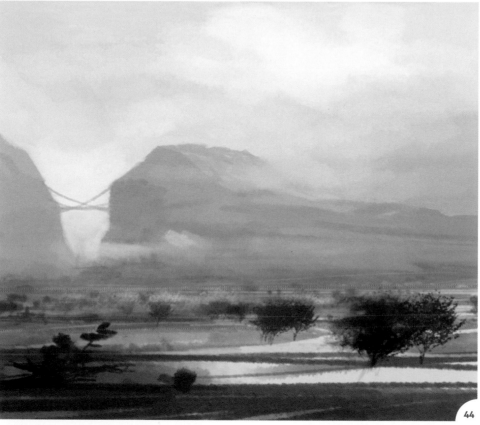

▲ Using the custom brush to add foliage to the scene

Step 43
Setting up your custom brush

Once done, you need to go to Edit > Define Brush from Selection and then name your brush. This brush will now appear at the base of whatever library is active; in this case the Default Brushes menu.

If we now scroll down we will see this newly added brush in its raw state. By that I mean that its parameters will be unmodified, so in order for it to work effectively and create the texture you need, you will need to adjust the spacing first and foremost and any other settings you feel are necessary in its options panel.

Step 44
Using your custom brush

Once done you can begin to use the brush, which in this instance is used to populate our landscape with shrubs.

Of course, as with any custom brush it will require some experience to get the desired effect and a careful adherence to light and perspective should be observed. Using custom brushes in general, though, can prove a powerful and time-saving option.

Step 45
Conclusion

This concludes an overview of most of the tools you will use on a regular basis when carrying out your digital painting. There are, of course, numerous other tools and functions at your disposal but these are perhaps the ones that will prove most useful.

Learning about and familiarizing yourself with the interface is just the first step but there is no substitute for practice and experience, as well as a solid understanding of art theory, which will form the backbone of the next chapter.

❝ There are of course numerous tools and functions at your disposal but these are perhaps the ones that will prove most useful ❞

Art theory

Discover the key theoretical techniques artists use to create great-looking images

Though armed with knowledge of Photoshop Elements and having tested the tools in your own landscape scene, you may still be unsure about how to express your ideas in a quality image.

Here, Christopher Peters takes you through some of the most widely recognized theories relating to the depiction of a character or scene. Starting with light and color, Christopher then works through composition, perspective and depth, portraying emotion, and storytelling, giving clear definitions and pictorial examples to help you truly understand some of the key theories you need to consider when arranging your ideas in a digital painting.

Introduction to art theory

By Christopher Peters

The history of art theory

For centuries, art has been subject to study and analysis. Early theories were written by philosophers such as Aristotle and Plato, whose over-arching ideological commentaries allowed academics to begin considering the purpose behind visual art. Even in this early era, a significant focus had been placed on finding out more about the purposes, functions and rules within art.

From these roots in Ancient Greek philosophy, the focus of art theory has evolved throughout history, and in the Renaissance era it took on more of a distinctly introspective, humanist interpretation.

At this point, the artist and their work became much more important to comprehend as an individual entity, and the theory behind art began to reveal greater social insight.

From there, artwork underwent significant changes as new tools and methods were created to represent art and its analysis. The introduction of diversifying cultures also served to reveal new ways to interpret and represent reality on the canvas.

Overall, the history of art theory is a huge topic that spans millennia and there are numerous historical volumes dedicated to each phase in its evolution. I highly recommend that you study this theme in detail in order to truly understand the background of this topic.

So why do we need it?

The word 'theory' often deters artists from learning more about how to create elements of a scene. They question: 'Why are we going into the theory when we can simply apply the action directly? Art has no standards and no rules – it comes from inspiration. So why study books when we can work with our intuition?'

All these debates about theory and its functionality are very common in the art world, but before we can decide whether or not it's important to our own work, we have a duty to delve into the theory and see its purpose and benefits for ourselves.

There are many ways to go about the study of art theory. The easiest way is to ease yourself into it slowly, to help digest the information. Nowadays, the internet, art books, tutorials and online magazines provide important support for those who want to experiment with new techniques or improve their own knowledge and techniques.

Fortunately, art theory is pretty user-friendly. Its purpose is to help us understand the rules, norms and methods we must study to achieve a certain result. You won't need to form any specific views or particular standpoints on

▲ The psychology of color is explored in the Light section of this chapter (page 44)

▲ This image has two vanishing points on the horizon line – read more about this in the Perspective section (page 58)

this topic. You won't need to strictly follow the rules and you are free to experiment and follow your own intuition when painting – you should simply note that art theory is a tool for simplifying our understanding of the technical aspects of an image.

So, it's time to grab a coffee, relax, and journey into the basic concepts of art theory...

❝ Art theory is pretty user-friendly. Its purpose is to help us understand the rules, norms and methods we must study to achieve a certain result ❞

▲ Discover how to divide an image to create a great composition in the Composition section (page 54)

Light and color

by Christopher Peters

Lighting affects everything. It is the method by which we see and interpret our environment. As it influences a wide variety of aspects in any scene, such as volume, color and texture, it's important to understand its properties in order to achieve a convincing light effect in your own work. It's also important to mention that shadow has an equal amount of power in a scene, as it represents the total abstraction of light and all its properties.

Beginner artists often focus solely on the study of color and forget that forms, boundaries and color choices are directly related to lighting. For this reason, we'll study lighting first in order to understand how our choices here will impact on other elements, such as the color and texture in the scene.

First of all, we must understand that there are a wide variety of light sources, color and textural reactions, and other complex lighting phenomena that simply cannot be reproduced in a digital painting. This shouldn't put us off trying to create a realistic light scene though, as we can simply manipulate various elements in our image to reproduce the effects we see when studying light in reality. Research is a key tool in underpinning our knowledge of lighting forms. I encourage readers to study natural and artificial lighting environments and make note of unusual color or textural effects.

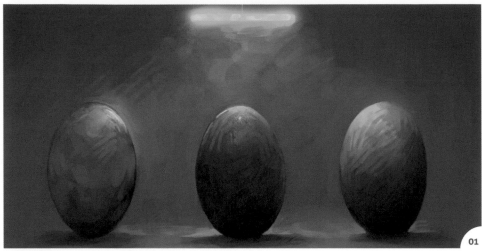

▲ We'll first think about the lighting situation that we want to begin painting

Step 1
Think first, paint second

There are a number of methods that support cognitive vision as the best starting point when lighting a new scene. In this section, I will describe and structure a rough idea of this process as simply as possible, as encountered through my years as a practicing artist. I will explain the initial basic aspects and apply them in a series of examples using Photoshop Elements.

These are the two working areas to consider:

1. Cognitive vision: Organize and sort the data in your mind. In this theoretical space, you can gather and organize all the information that we will need to analyze a scene.

> ❝ Reality and painting reality follow slightly different rules, so this may generate problems when painting a realistic scene ❞

2. Digital plane: The digital plane is our software (in this case Photoshop Elements), our digital tablet and computer.

These will shape our workflow.

First, in our mind, we make decisions on the possible elements that will form our scene, such as the objects we will illuminate, our light source, or the different geometric figures that we will use. It's also important to define the nature of our light source – whether it will

▲ There is no light source here, and so nothing is visible

▲ Let's see what happens if we turn on our lamp

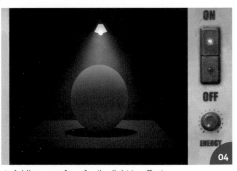

▲ Adding a surface for the light to affect

be natural or artificial – and if it will have any defining characteristics or properties (e.g. energy and distance). We can also decide on the properties of the objects, such as geometry, natural color, material, and textures.

We then define all these elements in a process called 'rendering'. In rendering, we refine the mental data we've decided on and translate it into a picture. There are two parts to this: the data principle and the visual correction principle.

The data principle analyzes and resolves the problems that might occur in your scene according to a realistic lighting scheme. This principle interprets the data as lighting reality; however, 'reality' and 'painting reality' follow slightly different rules, so this may generate problems when painting a realistic scene. The visual correction principle corrects the errors that the data principle might create. Knowledge of this stage is generated through previous study, or by being constantly exposed to lighting reality.

We will now work through this painting process in order to create an accurately lit scene.

Step 2
Visual data
First, in the mental data-gathering stage, I decide to use a ball on a floor plane and place a colored artificial light source (a lamp/flashlight) above the ball.

We can now begin translating this idea into an image and start rendering it. To start with, the scene is without a light source – there is a total absence of light and so nothing can be seen.

Step 3
Adding light
Now we can add the light source that we previously decided upon in Step 2.

Step 4
Adding a surface
In order to define our impression of the lit scene, we need to add a surface for the light to affect. To do this, we are going to add a simple object and a plane for it to exist on.

Step 5
Key scene elements
As you can see from image 04, the light rays hit the surface of the objects and allow us to understand their shapes, textures and shadowed areas. We use three important elements here to manipulate our impressions of the scene:

1. Light source
2. Object
3. Projected shadow

❝ Light rays hit the surface of the objects and allow us to see their shapes, textures and shadows ❞

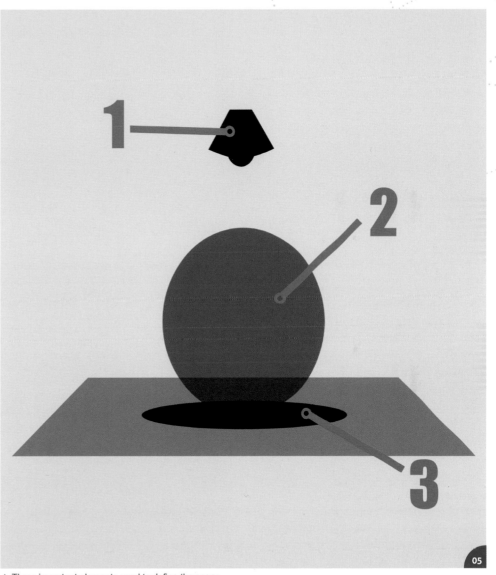

05

▲ Three important elements used to define the scene

Step 6

Lighting types: Natural

In order to begin defining our basic lighting situation, we need to consider the properties of different lighting sources to create a realistic effect. We will first consider the effects of the main light source. This type of lighting affects all the elements in the scene and can be present in a natural or artificial way.

Natural light, as its name suggests, comes directly from a natural light source. Examples of this form of lighting can include rays from the sun or moonlight.

Step 7

Lighting types: Artificial

In contrast to natural lighting, artificial lighting comes from a synthetic source, such as a lamp, neon strips, flashlights, and so on. As these are created using chemical or electrical means, they have a very different quality to them when compared to natural lighting.

Step 8

Lighting properties: Intensity

In addition to the type of lighting, we can also discern and portray the properties of the light. The intensity of the light is the degree to which energy is released from the source. Image 08 shows three examples of intensities – you'll notice how each of these provide different atmospheres in the scene.

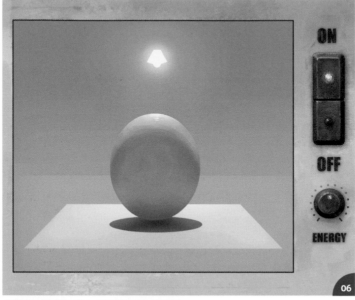

▲ Natural lighting is created by natural means

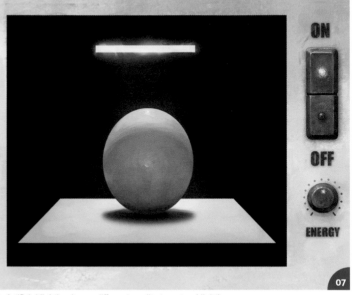

▲ Artificial lighting has a different quality to natural lighting

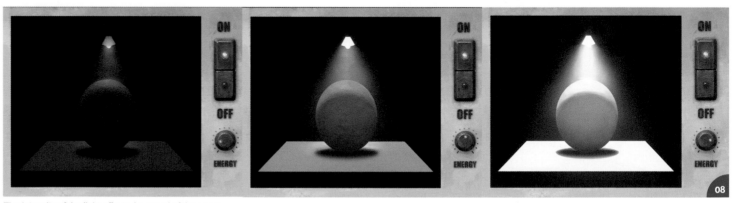

The intensity of the light affects the mood of the scene

Step 9

Lighting properties: Distance

Determining the distance between the object and light source is a key element of creating a light scene. The distance you choose influences the impact and illumination of the objects in the scene. As a rule, the further an object is from the light source, the less the lighting will affect it.

This image gives examples of spheres (1, 2 and 3) at the following distances from the light source (A):

1. 20 meters
2. 40 meters
3. 80 meters

Notice that sphere 1, at 20 meters away from the source, is brighter lit than spheres 2 and 3, due to its close proximity to the light energy emissions.

Step 10

Lighting properties: Angles

We must also consider the position and direction of the object in relation to the light source, as both of these properties will directly influence the amount of light affecting the object.

In this image (10), you'll notice that it's not only the linear distance between the object and the light source that affects the intensity of the lighting, but also the height and

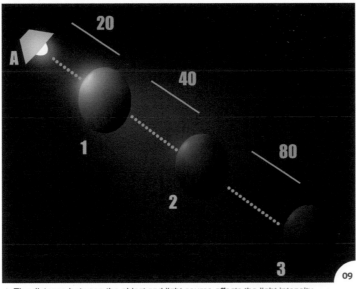

▲ The distance between the object and light source affects the light intensity

▲ The angle of the light determines an object's highlights

position of the object in relation to the light source. Each of these lighting properties can be manipulated to create a certain mood, atmosphere or narrative in your scene.

By focusing on different characters or objects with different lighting angles, intensities and colors, we can set up an importance hierarchy, and therefore a narrative element for the viewer to follow.

Step 11

Light and objects

An object is any element that occupies a place inside our geometric space; from the sword

that our character is wielding to the stone that forms part of the forest. In reality, millions of objects can exist in any given environment, each of which possesses its own unique contours, textures, materials, forms and colors. Because of these individual traits, not all of these objects react the same when exposed to light.

To help us determine and depict the way each object will react to light, we need to consider three different elements:

- Geometry
- Natural color
- Material/texture

▲ An example of an object that might exist in a scene

Step 12

Object geometry: Polyhedrons I

Solid objects that occupy a space in a scene are split into two types depending on their form/geometry: polyhedrons and non-polyhedrons.

Polyhedrons are volumes with flat faces and they subdivide into plates, prisms and pyramids. If you begin to imagine objects such as heads, legs and weapons as simple geometric entities, it becomes easier to understand how to illuminate a polyhedron.

In image 12, we can discern a clear, simple polyhedron base in the girl's head. It's easy to see the flat sides and main vertices from this angle.

Step 13

Object geometry: Polyhedrons II

With our polyhedron base established, we can look into adding a linear lighting focus to see how the light will affect different areas of the image.

We can see that every flat side of our geometric body has a value assigned to it, from 1 to 9. Number 1 has the most direct exposure due to its proximity and angle to the light source, and number 9 has the least exposure. These values can also be represented on a value scale ranging from absolute white at 0, to absolute black at 10.

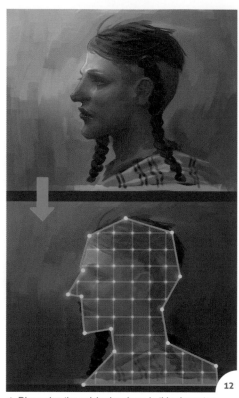

▲ Discerning the polyhedron base in this character

So how do we know what value to assign to each side? That depends exclusively on the position at which the light source is located in relation to our object. We must always keep the following conditions in mind:

- The sides with frontal exposure to the light source are around values 1, 2, 3 and 4 depending on the distance

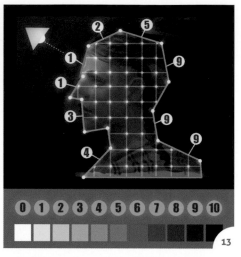

▲ Assigning light values to the different vertices on a polyhedron base

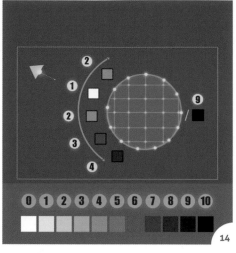

▲ Using the blocked value system and applying it to a curved edge

▲ Identifying the base colors of an object

- The sides with horizontal and vertical exposure are around values 5, 6 and 7

- The sides angled directly away from the light source, or sides that are blocked by other objects/sides, are around values 8 and 9

Step 14
Object geometry: Non-polyhedrons

Non-polyhedrons are bodies with a curved surface, like a ball, cone or cylinder. To light a non-polyhedron, we will use the same methods used to light the polyhedron, but will replace the values assigned originally to the flat sides, to the curved edge.

If we segment the surface into equal parts, we can then assign the zone nearest the source the value of 1, and the furthest point as value 9, varying the values as appropriate in between.

Step 15
Object color I

The base color of the object is a basic property that we can find in every existing object we could possibly want to paint. In more simple terms, it refers to the natural color that every element possesses; for example, blue fabric, a yellow raincoat, and the red color of an apple. The base colors of these objects will naturally influence the effect of different types of light.

Step 16
Object color II

Let's have a look at examples of how the base color of an object can change when exposed to different light sources. The host color that we'll use in the example will be a common yellow. This yellow will be submitted to both a warm mock sunlight and an artificial fluorescent light, and we will be able to see the different effects created.

Step 17
Object color III

As you can see from image 16, the effect differs dramatically when the same scene is exposed to different lighting types.

A natural, warm light makes the yellow take on a warm temperature, which affects the color scheme in the image as follows:

- Shadows: deep-brown
- Middle tones: orange
- Highlights: warm-yellow

The cooler fluorescent light affects the color scheme in the environment as follows:

- Shadows: brown-sienna
- Middle tones: lime-yellow
- Highlights: light-green

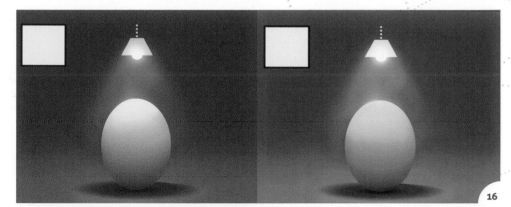

▲ How different types of lighting can affect the same base color

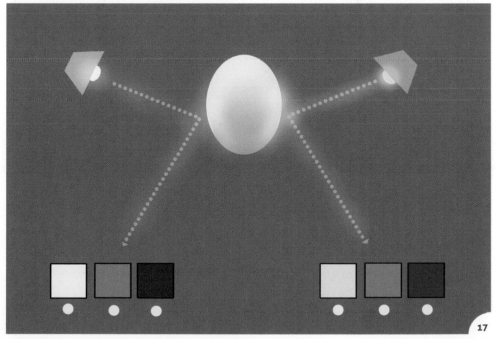

▲ The different types of lighting create different color palettes

Step 18

Object materials

Materials are another key object property that can have a significant impact on the effect of light. We can find a wide variety of materials in reality such as metal, wood, crystal, fabric, plastic, and so on. Each of these will react differently in certain lighting situations.

Step 19

Object materials: Metal

There are many different types of metal. Some have intense reflective properties, others are a little rusty and worn out. In general though, metal generates a vibrant reflection with high-contrast coloring and bright highlights.

> **❝ You'll find that wood can be shiny or matte, depending on the treatment of the wood, and it generally has an opaque, light-absorbing texture ❞**

Step 20

Object materials: Wood

Wood is one of the most common materials and can come in many forms, textures and colors. Learning how to paint wood is useful as many objects are made from wood, and so it is very likely you will encounter it as a texture. You'll find that wood can be shiny or matte, depending on treatment of the wood, and it generally has an opaque, light-absorbing texture.

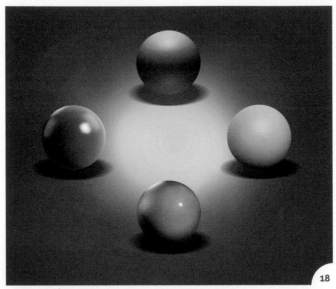

▲ Materials react differently under certain lighting conditions

▲ Metal generates bright highlights and distinct color contrasts

▲ Wood can be matte or shiny, and is generally opaque

▲ Fabric makes up a large part of our environment, so it's useful to learn how to paint it

Step 21

Object materials: Fabric

Fabric makes up a large part of our day-to-day environment. Characters wear blouses, shirts and pants; houses are furnished with curtains and bed sheets, and even sailing ships have fabric sails, so it's useful to learn how to paint this common material. There is a wide range of fabric texture types, such as silk, cotton, synthetic and wool.

Step 22

Object materials: Glass

Glass is unusual in that it gathers a lot of properties from surrounding objects, and for this reason is a particularly hard material to paint. The best way to tackle this is to use photographic references to guide your work. Its highly reflective property makes it particularly challenging to depict in a painting.

In image 22, you'll notice that the glass shape picks up the reflected hues of the two colored spheres. You'll also notice that there is a blue tint around the top and bottom of the glass shape. Blue is a common reflected color in glass materials.

Step 23

Object materials: Creating contrast

An effective way of allowing the viewer to interpret the materials easily, is to place contrasting materials with opposing

▲ The highly reflective surface of glass makes it difficult to paint

characteristics in close proximity to one another. This action reinforces the difference between the two materials and allows the viewer to recognize each material for what it is.

For example, you could contrast metal and skin by painting the metal with shiny, reflective properties and contrasting that with an opaque, desaturated skin material.

Steer away from painting the metal and skin with the colors in the same tonal range, and vary the tone and texture. This will help you to avoid the beginner mistake of having similar-looking materials that are difficult to distinguish between.

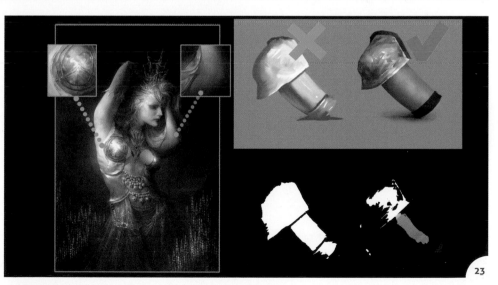

▲ Create variety using tonal differences in the contrasting materials

Step 24
Object materials: Texture

The texture is a property of the material of an object, and is simply the rough part of our object's surface. Thanks to the textures of objects, we're able to know the different materials that any object may comprise of. When digital painting, we can give texture to our object surface using two basic methods:

1. Hand-painted: We can create this texture using a paintbrush or any digital tool that allows spontaneous mark-making. In most cases, we can obtain an original set of marks that generate the impression of a texture (see left of image 24).

2. Photographic: We generate this texture using photograph textures. You'll need to use complex techniques to integrate the image successfully into your scene, such as changing layer blending modes to Overlay, Multiply or Soft Light. It also almost always creates hyper-realistic results, and so better suits hyper-realistic/realistic scenes (see right of image 24).

Step 25
Shadow

After discussing the effects of lighting on an object, we also need to consider the shadowed areas in an image that arise as a result of the lighting conditions.

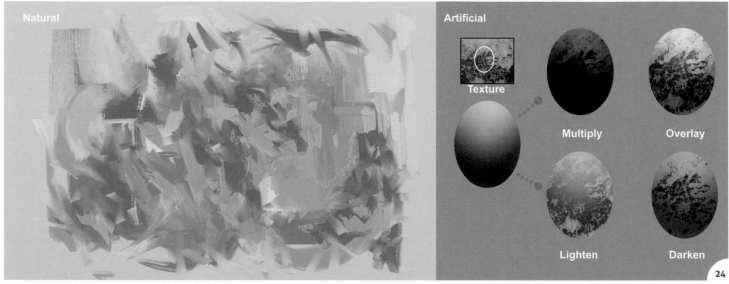

▲ The left image shows natural hand-painted texturing; the right image uses photographs for artificial texturing

In simple digital terms, the cast shadow is a projected shadow and is created by an obstruction between a light source and an object. There are a number of factors that define its characteristics, and these are outlined in the following steps.

Step 26
Defining shadow: Light intensity

The intensity in the energy of the light source will define the sharpness and definition of the shadow. If the light source has low energy, the projected shadow will be smooth and soft, but if the lamp's energy increases, the shadow will be more defined and sharp around the edges.

▲ Shadow is as important as light

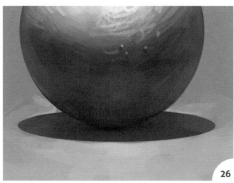

▲ An intense light beam will create sharp, crisp shadows

Step 27
Defining shadow: Light position

The direction and projection of a cast shadow changes according to the position of the light source. In image 27, you'll notice how position and beam direction affect the placement of the shadows.

Step 28
Final stages

So finally, after mentally defining the lighting setup and getting down the rough ideas according to the tips given, we're able to finalize the scene and begin the ultimate problem-solving stage as mentioned in the first step. This analysis stage determines the success or failure of the scene.

That said, it is important to order and simplify the analysis chain in order to create the image we've envisioned. So, in conclusion, we should:

• Order the space
• Define the light source
• Prepare the visual data
• Gauge the light source properties
• Work on the object's geometry
• Define the natural color
• Identify the material
• Apply the textures
• Check the cast shadows

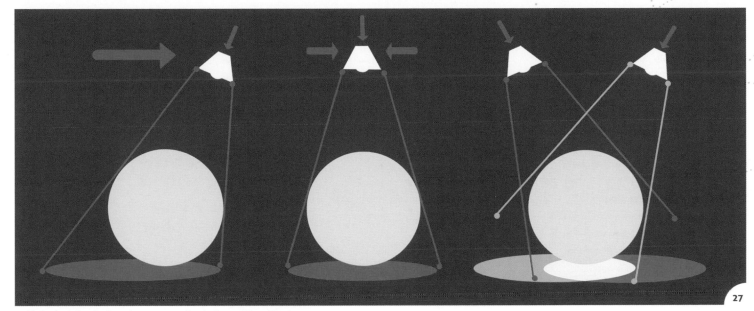

▲ Notice how the shadow changes according to the position of the beam

Though this is just a basic analysis chain, you can apply it to any geometric form in any scene. As you progress as an artist, you can make these steps more complex, but as a simple rendering process for lighting a scene, this is a great start.

❝ The direction and projection of a cast shadow changes according to the position of the light source ❞

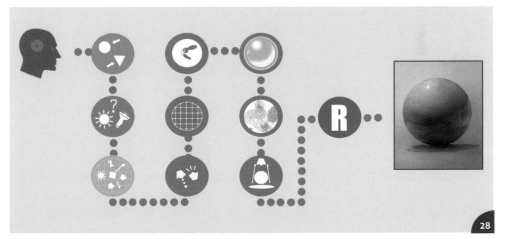

▲ The final thought process involved in creating a light scene

Composition
by Christopher Peters

To explain composition in simple terms, it is the placement of all the elements in our scene. This is not a random placement though; the composition has to be structured by our visual perception and our perception is always looking for a visual harmony between existing elements. Your choice of composition will define the final look of your artwork.

Composition defines the order and distribution of all the elements of an image such as color and form, using techniques based on balance, movement, rhythm, unity, contrast, focus and proportion.

To give you an idea of the different types of composition, we'll have a look at a few examples of techniques to consider when composing your image.

Step 1
Balance
Having equilibrium gives us a sense of visual harmony. An image typically contains a lot of elements and all of these elements possess a visual weight in either color or form.

To create equilibrium in a composition you need to look for a balance between all the various components – their weight, color and form – in order to create a consistent and harmonious image.

This doesn't mean that you are destined to make your images in a balanced way forever; it will depend on the effect you're trying to create.

❝ To create axial symmetry, you need to place two elements on each side of the composition ❞

Step 2
Axial symmetry
This type of composition is one of the most basic methods of putting all the elements in place.

To create axial symmetry, you need to place two elements on each side of the composition. These two elements need to be proportionally identical and the points of the first element need to coincide with the points of the other.

It's important to mention that these two elements are equidistant to the center point of our composition, but you should note that the position and orientation is reversed.

Step 3
Object symmetry
The main object is positioned in the middle of the composition at the axis of symmetry. The secondary objects are placed either side and of equal distance from the main object. This composition creates a sense of balance and solidity. However, this composition often looks too rigid and static.

▲ Here you can see a balanced image

▲ An example of placing objects using axial symmetry

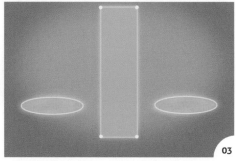
▲ Arranging your scene using object symmetry

▲ Compensating for uneven object distribution using another object of equal mass

▲ Using the rule of thirds to place points of interest in your image

▲ Making sure all the elements of your image are linked within your composition

Step 4

Compensating mass

As its name suggests, this principle uses other objects to compensate for uneven mass distributions in an image, rather than using a visual symmetry.

This lack of mass can be compensated by creating another mass with equal weight, and can be offset by texturing, coloring or filling the empty space with more visual information. So if you feel that your composition is a little unbalanced, you can create a mass to fill this space using texture, solid colors or any other combination of visual information.

> **ᒪᒪ Lines need to follow a consistent path with a logical rhythm, so you should be careful not to block the flow of the lines with intercepting lines ᒍᒍ**

Step 5

Rule of thirds

This rule is very simple: you just need to divide your canvas, as seen in image 05, and place the focus of the painting where the lines intersect. These zones are the focal points of the image. The viewer's eye is naturally drawn to these areas, so to create a comfortable composition you should place the main characters, objects or actions at these intersections.

Step 6

Unity

The concept of unity, or unifying an image, simply means that all parts of your composition must be somehow linked, or part of the same visual group. You should keep this concept in mind when composing your images.

In order to unify your image, you need to make sure to keep an order within your composition and that you don't let any objects stray out of it.

Step 7

Line composition

The lines of our drawings represent weight as well. All of these curved, horizontal, diagonal and vertical lines have a compositional rhythm, too. This rhythm needs to be constant and harmonic, like the tempo of a song. We can't lose the rhythm and tempo while playing a musical instrument in a band, because the tempo is the heart of music. The same happens in drawing. The lines need to follow a consistent path with a logical rhythm, so you should be careful not to block the flow of the lines with intercepting lines, as this may break up your composition.

The linear rhythm always follows a repetitive pattern, and this pattern creates our harmonic path. You can see some examples of harmonic lines shown in the composition in image 07 – be careful to note all the different directions and the trajectory.

07

▲ These are examples of both harmonious flowing lines and harsh lines that intercept the main object

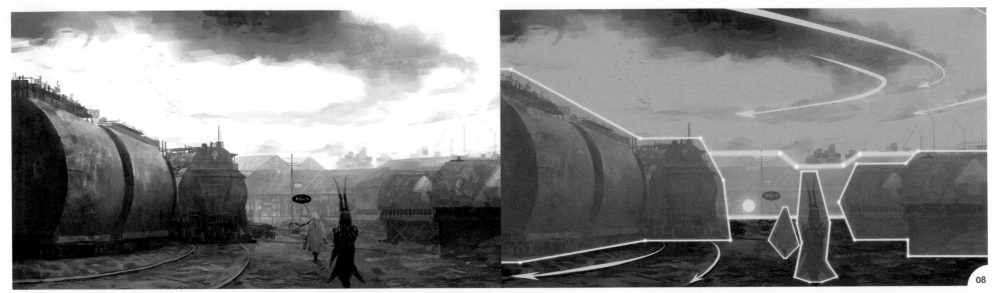

▲ Creating a sense of space and air using a spatial composition

Step 8
Spatial composition

The art of composing an image is directly
related to the emotions and sensations you
want to transmit in your piece. Each composition
has a unique way of transmitting a narrative
message. The composition is highly important
while planning your image; it can give viewers
a clear message and generate an emotive
reaction. So let's see some examples...

The main goal of spatial composition is to
create the effect of space and air in the
artwork. Usually, we use this composition to
present wide environments, to show big and

▲ Here the closed composition creates a sense of claustrophobia
Copyright © 2014 Applibot Inc

▲ Positioning objects or character at an angle to the frame creates dynamism
Copyright © 2014 Applibot Inc

impressive landscapes, and to present a world full of details. The spatial composition is a high-contrasting system that contrasts small elements with big ones to emphasize the difference of size and create a sense of vastness. The perspective plays an important role here, too.

Step 9
Closed composition

This is the opposite of spatial composition. The main goal is to somewhat trap the viewer into a contained place, which can then make the viewer feel a little claustrophobic.

A closed composition can also generate emotions such as rage, desperation, fury, envy and so on. It is also a useful storytelling device, to focus on details and specific situations.

Step 10
Diagonal composition

The purpose of this composition is to provide some dynamism in our scene. Visual elements falling diagonally reinforce the idea of speed and fluidity. Such compositions and linear models are very common in the comic, manga and commercial art genres as they create a striking visual appearance.

Step 11
The compensation gap

The aim of this composition is to emphasize the lack of visual elements and their weights,

▲ Adding blank areas can inspire an atmosphere of loneliness and depression

by compensating for the imbalance. Viewers visually try to fill the gaps and substantiate the lack of weight in the composition, and because of this, these compositions create the feeling that something is missing – an underlying imbalance that may strengthen the feeling of bitterness, loneliness, depression or sadness.

Step 12
Portrait composition

The objective of this type of composition is to fully concentrate on the emotion and gestural features of the character. This effect is generated by the compositional space. By adopting this format, you are able to maximize detail in gesture, emotion and facial features, and ensure that the viewer pays full attention to the individual within the frame.

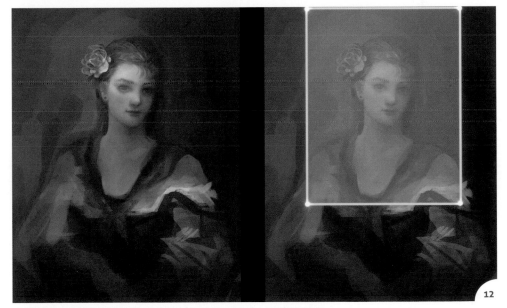

▲ Using the portrait composition to highlight details in the face and gestures

Perspective and depth

by Christopher Peters

Is it possible to create a three-dimensional reality in a space that only has two dimensions? Sadly not. Mathematically, in the physical world, we cannot work in three dimensions in a two-dimensional space. However, we can fake it visually.

We perceive reality in three dimensions: width, height, and depth, so when working in a 2D space we have to recruit the help of our friend, perspective, to create the illusion of depth.

Many of you have already read about perspective, and are probably already absorbed in the mathematical complexity of it. Perspective is an essential tool, and we need to understand it, but we shouldn't forget that perspective's true nature is simply to create a visual effect.

There are a few simple rules that make it easier to work with perspective. The human eye is easily fooled, so you only need to create minor spatial indicators to create the illusion of 3D space. If we don't have the natural skill to sketch 3D perspective by eye, it's important to take note of the lines and angles in a real environment to get an idea of natural perspective.

▲ The horizon line (HL) dictates the viewpoint of the image

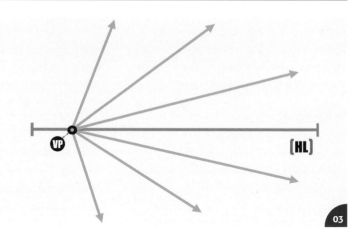

▲ The position of the viewer's eye establishes how the scene is viewed

▲ Vanishing points are the place to which all parallel lines converge

Step 1

The horizon line

Linear perspective has a lot of basic elements that we need to keep in mind when starting to draft perspective in an image.

First, the horizon line (HL) is the line that coordinates the view point. If we draw the horizon line above the main objects/eye-level, the image will be set closer to the ground. If we draw the HL close to the bottom edge of the canvas, we get the impression of elevation. The HL also determines the position of the vanishing points, and will guide you in the placement and position of these when you sketch it out in your image.

> ❝ Vanishing points are points in the distance of the scene that all parallel lines will head towards to create a 3D effect ❞

Step 2
The viewer's eye

This is a very simple and obvious aspect. Basically, it represents our view point at eye-level. It determines the position of our view.

Step 3
The vanishing point

This is where the magic begins! Vanishing points (VPs) are points in the distance of the scene that all parallel lines will head towards to create a 3D effect.

For the most part, these are situated on our horizon line, though there are occasions when this doesn't work (i.e. the bird's-eye view). We'll discover more about these later.

> ❝ You can create a depth hierarchy in the scene by sizing the objects according to importance. The main objects in the scene need to be bigger in the scene ❞

Step 4
Picture plane

The picture plane, also known as the 'painting' plane, is the 2D space that we use to draw our perspective; for example, the digital workspace on our screen, or the more traditional canvas or paper surface.

▲ The picture plane refers to your 2D workspace

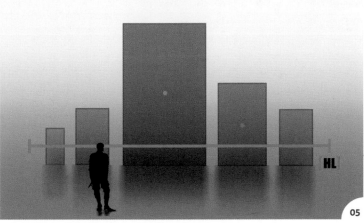

▲ Arranging and sizing objects according to importance

Step 5
Relative sizes

You can create a depth hierarchy in the scene by sizing the objects according to importance. The main objects in the scene need to be bigger in the environment. We also naturally perceive a small object as distant and a large one as closer to us, so you can use this basic principle to create an effect of depth in your work.

Step 6
Overlapping perspective

When a close object blocks a distant object it's called an 'obstruction', or an 'eclipse'. This is a very obvious method used to create layers of depth. This arrangement helps define the order of objects in the space and directs the attention of the viewer through the scene.

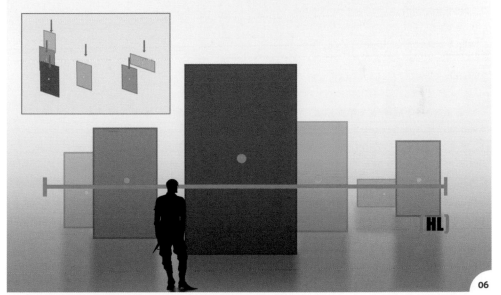

▲ Using layers of overlapping objects to create the illusion of depth

Step 7

Creating a one-point perspective

There are three basic ways to create perspective in your work. With practice, you will eventually be able to represent a more complex impression of perspective, using multiple vanishing points with hundreds of intercepting lines.

So to start, we will create the one-point perspective. This is the most basic perspective in drawing. It has just one vanishing point on it and all parallel lines in the scene converge to the same point.

1. So to start, set the viewpoint in front of us in the center of the paper and draw a horizontal line across the page. This will be our horizon line (HL). We then draw one vanishing point at the center of the horizon line and name it 'VP1'.

2. Now that you have the VP, draw a single rectangle to the left of the paper, above the horizon line.

3. Draw a line from VP1 to points A, B, C, and D.

4. Limit the depth of the rectangle by drawing a horizontal and vertical line parallel to the rectangle shape, on the receding lines. Now erase all the remaining lines in the space, and you'll see that we've created four new vertices: the A2, B2, C2 and the '?' plane.

1.

2.

3.

4.

5.

6.

▲ The key stages in creating a one-point perspective

5. Now we can complete the hidden plane. Draw a horizontal line from C2 to the diagonal line positioned between VP1 and D. This line is parallel to the horizontal one that we drew from A2 to B2. Name it 'D2'. Now draw a vertical line from D2 to A2.

6. Erase the remaining lines and fill the cube with a color. And voilà! We've created a 3D rectangle with just one vanishing point.

Step 8

Creating a two-point perspective

This perspective is highly versatile and is really useful when drawing interior spaces, objects, corners and buildings. So let's see how it works.

1. Draw your horizon line in the middle of your picture plane. Add two VPs on either side of the horizon line and name them 'VP1' and 'VP2'.

2. Now draw two short vertical lines positioned at the right and left side of the horizon line (HL). Then add a longer vertical line between these two lines and label them 'A', 'B', and 'C', respectively.

3. Now we are going to draw a diagonal line from VP1 to B, and another line from VP2 to B. Next you need to mirror that by duplicating all the lines to the underside of the HL.

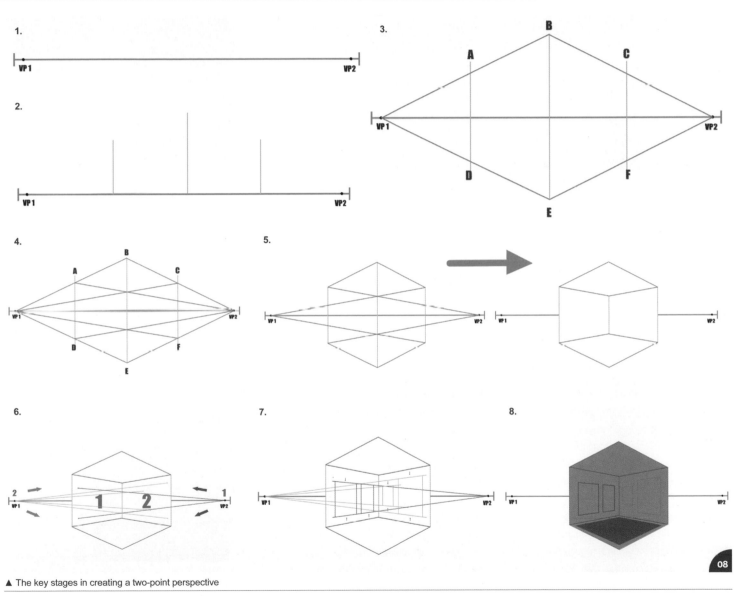

1.

2.

3.

4.

5.

6.

7.

8.

▲ The key stages in creating a two-point perspective

To simplify the reading of the image, we'll rename all vertices with the letters 'A', 'B', 'C', 'D', 'E', and 'F'.

4. Draw a diagonal line from VP1 to C, and another from VP2 to A. Then mirror that action on the lines below the HL.

5. Erase all the remaining lines and we'll get a view of a rectangle as seen from the corner. You can also erase the closest faces to create a concave object.

6. Now project some diagonal lines from VP1 to the inner face of face 2, and more diagonal lines from VP2 to the inner face of face 1.

 As you can see, VP1 controls the angle of the lines on the inner face of plane 2, and VP2 controls the angle of the lines on plane 1.

7. Complete the image using vertical lines to create some windows on the faces. You can project more lines from the vanishing points to create more elements in the scene. Draw a few lines in to create details on your cube.

8. Now you can add a flat color and some shading effects and textures to make it look interesting and enhance the 3D effect. In image 08 you'll see the final effect created using a two-point perspective.

1.

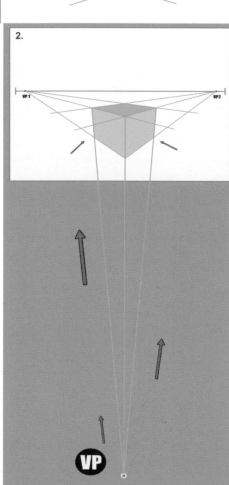

2.

VP

▲ The key stages in creating a three-point perspective

3.

09

Step 9
Creating a three-point perspective
The three-point perspective allows us to add an extra point on a third axis that projects out above or below the HL.

1. Draw the HL in the middle of the paper and add two VPs to either side of the line. Project diagonal lines from the two vanishing points to the center or the HL.

2. You'll now need to extend the length of your canvas to fit VP3 in the scene. Add the VP3 below the horizon line and project diagonal lines upwards from that point until it intercepts the object's vertices.

3. To create your square objects, project lines from all VPs until they all intercept. You can then color in the cubes created by the intersecting lines. See image 09 for an idea of how these work.

Step 10
Color perspective: daylight
You can create the illusion of depth and perspective in your color choices, too.

Have you ever looked around on a journey through a scenic landscape and noticed that mountains near the horizon have a blue tint? Mountains or trees are generally not blue in color, so why do they appear so at a distance?

The answer is simple: When we view objects over distances and through a greater area of light, atmospheric moisture, and dust, our view of those objects is affected by that 'filter'. The objects become pale and diffuse as more of the atmosphere hovers between ourselves and the objects. So let's see some examples of different atmospheric perspectives…

First, the basic daylight atmosphere. This is a very common atmosphere. The blue sky acts as a mirror, and this mirror projects a bluish mist that makes the objects look distant. Use layers such as Overlay, Screen, and Soft Light here to create this same effect in your work. You'll need to paint it in with soft brushes.

Step 11
Color perspective: cloudy day
This kind of atmosphere is one of my favorites. The clouds block the light coming in from the sun and generate a

10

▲ A depiction of the very common daylight atmosphere

11

▲ Creating a more ambient, cloudy effect

12

▲ The color used to create the sky in our example

grayish ambience. All the elements in the scene seem to be under a dense mist.

To create this effect in my work, I use layers such as Screen or Normal and use a soft rounded brush while painting. In image 11, you can see mist in the background, and a color palette full of gray tones.

Fluorescent lights such as street lamps also project reflections into the atmosphere and increase the distance between objects.

To create this effect, use layers such as Color Dodge, Overlay or Linear Light to create multiple reflections, and other layers such as Screen or Normal to emulate the mist created by the artificial light sources.

Step 12
An example of color perspective
The following mini tutorial will help explain the idea of color, depth, and perspective by applying these theories to a landscape scene.

To begin, we fill the first layer with a flat blue tone. This plane will be our sky.

Step 13
The ground plane
Now choose the Selection tool, and create a rectangular selection and fill the selection with a grayish-brown color. This plane will be our floor.

▲ Using the Selection tool to create jagged rocks

Select the Lasso tool and make random selections on your ground plane to emulate a rock texture. Finally, fill the shapes with a mid-gray tone.

Step 14
Rock textures
Select the Brush tool and paint details on the rocks, floor, and background. As you can see, I use the Rounded brush to make simple strokes and create the effect of jagged rock (image 14).

Step 15
Mist and atmosphere
Now select a soft brush and pick up the background's color. Then paint softly over the rocks and sky, creating a blue mist. At this stage you also can paint extra details and rocks in the background.

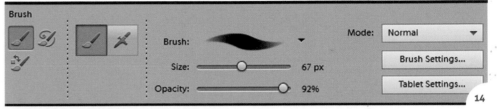

▲ Refining the rock texture using the Rounded brush

▲ Using the blue background color to create mist

▲ Final color adjustments increase the sense of depth

Step 16
More color
Add an Overlay layer. Once you've done this, select a red tone and paint some lighting effects between the rocks and the sky.

Finally, adjust the general color palette by adding layers in Overlay, Multiply, and Dodge mode. Try different options until you get a good result.

In our final scene, the cold atmosphere increases the depth in the painting. Remember that if you need to create the impression of a big space or distance, you should cover the background with a low opacity mist. The color of the mist depends on the color of the background.

Step 17
The weight of color
It's also important to take the visual weight of your color choices into account when creating depth in a digital painting.

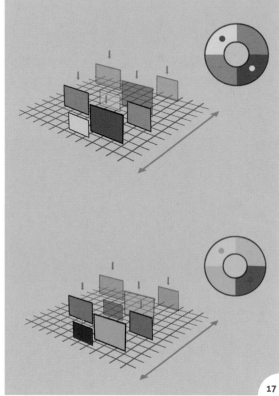
▲ Comparing the illusion of weight in warm and cool tones

Here's how it works… Warm colors have more weight than the cold tones; this is why blue, green, and purple tones appear lighter. Because of their weight, warm colors appear closer to us, and the cold ones seem to be further away. Adjust the focus plane in your image according to the distance and color palette you want to adopt.

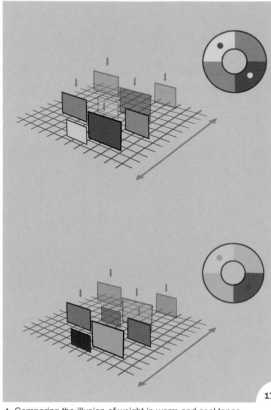
▲ Examples of a key method practiced in Renaissance art: the sfumato

Step 18
The sfumato effect
We've integrated a lot of techniques from traditional art into digital media. One of those traditional techniques is the use of the 'sfumato' effect. This technique is not directly related to perspective; however, it does help in creating blurred borders, which enhance the idea of

visual depth and distance between elements in a scene and so give the illusion of perspective.

Step 19
Digital sfumato
Needless to say, in a digital painting the sfumato technique won't be created the same way as it would in a traditional painting. Creating sfumato

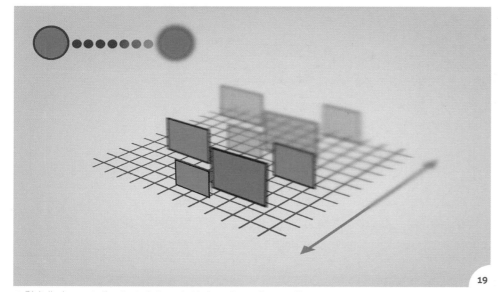

▲ Digitally demonstrating the techniques behind creating a sfumato effect

digitally is a fairly straightforward process and simply involves applying a blurred effect to the distant objects in your scene by painting random brushstrokes at the borders of those elements.

Step 20
Sfumato in Photoshop Elements

So as a final example, let's see how the sfumato effect is used to create an image in Photoshop Elements.

1. To start, add a new layer to a blank canvas and fill it in with a dark tone. Then choose a brush and apply the settings as shown in image 20 (1).

2. Paint a series of shapes on the canvas (2).

3. Add volume by painting layers and lighter tones in the center of the shape. Paint random brushstrokes around the borders to blend them to the background color, too. Then continue blending and refining them to make them look like a fog in the distance (3).

4. You can also add layers like Color Dodge and Overlay to adjust the color palette (4).

5. You should create a gradient at the borders of your objects that gives the impression that they fade into the background (5).

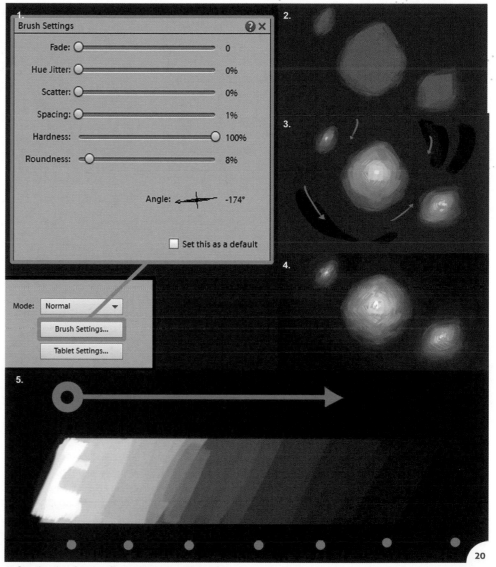

▲ Creating the sfumato effect in Photoshop Elements

Portraying emotion

by Christopher Peters

Art is designed to cause a sensitive reaction, whether the artist intends to portray an emotion or not. It's an unavoidable effect. Any single painting can produce extreme emotions in the viewer, and these can differ drastically depending on the individual.

In museums and art galleries you may notice people trying to decode hidden messages in artwork. When listening to their conversations, you might hear conflicting interpretations and opinions such as: 'That's an ugly painting!' Against: 'This artist is a genius!'

The world could fight forever and people could get involved in the most heated art debates. Nonetheless, the paintings would remain there, exactly where they have remained for the past 200 years, receiving the appreciation or the indifference of the masses. This is the tireless job that the creator gave to their creation: to be the witness of subjective perception.

However, if man inexplicably disappeared from Earth tomorrow, art would disappear too, because there wouldn't be anyone to decode the messages. In this way, art can be considered ever-lasting until man no longer exists.

Step 1
Color perceptions
Johann Wolfgang von Goethe's studies about the psychology of color revolutionized the scientific perceptions of color use. He presented new alternative ideas about color perception, and after gathering the support of other intellectuals, his psychology of color became a key topic of discussion in disciplines such as design and fine arts.

When we think about feeling calm, we imagine nice, harmonic environments with wide spaces and light tones. However, if we think about rage or fury, we imagine closed spaces and red and warm colors. The colors are able to produce sensations, denote feelings and transmit messages, because of their direct relation to our daily sensitive experiences.

For example, we perceive red as a warm color with a hot temperature, because we unconsciously relate it to fire and the burning sun. All colors represent a kind of emotion, like notes in music – all colors need to work together to create certain reactions.

Step 2
Warm colors
It's common to read about warm and cold colors in art theory, since they are the most basic form of color composition; these two groups represent different emotions and sensations.

The warm color group is composed of the following colors and values: red, yellow, orange, and brown, as well as its close

▲ Certain colors create sensory reactions due to their association with certain elements

▲ The range of tones and values present in the warm color spectrum

▲ The range of tones and values present in the cold color spectrum

tones in the color wheel. As previously mentioned, these colors usually have the effect of producing a feeling of warmth, and are therefore related to the emotions of rage, passion, love, fury, sensuality and power.

Step 3
Cold colors
This group is composed of blues, greens, purples and their surrounding tones in the color wheel. These colors create a cold

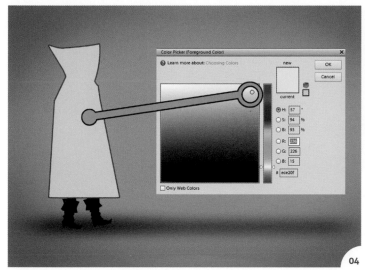

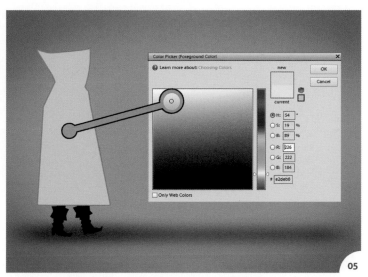

▲ A highly saturated image creates a sense of weight

▲ A low saturated color palette creates a more serene feeling

▲ Examples of using heavier colors and saturations to indicate weight

effect generated by its visual relation to ice, snow, sky or the sea. The cold color group has the ability to create space and calm, coldness, solitude, sadness, seriousness, darkness and other related emotions.

Step 4
High color saturation

The saturation of a color is also a determining factor in creating the color's reception. Vibrant tones have weight and reflect solidity, hardness, thickness and mass. So if we want to create the feeling of power or weight, it's a good idea to paint the elements with highly saturated colors.

Step 5
Low color saturation

These tones are close to the grayscale in the Color Picker (you can find the Color Picker below the Paint Bucket tool in the Toolbox in Photoshop Elements). These colors tend to look pale and smooth, and appear dusty and pastel-toned, and so are best used if you're looking to create a serene or aged feeling.

Step 6
Color weight

As you can see in image 06 here, the blue element seems to be lighter than the red one. This effect is created by comparing the weight of the saturated red color against the lighter, desaturated blue. The same happens in the second example with the feathers.

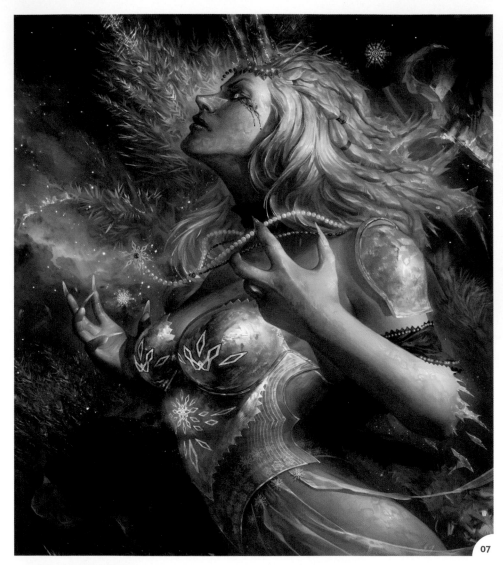

▲ A dim lighting setup creates a calm and relaxed feeling here
Copyright © 2014 Applibot Inc

▲ Zenithal lighting creates drama and tension in the scene

> **❝As well as color, light plays a fundamental role in creating a sensitive reaction from the viewer 77**

Step 7

Light and emotion: Dim light

As well as color, light plays a fundamental role in creating a sensitive reaction from the viewer. There's a huge variety of lighting compositions that we can use to represent different emotions.

Most of the time, dim light represents a calm and relaxing feeling. When we read by night we like to make the light dim because it produces a passive mood, and improves our concentration state.

This effect is generated by a light source with low energy, and can be enhanced by using pastel tones and color harmonies in the painting. In some cases, dim light can also generate spatial instability; creating

▲ This lighting setup creates a mysterious ambience

▲ A directional spotlight can create suspense

▲ Artificial lighting is used to create a dark and exciting atmosphere

an abstract spatial reference and blocking out any visual limitations in the scene.

Step 8
Light and emotion: Zenithal
Zenithal lighting generates a high contrast between light and shadow. This occurs when a light source is placed above the objects in the scene (at a right angle, 90 degrees to the object).

This kind of lighting enhances the drama, tragedy or tension in the narrative. This effect works best when a bright object is contrasted against a darker background.

Step 9
Omni light with low intensity
This is the perfect lighting setup to paint a mysterious scene, or maybe a mystical illustration. This is the lighting that an artist with dark tendencies may look to integrate into their work. Also, its low energy gives you the chance to emphasize the key regions of your illustration. So, if you want to create a mysterious ambience, this is your lighting.

Step 10
Directional spotlight
This kind of lighting isn't really common in digital painting. It has a high energy that flattens the object's detail and texture information and simplifies the reading of an image. However,

this lighting works well when making special emphasis on shapes and forms. The directional spotlight is used to generate desperation, tension, surprise, and fear. Clear examples are the horror games that use this technique to produce tension and surprise. So if you're looking to scare someone, don't forget to include this lighting type in your sources list.

Step 11
Artificial lighting
This lighting setup reminds us of nocturnal excesses, the world of crime, the night and dangerous places. It generates exaltation, euphoria and excitation. So, if you want to create nocturnal chaos, this is your lighting.

Overall, there are lots of lighting combinations to work with, and each one can produce different responses in the viewer. It is your duty to observe real-life lighting situations and apply them as appropriate to your own work. I've explained a few here, but I encourage you to research and learn more about the way light affects our reactions to certain situations.

❝ The directional spotlight is used to generate desperation, tension, surprise, and fear. Clear examples are the horror games that use this technique to produce tension and surprise ❞

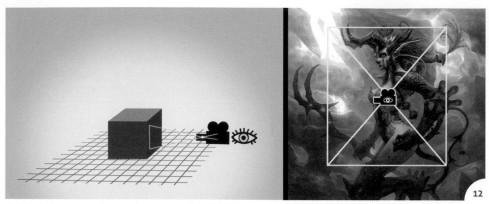

▲ A front-view perspective creates a sense of stability in the scene

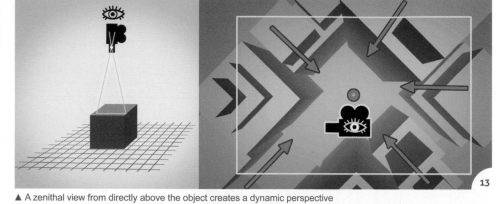

▲ A zenithal view from directly above the object creates a dynamic perspective

Step 12

Emotional perspective: Front view

Perspective can produce emotion as well. For example, when we look down from a tall skyscraper, people often feel vertigo, or power, and maybe even fear.

Looking up from the ground floor though, people can often feel inferior or very small. Emotion can be created by depicting perspective points such as these.

So to start, the front view is the most common perspective, and generates a calm, stable standing by showing standard solid objects in our scene. This view is really simple to show; you just need to place your horizon line level with the viewer's eye. If you want to present a calm scene with a slow-reading narrative, then this kind of perspective is for you.

▲ A bird's-eye view positions the viewer over the objects in your scene

Step 13
Emotional perspective: Zenithal view

This is an extreme view. The camera is placed at a right angle in relation to the floor. The resulting dynamic effect makes us feel like we are falling from a building at high speed. So, if you are looking for a dynamic perspective, speed and velocity, this is the perspective you'll need to use.

Step 14
Emotional perspective: Bird's-eye view

This is an aerial perspective as well. The focus of the camera is placed above the elements and its elevated view makes us feel like we are flying above the objects in the scene. You can use it to amplify the focus of an object, show a wide environment from above or to create the feeling of flying over a city. You can make the viewer feel like a bird in the sky.

Step 15
Emotional perspective: Worm's-eye view

This perspective is the opposite of the bird's-eye view. The focus of the camera is placed below the elements, and as the name suggests, this angle makes you feel as though you're at worm level, looking up at all those huge objects.

Step 16
Emotional perspective: Extreme view

You can also adopt an extreme angle and perspective from the worm's point of view in your image. See image 16 below for the effect this creates.

To conclude this chapter, I encourage you to experiment with all the tips discussed. Creating emotion in art can be a vast topic to research, and to progress as an artist it's important to experiment and work to find your own style. As a rule though, it's a great idea to look around you and notice how people react to certain situations and how they get amazed or scared by different factors.

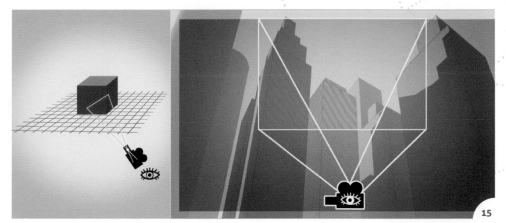

15

▲ The worm's eye view from directly below an object

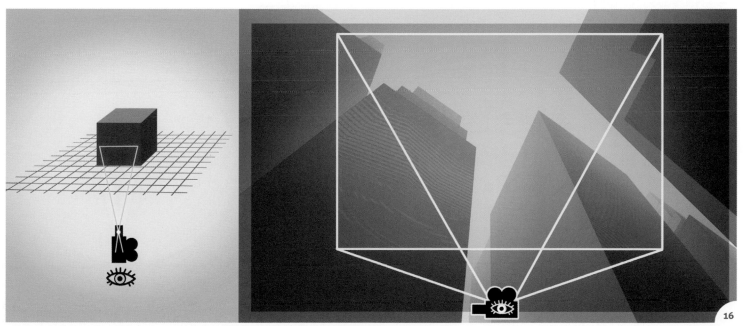

16

▲ An extreme worm's-eye view from an angled viewpoint

Storytelling
by Christopher Peters

As you will have read over the course of this book, an image is composed of a number of different factors, such as composition, emotions, color and light, perspective, and so on. Every element is crucial in creating a coherent idea, and you need to use all of these aspects to create an image.

As well as the placement and depiction of each element, you also need to consider that each of these provides visual information and all of that information is then translated into a message.

Step 1
Image storytelling throughout history

These days, giving a clear message using imagery is both a form of poetry and persuasion. Media outlets use images as a way to hook consumers and influence them into acting a certain way. Does this sound a little diabolical? Perhaps not; people like to consume and the media world simply makes use of the means and tools that it has in its arsenal to fulfill its task – to tell a story and generate a specific reaction in its audience.

Creating stories and concepts based on images is not a new idea. Throughout history there has always been a need for people to communicate messages using images; from the signposting systems used by primitive man to indicate dangerous places, to the beautiful illustrations of Nordic mythology,

to complex conceptual systems such as religious iconography. It doesn't matter where or when, people have been making use of this resource as an iconic, narrative, and persuasive weapon since the dawn of time.

Step 2
Narrative in art

The goal of narrative in public imagery is not the same that is applied in a work of art. There is a big difference between creating a story that tells of the desperate, deadly fight between a knight and his nemesis, and telling a simple, happy story made for kids. As an artist, you must know the difference between storytelling as a concept of modern marketing, and its counterpart: storytelling as a resource of pictorial narrative.

Narrative is directly related to the concept of an image, and narrative tools are used to establish the structure and rhythm of the visual reading to help the viewer understand the message. For example, what would happen if we wanted to tell a funny story to a friend and couldn't tell it in a clear way? They probably wouldn't be able to understand us and we'd find ourselves repeating the story to little effect, other than making it boring and predictable. The same thing would happen if we couldn't tell a story in an image; people couldn't possibly understand the concept, they would surely get confused and then interpret the image differently to the way the artist intended.

01

▲ Using an image to tell a story

02

▲ Gauge your audience and set the tone of the image appropriately

There are artistic genres and styles that are specifically designed to depict a narrative. Some of these tell stories using large and complex conceptual structures and others just want to communicate a simple message. It all depends on the purpose and nature of the story.

In order to tell our stories clearly, we have to utilize a variety of elements that are available to us as artists, such as composition, color, light, and complementary elements.

We will learn some of the most effective techniques in the following steps of this tutorial, so we can understand the various effects.

Step 3
Storytelling with composition

The objective here is to frame the principal action inside a logical margin that allows the viewer to read the image correctly. This is a basic trick that every artist can manipulate to create a coherent narrative effect.

Your narrative should have a logical chronology that follows a coherent sequence. It's important to know the sequence of events in your story and depict them in that order in your image, using techniques such as framing. Here you can use the frame of your image to crop the focus to key aspects of the image.

Step 4
Storytelling with light

Using lighting is an important aspect in a visual narrative. Its objective is to either complement the sensory messages in an image or draw attention to the most important narrative elements using highlights.

Step 5
Storytelling with color

Color is an element that projects sensations, weight, and visual information. By understanding how color influences the senses, we can play with different chromatic effects to reinforce the message that we want to convey.

Step 6
Storytelling using narrative indicators

You can also use indicative narrative objects in your scene. These narrative indicators are secondary objects that complement the visual narrative and reinforce the main subjects, drawing better attention to the action that you want the viewer to focus on.

❝ Your narrative should have a logical chronology that follows a coherent sequence ❞

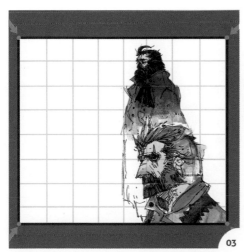
▲ Choosing and framing key events in your image

▲ Using light to draw attention to a character

▲ Using a certain palette to set the mood in your scene

▲ Secondary elements draw attention to the main action

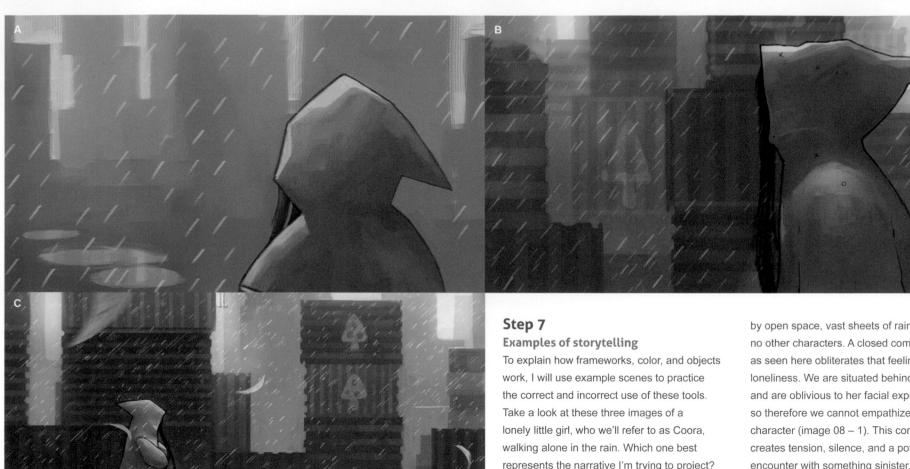

▲ Storytelling examples A, B, and C

07

Step 7
Examples of storytelling

To explain how frameworks, color, and objects work, I will use example scenes to practice the correct and incorrect use of these tools. Take a look at these three images of a lonely little girl, who we'll refer to as Coora, walking alone in the rain. Which one best represents the narrative I'm trying to project?

Step 8
Example A: Composition and color

It's difficult to determine the story in example A, because it is a closed scene. Ideally, to create an impression of loneliness, we would need to create a large environment surrounded by open space, vast sheets of rain, and no other characters. A closed composition as seen here obliterates that feeling of loneliness. We are situated behind Coora and are oblivious to her facial expressions, so therefore we cannot empathize with the character (image 08 – 1). This composition creates tension, silence, and a potential encounter with something sinister. It doesn't represent a poor girl in the middle of the rain.

This example has a palette with a high color saturation, which makes us discard it immediately. It doesn't represent the mournful gray tones of a typical cloudy day. The lighting also focuses the viewer's attention down

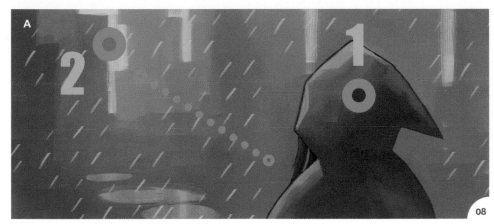

▲ This scene doesn't fit the intended narrative

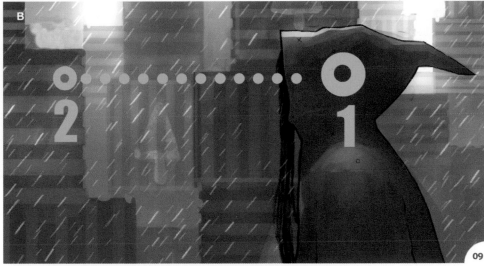

▲ A close-up composition framing the character isn't quite what we're looking for…

the road that Coora has to travel (2), rather than on the character. So it doesn't represent the narrative sense that we're looking for.

Step 9
Example B: Composition and color

Example B has a slightly more accurate composition and so depicts the narrative a little better. Because the viewer is positioned closer to the character, they are able to note a sense of introspection on Coora's part, and therefore establish an intimate connection with the character. This exact setup isn't quite what we are looking for, however (image 09 – 1 and 2).

Color-wise, this image shows an appropriate desaturated palette that is near to a gray color. However, the lighting has a warm tone which eliminates the sense of coldness.

Step 10
Example C: Composition and color

Of the three examples, example C has the best narrative. The spatial composition makes us view the girl from a distance, giving the impression that she is alone. We can also see more narrative indicators, such as puddles and buildings. Due to the placement of these elements we read the scene from left to right, which creates a chronological progression through the image (image 10 – 1 and 2).

Example C also has an appropriate color and light setup that fits the mood of the scene. The cool gray color palette with low-lighting contrasts both reflects the natural 'rainy day' lighting and creates a sense of cold loneliness. The grays also contrast with the yellow coat that Coora is wearing, which focuses our attention on her.

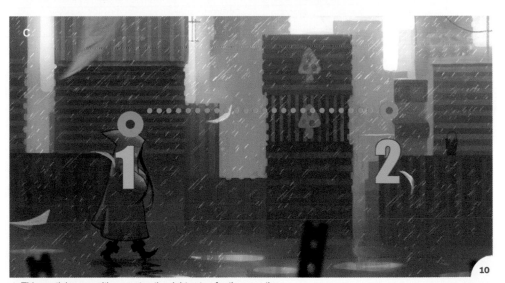

▲ This spatial composition creates the right setup for the narrative

Step 11

Narrative indicators and reading curves

Looking at the earlier examples, we can also assess the scene for narrative indicators.

Narrative indicators are objects that you can place in the composition to complement the visual story. From our three examples, C has a greater number of useful narrative indicators to help form the story.

First, the rain falls in the opposite direction to Coora's destination, which creates the idea of struggling against a barrier, and the viewer assumes that the character is troubled. Seeing the papers flying and her hair moving in the wind enhances the mood and atmosphere of the image, and also serves to reinforce our reading curve.

So what is a reading curve?

A reading curve is the road that our eyes travel in order to read an image. It is compounded by anchor points and every anchor point is represented by either a main or secondary narrative indicator or point. The reading curve is a very useful tool to help you create rhythm in your image.

Step 12

Placing narrative indicators

The main points in your scene are the narrative accents and are almost always

the elements with the most narrative importance within the image. In this case, the main point is our friend, Coora.

Secondary points are all the elements that complement the main ones, and are represented by elements that reinforce our story. In example C, you'll notice that the secondary points on the reading curve are the papers flying through the air. These points guide our sight from the wet floor to the main point that is Coora's head, and on through the image.

Step 13

Reading curve types

There are many types of narrative and different types of reading curves you can use to create different rhythms in your image. You will find examples of these in image 13 – note how they create different moods and atmospheres in each scene.

- Linear: The narrative elements are distributed in a linear way, sorted from left to right.

- Circular: The elements are distributed in a curve, interspersing the secondary points with the main points, and generating a harmonic reading.

- Zig-zag: The elements are distributed in a zig-zag shape, generating an effect of rapid and dynamic movement.

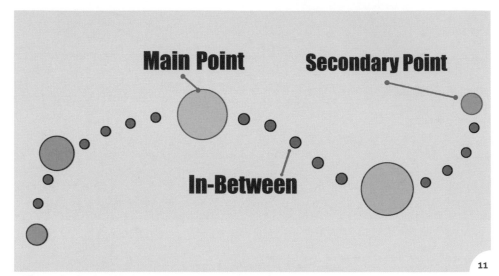

▲ The reading curve and various anchors/points represented by narrative indicators

▲ The reading curve applied to example C

▲ Examples of different reading curves

Project overviews

Learn how to create different art styles using Photoshop Elements

You'll often notice established artists express images with a distinct style. As a new artist however, it's often difficult to pinpoint your own style straight away.

To help you determine your own art style, seven artists, including David Smit and Eric Spray, offer a comprehensive guide to creating a distinct image style.

Each artist runs through the complete creation of an image in a specific style of art – real-world landscapes, sci-fi scenes, stylized illustrations, speed-painting, using traditional sketches, cartoon animals, and working with photographs. These helpful guides should encourage you to follow the examples and develop your own working style throughout the process, as you gain confidence with the tools and techniques.

FREE BRUSH SET

www.3dtotalpublishing.com

Download your free brush set for this project

Real–world landscapes
by Takumer Homma

In this tutorial, we will work through creating a landscape painting using some of the tools Photoshop Elements has to offer beginner artists. With this guide, the software, and the help of a few basic art fundamentals, you will be creating convincing artwork in no time.

Before we jump into the painting stage, you should start by finding inspiration. For this tutorial, I looked up Mount Roraima and expanded my research from there. Researching will give you a headstart and help build up your visual library. Try not to rush this step as this is where you want to sit back, relax and be open to what you see – let your imagination go wild.

It's a good idea as a beginner to play around with the brush settings and familiarize yourself with each individual effect, too. I've supplied a set of brushes available as a download to start you off (**3dtotalpublishing.com/resources**).

To start painting in Photoshop Elements, you will need to move out of the photo manipulation mode and enter Expert mode. Simply press the Expert tab at the top of the screen and turn the Navigator on by pressing F12 – now we can start painting.

Step 1
Adding a texture wash
First, grab a big texture brush from the panel on the left and block in masses of warm orange and yellow colors. We want to get rid of the white background so we can judge values and colors, and it is easier to have something to measure with while painting.

Zoom out using the Zoom tool (again on the left) and brush color across the canvas with big horizontal strokes. You can change and shift the colors with every stroke to give it variation and interest; we don't want a solid color. You can select different brushes by clicking the right mouse button (RMB) and selecting from the drop-down list.

Step 2
Blocking in the sky
Start filling out the canvas with a cool sky. Pick a blue-gray from the Color Picker and give it a few horizontal strokes. We can also define the horizon by marking it in with a light blue-gray. This should establish a rough gradient effect from dark to light. In most cases you should have a dark color on top of the canvas gradually shifting lighter as it reaches the horizon.

Step 3
Roughing in the design
Stay with the big brush and start roughing in some simple shapes now. Please keep in mind that we need at least three areas in our painting: a background, a mid-ground and a foreground. You can start adding hints of a warm-orange mountain and a yellow-green landscape, using the complementary blue hue as the shadow color.

▲ Laying down the base for your image

▲ Blocking in the sky with a light-gray hue

▲ Using the big brush to establish the foreground, mid-ground and background

▲ Creating the illusion of depth

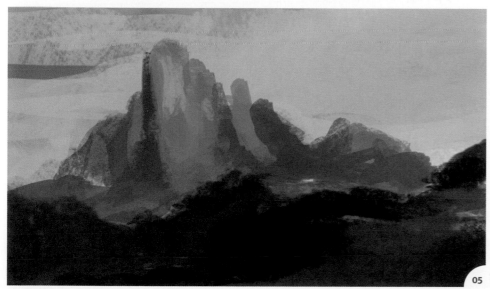

▲ A variety of color helps to define shapes

Try to avoid using small brushstrokes because we don't want to jump into the details just yet. In your Brush setting (in Tablet settings) turn on Size and Opacity – this will allow for pressure sensitivity and brush thickness.

Step 4
Roughing in the foreground

In this section, we are going to try and bring the foreground elements closer to us by using darker tones and bigger shapes to create an overlap, which also creates an illusion of depth.

Pay attention to the movements of the plains; we want to avoid a perfectly flat plain, so start by playing around with different curves and heights in your strokes.

Step 5
Adjusting horizontal and vertical lines

Here we will be extending the foreground plains horizontally, keeping the overall feeling relatively horizontal to emphasize the vertical shapes.

Now that we have a variety of colors on the canvas, you can pick the colors from your image by holding the Alt key while in Brush mode. Remember to avoid detailing for the moment, as this is still the roughing-in stage – just continue with the broad strokes.

From here, try to keep your eyes on the Navigator to make sure your image reads well. It is important to maintain the clarity, even in a zoomed-out version.

Step 6
Checking the tonal values

It's important to keep checking your tonal values throughout your painting. You can do this by going to Enhance > Adjust Color > Adjust Hue/Saturation, or using the shortcut Ctrl+U.

Slide the Saturation all the way down to -100. This will turn the image to grayscale to allow you to evaluate your tone without the distraction of color variations. Check you have the three major values: light-gray for background, mid-gray for mid-ground and dark-gray for the foreground.

Step 7
Starting on detail

We will spend some time developing the focal point and really clarifying the light direction in the scene. The light source here will be a direct light from the sun coming in from the right-hand side straight onto the main rock. Follow the direction of the light and begin working on the shadows. This does not have to be accurate; as long as you keep the direction consistent, it will look convincing.

Step 8
Flipping the image horizontally

Every now and then it is good to flip your canvas to get a fresh view of your painting. This will allow you to spot any flaws easily and check to see if the composition is working.

▲ Check your tonal values using Ctrl+U

▲ Clarify the light direction to emphasize the focal point

▲ Flipping your canvas creates a fresh impression

▲ Adding highlights to the image to define shape

Go to Image > Rotate > Flip Horizontal to
flip the canvas and check the progress.

Step 9
Adding a warm, soft cloud

Just like any object, cloud has a form and a
shape. Add some cool grays on the darker side
and warmer oranges and yellows on the edge
highlights. It's important to design the shapes of
your cloud to complement the rest of the image.

Here we have added the highlight that
leads to the main rock. When painting
clouds, pay attention to the variety of
sizes to maintain the interest.

Step 10
Blocking in the rock

First, zoom in a little and start painting the
details on the rocks. Pay attention to the variety
of sizes and don't overdo the details yet, just
add enough to create interest and maintain the
interaction between the empty and crowded
areas. Play around with different brushes, too.
You can create a flat brush by going into the
Brush Settings and decreasing the roundness,
and changing the angles of the brush by
moving the cursor around the circle. You should
avoid perfectly straight lines and mirroring.

Straighten up the rocks using the Lasso
selection tool (the shortcut key is L). First draw
around the rock and close the selection. Press
the Move tool or shortcut key V and a bounding

▲ Start adding detail to the mountain rock to create a realistic effect

box should appear around your selection. If you
press and hold Ctrl, then drag a corner, it will
allow you to distort or transform your selection.

Finally, we can begin adding the surroundings.
Just below the mountain rock, start painting
the landscape leading up to the rocks. Keep
your eyes on the major shapes rather than the
detail, establish the light and shadow, and use
small S-shaped curves to create movement.

Step 11
Growing vegetation

Flip the canvas back again (from Step 8) and
tweak and fix anything that jumps out. It's
better to fix the problems in the early stages.
Then proceed to block in some vegetation,
just like we did for the clouds. Focus on the
major shapes and separate the highlighted and
dark areas. Group your values and color as
though it is one big shape and avoid painting

▲ Blocking in, defining and adding mass to the vegetation

each blade of each grass individually – keep
it simple by just using a variety of masses.

Continue working on the vegetation by adding a
variety of vertical lengths that stick out from the
masses. Use textured brushes or a soft brush

to ensure the edges have some rough shapes.
Paint them as if you are drawing a circle; they
are basically a few different circles put together.

Crowd the bushes and vegetation a little more
while maintaining the soft edge. Be aware of

the overall silhouettes in the foliage, and not the details. Try not to rush this. Take your time distributing these masses because maintaining a balanced composition is very important.

Step 12
Checking the color temperature
The mountain has begun to look dull in comparison, so let's try and make it more interesting. We will keep the original values here but increase the saturation while shifting the hues between orange and yellow. It may look a bit too intense at this point, but we can reduce this easily in the digital medium, so play around with it.

Step 13
Refining the whole image
Things should be coming together at this point, so it's time to zoom out and look over the entire piece, or use the Navigator by pressing the shortcut key F12. If it reads well as a small thumbnail it means that you have a strong image with clarity. From here onwards, there will be only small tweaks, so let's give some attention to the surrounding rocks and landscape in the mid-ground. Keep it simple so it complements the complexity of the focal point.

I revisit the foreground and add some taller vegetation to break the flat silhouette of the foreground. I also think that the cloud behind the mountain is a little too rough, so I clean it up by grouping the values closer

together. The main intention is to keep the rocky area the busiest area in the image.

I also add a few highlights here and there and define the shapes more without making it a distraction. Maintain the subtle value shifts in your brushstrokes so you don't create a strong contrast.

Step 14
Texture stamping
Let's try adding some noise to the rock. From the list of brushes, select the one with a high-resolution texture. Create a new layer, Shift+Ctrl+N, and stamp the texture on top of the rocks. Be playful and try different textures; if it doesn't work you can just delete it, so don't be scared.

Now we need to integrate the texture stamp that we've just created. While you have the texture stamp layer highlighted, go into the layer blending mode drop-down menu, which is right above the layers, and flick through each one to see if it creates any interesting effects. For this image, I find that the Color Dodge layer mode seems eye-catching. You can duplicate the texture a few times to cover the entire surface of the rock.

After reviewing the noise layer effect, I realize it seems too busy at the moment, so let's quickly try and reduce the noise by painting over it with some nice, broad strokes.

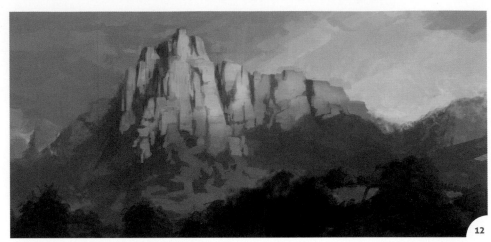

▲ Focusing on the color of the mountain range

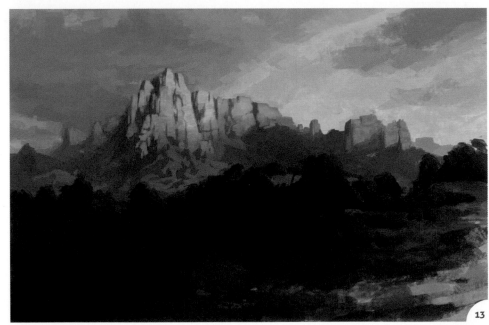

▲ Reviewing your image using the Navigator or Zoom tool

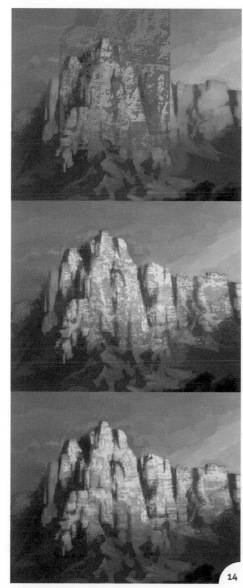

▲ Integrating the texture stamp on the mountain

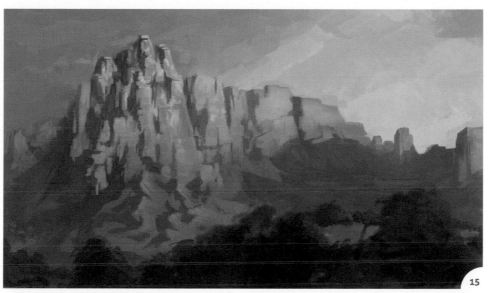

▲ Hand-painting all the textures works better than a texture stamp here

▲ Reducing the yellow hue in the scene to give it a warmer tone

Step 15
Changing the mountain texture

Unfortunately, I don't think the texture stamp will work out, so let's get rid of the layer and paint the texture in manually. Sometimes it's good to try something random just to experiment.

So now it's back to the grunt work. The main rock is looking too flat so add a little more depth by extruding some of the details in the Z-axis. Keep reminding yourself that there are three axes to show here: X, Y and Z.

> **❝ After walking away from the computer and looking at the image with fresh eyes, the piece is starting to look too yellow ❞**

Step 16
Adjusting the Hue/Saturation

After walking away from the computer and looking at the image with fresh eyes, the piece is starting to look too yellow. We can adjust this by opening up the Hue/Saturation adjustment function (Ctrl+U), and sliding the hue bar slightly to the left to warm up the scene.

Now go to the top of the Hue/Saturation menu in the master drop-down menu and select Yellow. This allows us to single out only the yellow areas in the scene. Slide the hue bar to the left on this too to increase the warmth.

Step 17

Adding a character

At this point, it feels like there is a need for a character in the scene. Adding a person helps with the scale and proportion of the objects.

I start with a sole figure, but the character is looking a little lost and lonely so let's add a friend. Keep it simple and abstract and pay attention to the silhouette; the body mass, legs and the head should be visible. We only want to suggest these structures without painting every detail.

Step 18

Adding colored highlights

For the final tweaks, roughly add some highlights in some of the yellows and greens around the foliage. We can also add some rocks to separate and create resting areas within the foliage. Try to distinguish the hard-edged rocks and soft-edged foliage. We can soften the clouds using the Soft brush as well, but try to keep some of the hard edges in the cloud for a little variety.

Step 19

Finishing the highlights

Continuing from the last step, we add further detail, hinting at highlights and also small variations in height. Keep it minimal because if you overdo the highlights, it will start looking too busy and can draw the viewer's eye away from the focal points.

17

▲ Add a character to reinforce scale and proportion

18

▲ Creating definition between objects to maintain interest

Sci–fi storytelling

by Simon Robert

In this tutorial I will guide you through the process of painting a sci-fi scene in Photoshop Elements. I will start with the simple sketching method I use and then finish it up by adding just enough detail so the painting stands alone as a finished piece.

Coming from a traditional art background, I apply the general theories and methods applicable to paintings and sketches, but in the digital media form.

First, I'll start by introducing the Photoshop Elements interface, the tools we'll use for this project, and the importance of using layers. Then I'll move on to the initial black/white thumbnail sketches, then the color sketch, and finally polishing the selected color sketch.

I will use only one brush throughout the whole painting process in order to demonstrate that it will be all you need to create a great image, if you can use it in clever ways.

The theme of this piece will be storytelling, using a sci-fi scene. This painting will feature an old house untouched by time, left in a futuristic city somewhere on Earth. I've chosen this theme because it gives me a lot of possibilities for storytelling with the design elements I'm going to paint. It's a theme about contrast, first of all, and it gives me the chance to play with both futuristic and traditional elements in the scene.

Step 1
Setting up the workspace

The first thing you'll notice when opening Photoshop Elements is that you don't see your painting tools. To see them, you'll have to change to Expert mode. Just click on the Expert button found on the top bar and you'll see all the tools on the right-hand side. We are going to use the Brush, Eraser, and Color Picker tools.

Also, on the lower right side of the screen, press the Layers button. This area will contain all the layers we are going to use for our painting. Right now, it will be empty.

Step 2
Important performance tweaks

Raising Photoshop Elements' History panel to 200 can be a life-saver. This also means you have 200 'Undos' at your disposal. This is especially useful at the beginning when you don't feel too confident about the decisions you're making. To change the History settings, go to Edit > Preferences > Performance. I recommend changing your History States to a minimum of 100 – I always use 200, but this can vary depending on your machine.

If you go to Edit > Preferences > General, you can also check the Allow Floating Documents in Expert Mode box, which will allow you to arrange any open windows. There are also other options under the Preferences tab that can be helpful.

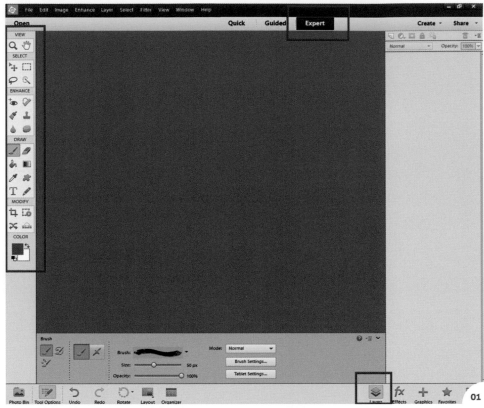

▲ Start by setting up the workspace so we'll have a smooth workflow later on

Step 3
The tools

First of all, create a blank file which will be the canvas. For landscapes, I prefer using wide formats. Go to File > New > Blank File, which will open the new window. You can choose from a variety of formats but I'm going to set mine to be 6000 × 3500 pixels.

❝ I resort to custom brushes only when I'm looking for some specific effects/textures ❞

My images often get printed, so I always paint at 300 dpi (pixels per inch). If you're only looking to use it online or digitally though, 72 dpi works better to create a smaller file size. Finally, hit OK.

▲ Raise Photoshop Elements' default History States to 200 to get greater flexibility

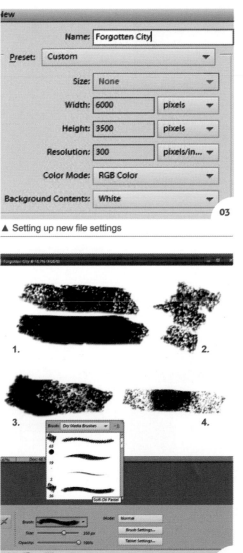

▲ Setting up new file settings

▲ The library of brushes that covers most painting needs

Step 4
Brush settings

For this tutorial, I'm using the default Photoshop Elements brushes. I think they work great in general and I resort to custom brushes only when I'm looking for some specific effects/textures.

So to start painting, select the Brush tool. With the Brush tool selected, I right-click on the canvas, and select Dry Media Brushes from the drop-down list. I choose the Soft Oil Pastel brush from the list.

In the lower left corner, you can change the brush settings, such as Size and Opacity, by clicking on the Brush Settings button.

I always keep the Opacity at 100%. By applying different pressure levels with my hand on my Wacom tablet, I can vary the Opacity that way.

I almost always start sketching an image with a bigger brush size, too.

Because the pastel brush has a distinct texture, it gives me some extra detail that I can interpret in different ways using different methods, such as varying the brushstrokes (1), tapping the brush on the canvas (2), using white brushstrokes over a black base (3), and vice versa (4). You can see examples of these in image 04.

▲ Once I see something I like in my thumbnails, I select them and take them a step further

Step 5
Very loose thumbnails
Before starting to sketch, I create a new layer by clicking on the Create New Layer button in the top-right corner of the screen. I keep my canvas zoomed out all the time so I constantly see my thumbnails from a distance. I just keep looking for interesting ideas. I also try to keep my thumbnails format roughly the same as my canvas, so they translate well from small to large later on.

I'm not using any reference images at this point because they tend to influence me too much. I just draw whatever comes to mind and then resort to references later. Black-

▲ The light-gray background and mid-gray mid-ground

and-white sketching also lets you quickly lay down a few ideas and focus on composition.

Step 6
Refining the selected sketch
I begin by getting rid of the intimidating blank white of the canvas. This is really important because after a few brushstrokes, I'll have a base to start from. Now I paint the background with a light gray – let's call it 'Sky'.

I then create another layer and name it 'Middle-Ground'. I can go crazy with this one and start laying down some random shapes. Knowing that my theme is a futuristic city, I start blocking out some tall building silhouettes with a mid-gray, leaving some spaces between for the sky.

Step 7
Creating depth
Lastly, I create a third layer and paint the foreground in with a dark gray. With these three layers, I am able to add depth to the scene. Because they are all separate layers, I can also work on each layer independently without worrying that I'll ruin the others.

In this painting, I also add in an old house on a hilltop, surrounded by a futuristic setting – the first story element of the picture. The idea behind the old house is that time hasn't touched it. It's managed to survive way into the future, creating a nice contrast between old and new.

Step 8
Adding more elements

Having the house on a hilltop allows me to add a flying car parked in front of it. To clearly show that it's a flying car, I create a big empty space underneath it.

I select the Eraser tool, and, same as the brushes, I right-click on the canvas and select the same Soft Oil Pastel brush. The Eraser is a powerful tool, allowing me to paint 'negatively' using the same brush texture. So I erase some of the ground plane and add the car – my second important story element.

Step 9
Apply some depth

I want to add an element that connects all three planes, and will lead the viewer's eye from the foreground into the background. So I paint a suspended highway on a separate layer, using an intermediate value between the foreground and the middleground. Because the highway is behind the house and the car, I create its layer behind these two. I paint behind the layers as well, just in case I have to move them around later on.

To create another element of depth, I also paint the objects in the foreground with darker values, and make them lighter as they recede into the distance, to mirror naturally occurring atmospheric effects.

▲ Painting the dark, ground-level base, then adding the house as a storytelling element

▲ Getting an idea of where this image is heading…

▲ It's important to lead the viewer's eye through the painting

10

▲ With enough elements in the sketch, you can tweak the lighting. This is the result of lightening my image

11

▲ Using a strong light color in the image (but not white), saving the white tone for the intense highlights

❝ I want the time in the scene to be around two o'clock in the afternoon, with the sun hitting the scene from the right-hand side ❞

Step 10
A few lighting tweaks

I want the time in the scene to be around two o'clock in the afternoon, with the sun hitting the scene from the right-hand side. This will give me some interesting and fairly dramatic light and shadow possibilities for the house, that I hope to incorporate into the scene in the subsequent steps.

For now, I'm happy with the sketch so far, but as a general observation I feel as if it needs to be a bit lighter overall. There are a number of different ways to add light into a scene, though on this occasion I will simply adjust the brightness settings of the objects.

Because I currently only have a few layers in my Photoshop Elements file, I'm going to individually raise the brightness on each of the separate layers, one by one.

To start adjusting the brightness for the Sky layer, I click on the Sky layer to select it, and go to Enhance > Adjust Lighting > Brightness, and raise the Brightness to about 61. I then carry on and change the Brightness settings for the Middle Ground (50), Highway (40), and the Foreground and Car (60). As you'll see here in the image, the whole scene now has a lot more contrast between the shadows and light areas – and I like that.

I think this sketch is now good as it is, as a basis for adding lighting and shadows, and will be a great guide for my upcoming color sketch.

Sometimes when I work on a more complex piece, I might spend more time on this step, establishing deeper shadows or more complex shades, but for these purposes, this one will do.

Step 11
Light and shadow

Next, to add a little extra dimension to the image, I will begin to add a little highlighting

to the objects in the scene by painting in brighter tones hitting each object.

To start, I create a new layer for each element (house, foreground, and so on) and paint the light on these individually.

I could have painted the highlights directly on the objects, but it's better to keep them on a separate layer in order to help us adjust them easily later on without affecting the objects themselves.

I choose a light gray for the highlights in the scene – not pure white. I leave that for the super shiny highlights only.

I also keep the light strongest on the house because it's the focus of the picture. Adding highlights to your main focus is a subtle trick that works to draw the viewer's eye towards that area. This works well when used sparingly, and I use this technique here, making sure that I don't exaggerate it to the point that it becomes unrealistic and ruins the image.

❛❛ I save a copy of the black and white sketch and keep it open all the time next to my color study as guidance ❜❜

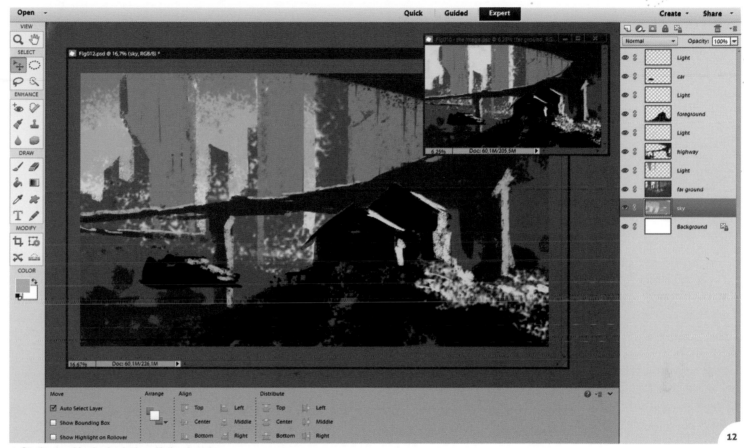

▲ Starting to add color, beginning with the sky color

Step 12
The color study
Now my black-and-white sketch is done. I have all the information I need for the image components, the values and the general light setup. I can now begin to progress with the color.

So to start, I save a copy of the black-and-white sketch and keep it open all the time next to my color study as guidance.

I begin my color study by painting directly on each of the existing layers. I start with the sky color because that's going to affect all my other colors in the picture.

I use this blue when painting the shadows, shadow highlights, fog, and everywhere that has no direct sunlight.

Step 13
Adding more colors

When I finish adding the blue sky, I make sure I keep it the same value as the sky in my gray sketch. I test this by painting a bit of the blue on my gray sky. Both colors should have roughly the same brightness. This color will be my main sky color.

I then add variation on top of this to keep it vibrant and interesting. Again, use a large brush by tapping it to get some of that nice texture. I follow this process for each main color.

After I have them all down and my grays are gone, I can begin adding more detail.

Step 14
Colors and refining

1. First, I paint the shadow of the buildings by keeping the values. Notice that I don't make super-crisp edges. This is because the buildings are distant, and I'm also not going for a clean, sharp style – I want a rough, traditional finish to the scene.

I then refine the edges and shapes of the shadows, while thinking about how light and shadow might hit them. With this in mind, I then fill in the shapes. I also fill them in under the light layer, too. This way, when I paint the light on top using the same textured brush, the blue will show

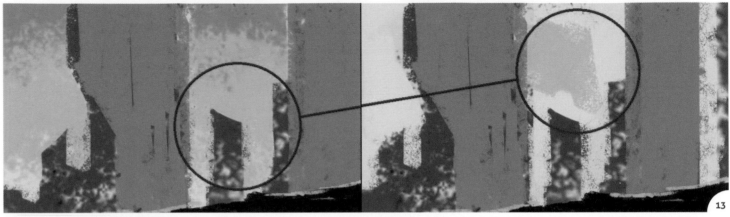
▲ Matching the values quickly by painting with the color on the gray sketch `13`

▲ Selecting and inverting the buildings to restore the building contours against the sky `14`

through the gaps in the brush texture and create some nice extra detail.

2. After I paint the light on top, I don't have to worry about keeping inside the contour because I can use the building shapes to create a selection. While on the Light layer, I hold Ctrl and click once on the buildings layer (on the right in the Layers panel).

3. I then invert the selection I've just made using Ctrl+I and then hit Delete. You'll see that the brushstrokes over the selected lines have now been removed.

Step 15
Colors and refining

I can now start to refine the highway. To create the straight lines holding the highway

up, I hold down Shift as I drag the line, and click at the point I want my line to end. As the

> **❝I keep all my saturated colors in the foreground and use a combination of atmospheric effects to create depth in my painting❞**

▲ More contrast in the foreground creates the illusion of depth `15`

▲ Starting with a dark blue base on the house and painting white on top to allow the blue to come through `16`

highway goes off into the distance, I want it to fade out. I do this by blending the highway's distant shadowed parts into the background. I keep all my saturated colors in the foreground and use a combination of atmospheric effects to create depth in my painting.

Here, you'll notice that the light saturation becomes less intense (see the gray circles in image 15), and the shadows become lighter (see the red circles) as the scene recedes into the distance. The elements closer to the viewer in your scene should have more contrast in general, to create a more realistic illusion of depth.

❝ In order for the light to feel warm, I go with a really light yellow instead, and reserve the pure white for highlights ❞

Step 16
Lighting the house

I want the old house to be white, sitting on a green hilltop. The white will stand out from the surroundings and it will also reflect a lot of the ambient colors, giving me some nice opportunities to play with reflections.

The light side of the house will be almost white. In order for the light to feel warm, I

go with a really light yellow instead, and reserve the pure white for highlights. The shadowed part of the house picks up a lot of the sky blue, and for the absolute darks of the house, I use a very dark blue (not black).

Step 17
Grass texture

The brush texture comes in handy again when creating the grass. I start with an earthy color as a base and then tap my brush on top of it with the green color, so that the earth color will show through. This gives me a great base for later when I'll start adding details like smaller bushes, rocks, and so on.

▲ Overlaying grass texture with a large brush size `17`

▲ Placing scale details in the scene to help the viewer understand the image

I use warm greens for the lit parts and cold greens for the shadowed side. I apply this same principle throughout the whole picture – warm colors against cold colors. The warm colors aim towards yellow and orange while the cold ones aim towards blue and green.

Step 18
Adding details

I unhide my car layer and quickly add a few more details to it. I like flying vintage cars so I'm doing a little homage to *The Fifth Element*. My background is a muted purple so I choose its complementary color for the car – in this case, orange. This creates a nice chromatic contrast and also keeps my car visible.

Next, I add a porch in front of the house, and scribble in a little human silhouette on it. All the details that I'm going to paint from now on will be scaled in accordance to this small human silhouette.

Step 19
Dramatic lighting

I keep refining the house structure, while trying to figure out exactly how the light comes in from under the highway and how it hits the house. I establish that the light direction comes from the right side of the image.

I want a dramatic light so I decide to keep the top part of the house in shadow. Because the house is white, there is a lot of bounce light around it so I keep my shadows darker at the top extremities of the house. Shadows tend to get darker the further they are from the bouncing light coming up from the ground.

Step 20
Trees and bushes

When I paint trees, I try to simplify them to a few basic shapes. I want the viewer to immediately understand that it's a complex Cyprus tree, but I want to make this clear in a simple way. I could easily spend a lot of time painting branches and leaves but I don't want that. The

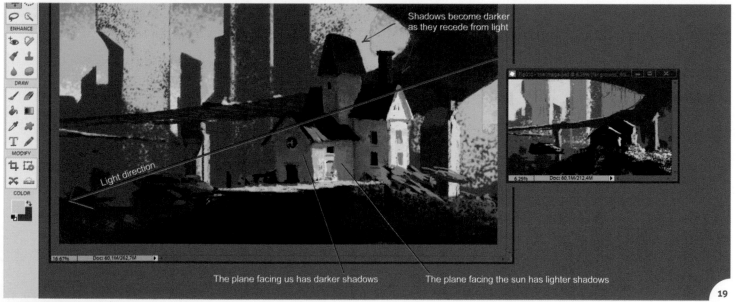

Shadows become darker as they recede from light

Light direction

The plane facing us has darker shadows

The plane facing the sun has lighter shadows

▲ When constructing shadows you can modify them in favor of your chosen light setup

texture of the brush does most of the work for me, and this way I get a more spontaneous feel rather than an overworked one.

I add more detail to the porch area and some dark bushes to the left. I paint these in really dark to emphasize the distance between them and the buildings in the distance. This also clearly defines the edge of the hilltop. I do the same on the right side, only this time with light.

Step 21
Perspective correction

Before I paint in more details, I want to make sure that my perspective is right. Because this is a more simple scene, I didn't start by building up my perspective lines first. So for this image, I'll work with a set of overlaid lines to help define the perspective in the scene.

1. First, with the Line tool, I fill my screen with parallel lines. I select them all by holding down Shift and merge them into one shape.

2. With the lines layer selected, I press Ctrl+T to enter Transform mode. Now, while holding down the Ctrl+Shift keys, I pull on the top-left corner of the Transform box and align the lines to one of my roof's major outlines.

3. Because I use a two-point perspective, I duplicate the lines layer (File > Duplicate) and mirror them (Ctrl+T, right-click on

▲ Trying to keep the amount of details to a minimum and use them to a greater effect

20

the Transform box, and then select Flip Horizontal from the list). I change their color to white to avoid any confusion.

4. Now I adjust the house's perspective according to my two perspective lines. You can change the Opacity of the lines using the Layers functions in the upper-right corner of the Layers panel.

❝ If I wanted the car to be less important, I would have left it completely in shadow. It's a subtle way of telling the viewer which elements in the painting are the most important ones ❞

▲ Quickly fixing the perspective with the Line tool

Step 22
The car

For the car, I carry out an online search for a 1970 Camaro and use it as a reference. I start by painting the car with a base orange color and then paint the light on top, as it's easier to paint the light on the finished car structure.

I want the light to slightly touch the hood of the car so it stands out a bit more. The light that comes in through the trees falls on both the house and car and connects them.

If I wanted the car to be less important, I would have left it completely in shadow. It's a subtle way of telling the viewer which elements in the painting are the most important ones.

Step 23
Detailing the highway

I constantly jump from one point of interest to another when painting. I don't want to spend too much time polishing something because I tend to burn out quickly that way.

To make it more interesting, I give the highway a slight curve so it catches the light in a more interesting way. I follow the form when painting round objects or inclined surfaces, as you'll notice in the examples in image 23.

▲ Using the light to mark important parts of the painting

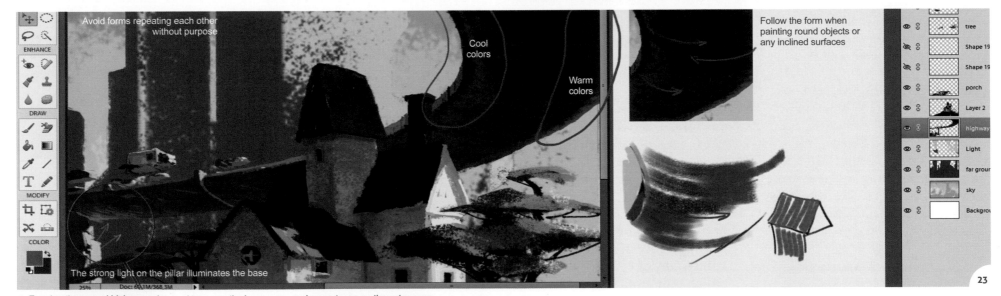

▲ Forming the curved highway using cool tones on the inner curve and warm tones on the outer curve

The side curving towards the sun gets warmer colors, while the other side adopts cooler ones. This allows the two sides to be in contrast with each other and so helps better define the form of the highway. When painting something like this, I always follow the form with my brushstrokes.

I also add in light detail around the pillars supporting the highway. The strong light on the pillar illuminates the base of the supports and helps define their role in the scene.

Step 24
Small but important tweaks
While working on the highway, I notice two annoying things that create unnecessary confusion in the scene. I'll need to change these before continuing with the image.

If you look at point A in this image, you'll notice that the distant building almost perfectly continues the shape of the pillar and can be confused as being part of it. You should avoid forms repeating each other without purpose in an image. Normally, I would modify the background, but in this case it actually gave me the idea to extend the pillar vertically and make something out of it.

Point B shows the top of the roof almost touching the highway's contour. To fix this, I move the Highway layer up a bit, away from the direct line of the roof.

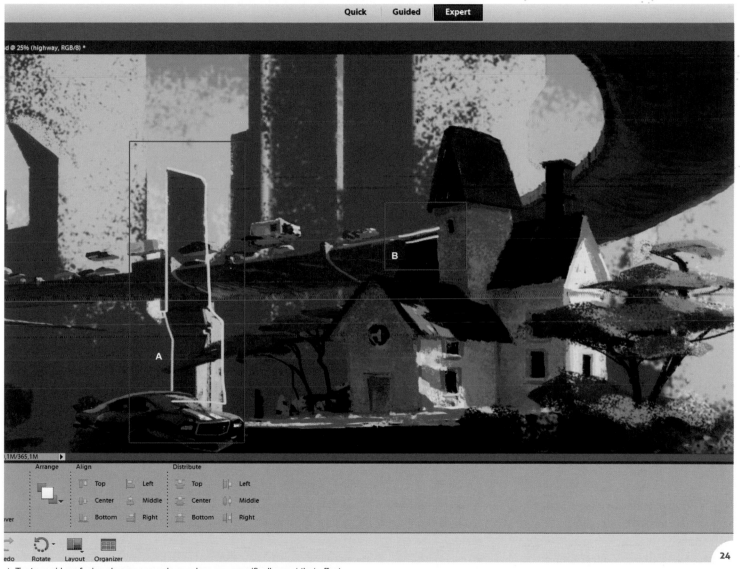

▲ Try to avoid confusing shapes or overlays unless you specifically want that effect

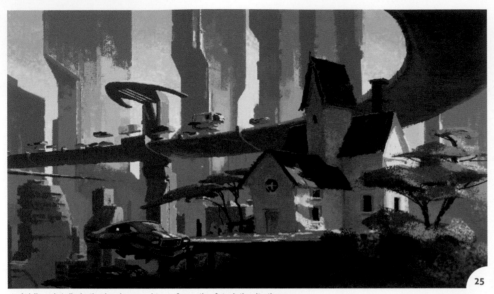

▲ Adding details in the background to enforce the futuristic city theme

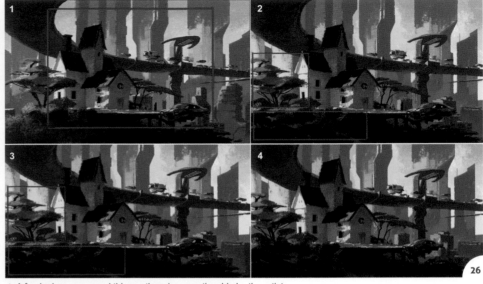

▲ A fresh view can reveal things otherwise unnoticeable by the artist

Step 25
Sci-fi shapes in the background

I extend the support pillar and give it an alien shape because, as I mentioned before, I want the background to feel futuristic in comparison to the old house. I also add another layer of buildings to give the city more substance and emphasize the feeling that the house is surrounded by modern technology.

I also start refining the buildings and sky, this time with smaller brushes. I need finer details in the distance as the texture at those points is too big. I still keep the buildings really simple, I just indicate detail with brushstrokes.

The background is also a bit too dark and needs to be lighter for better contrast and depth (the top roof of the house in particular). I go to Enhance > Adjust Lighting > Brightness > Contrast, and lighten both its shadow and light layers. I keep the vehicle silhouettes clear by tweaking the background in their favor – dark against light.

Step 26
Fixing methods

I find that, after a while, my brain gets used to the image and I don't see my mistakes, so I go to Image > Rotate > Flip Horizontal to flip the image and check mistakes with the composition.

1. Immediately I notice that my composition has a tendency to lean towards the right side, which unbalances the painting. Because I have everything on separate layers, though, fixing this is easy.

2. I first move my background buildings to the left to help counterbalance the composition. Though I then notice that the building on the right side of the painting points towards the edge of my painting, which leads the eye right out of the frame. To fix it, I change the shape.

3. I move the trees towards the edge of the painting. I use their dark shape to better

frame my composition and to counterbalance the heavy shapes on the opposite right.

4. Finally, I shrink the car a little because it looks too big and it wasn't in the right position.

To move the layers, I click on them and drag while holding down the Shift key. This restricts the movement to either the X or Y axis, depending on the direction I drag the layer in.

Step 27
Values check

To check if my values are right, I duplicate my image (File > Duplicate) and set it to Grayscale

(Image > Mode > Grayscale). A few areas pop up that are either too dark or too light. For example, some values in the foreground are too dark and so make the area appear flat. For example, the car is too light and gets lost in the distance, creating confusion. The trees should be a bit darker, and the foreground is too dark and flat – it needs more volume. I need to lighten the area and break it up a bit.

To fix these areas, I just can over-paint them with my brush set to Lighten or Darken modes – this way I get to keep my textures. If I want to lighten the value of a color, I pick the color with the right value (hold Alt for the Color Picker) and set my brush to Lighten Mode. This is found in the drop-down menu above the Brush Settings button on the Tool Options panel. I then paint over the desired area. This only affects the areas where the values are darker than the one I have selected, and it will keep the textures intact. If I over-paint with my brush on Normal mode, I have to repaint the textures as well.

Step 28
Polishing the background
When I polish the buildings in the distance, I only suggest details like windows, smoke, and so on. I don't want these to stand out at all, so I paint just enough to sell the idea. I introduce some rounded shapes like domes and smoke for shape contrast and also to soften that hard angular area a bit.

▲ Checking the values by shifting the image to Grayscale. The first image highlights a number of problems that are then fixed using Lighten and Darken brush modes

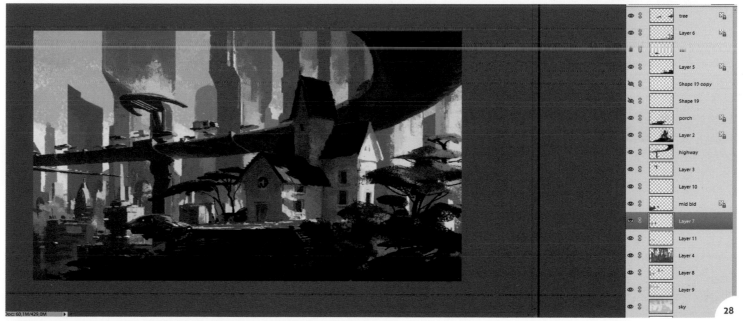

▲ Keep jumping between layers when adding the final polish so you don't overwork certain areas

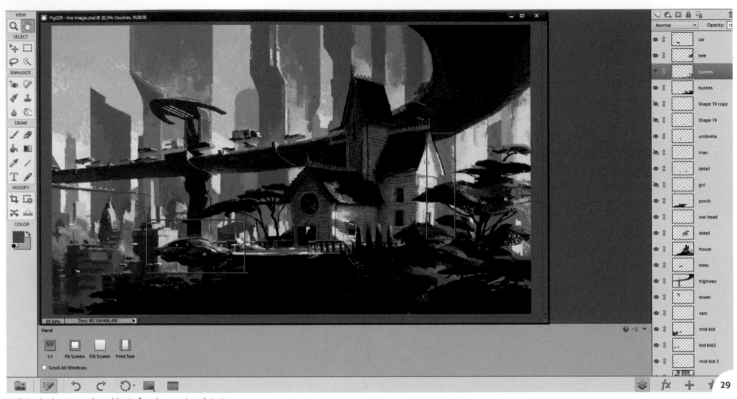

▲ Introducing everyday objects for viewers to relate to

I also darken the previously lit area because the tower was getting too much attention. I prefer to let the area around the house's tower be lit instead.

I also add a glow around objects directly hit by the sun. To create a glow, I lighten the color around the object using a light yellow or light blue, depending on the situation.

Step 30
Finishing up

At this point, I decide the painting now has everything it needs – any detail from now on wouldn't change much about the scene anyway.

I merge everything into a single layer (create a new layer and press Ctrl+Alt+Shift+E). Now I can color-correct the image if needed.

One last thing I do after merging the layers is to darken and lighten some key areas with the Burn and Dodge tools.

Also, if you go to Enhance, you'll find a lot of tools which could come in handy to adjust your colors, contrast, sharpness, and more.

I save the file as it is and also save a smaller JPEG version to be used on the internet. You can do this by going to File > Save As and choosing the file format from the Format list. And with that, we're done!

Adding a few flying cars in the distance gives the city some movement and life. To balance out the color palette, I use a bit of green in the distance along with some warmer tones.

Step 29
Final details on the house

At this point I introduce more story elements that can be interpreted by the viewers any way they want. I'm going to finish up the house and surroundings with details that give them more personality.

To set it clearer in history, I carry out an online search for American houses and look for interesting details that I can then use on the house. I make sure that the house looks old but still lived-in. I do this by adding

❝ To create a glow, I lighten the color around the object using a light yellow or light blue, depending on the situation ❞

everyday things, such as a chair and an umbrella, to indicate the presence of life. I keep painting everything on new layers, just in case I decide I don't like them.

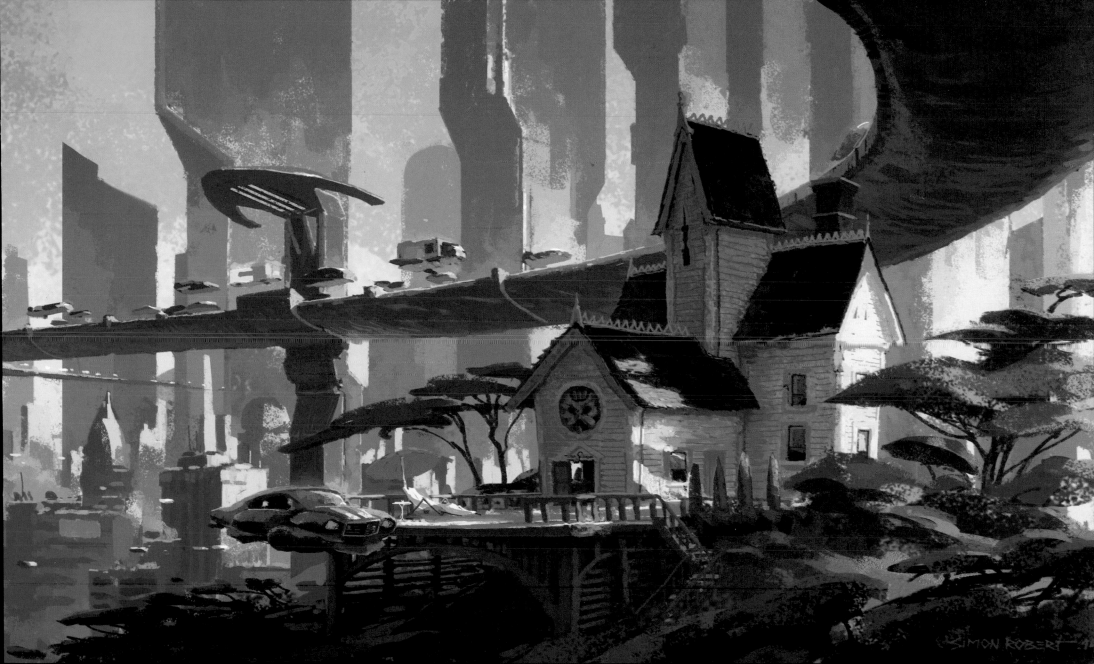

Stylized illustration

by David Smit

In this tutorial we'll discuss how to make a stylized illustration in Photoshop Elements.

Stylized illustrations are my favorite image to create. You can choose which parts you want to simplify and which parts you want to keep realistic (if any). And the best thing about stylization: there are no rules. Anything you want or can think of, you can do.

This doesn't necessarily result in a good illustration, of course. Doing stylization right can be hard, but it's important to remember that any rules you might think or know are suggestions and nothing more.

In this tutorial we'll discuss many things, but keep in mind that there are two major parts to any drawing or painting:

1. The tools: Learning how to handle the program (or the pencil) will require some time and effort. The more you practice, the less you'll have to think about it, so experiment as often as you can.

2. The skills and knowledge you need for drawing: As you encounter more illustrations and sketches and discover more about art, the more you'll get a feeling for shape, color, shading, anatomy, stylization, and all those separate elements that you need to make an illustration.

Don't expect your first illustration in a new program or with a new tool to be 'the best thing ever made – ever!' It won't be. And after ten illustrations it still won't be, but if you enjoy the making process and figuring out how to solve this visual problem, then it's only a matter of time before you suddenly look up and you've become a professional illustrator. Enjoy the process and I hope you'll feel more confident tackling your own illustrations in the future.

Step 1
The software

When you open Photoshop Elements, you'll open it up in Quick mode by default. For this project we'll be using the Expert layout, so to switch, go to the top-middle toolbar that says Quick, Guided, Expert, and click on Expert.

On the left-hand side of the screen you'll see a selection of tools, and on the right you'll have your layers. These are the most important parts of any drawing program. Each program has its own extra bells and whistles, some of which we will use later on, but the key functions are the paintbrush (shortcut B key, or located on the top-left of the Draw section in the left-hand panel) and the layer tool on the right-hand side.

Step 2
The Brush tool

The Brush tool is your best friend – or at least, it should become a close companion.

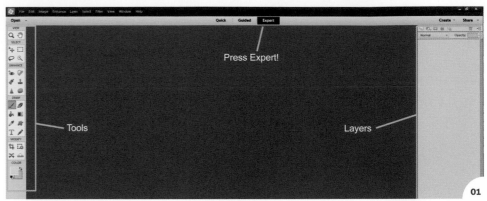

▲ A quick overview of Photoshop Elements and our main tools

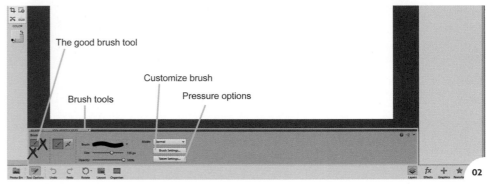

▲ Your friend, the Brush tool and its options

First, make a new canvas (Ctrl+N). Once you have your scary new white canvas, add something to it. We can do this using the Brush tool (press B). Once you have selected the Brush tool, you will see an option menu at the bottom of the screen. On the left-hand side of these options you'll see three icons, each of which has a different effect. If you press B again, you'll cycle through these other brushes, so if you suddenly notice that the brush is behaving strangely, look there first.

You can change the size and opacity of your brush in the middle of the bottom menu. In Tablet Settings you can set the pen pressure to influence the size and opacity of your brush, too.

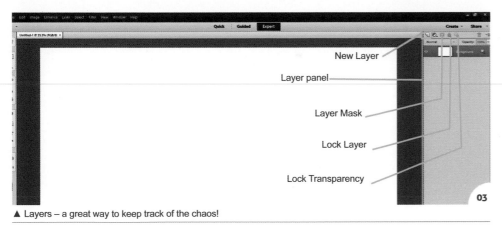

New Layer

Layer panel

Layer Mask

Lock Layer

Lock Transparency

03

▲ Layers – a great way to keep track of the chaos!

04

▲ The first sketch – a rough first step

In Brush Settings you can customize your brush to your own preferred settings.

There are a lot of different types of brushes you can pick from, if you press the left mouse button (LMB). The most common are the following:

• Hard Round brush

• Soft Round brush (these two are the most basic brushes, and are great for most things)

• Chalk brush (this one is my favorites – it's one of the more square-looking brushes)

Experiment with these and find one that works for you. Often you will find that sketching, painting, and painting details all use different brushes depending on the effect you want to create.

Step 3
Layers and more layers

Layers do what you expect them to do. They are placed on top of each other, and if you use them well, they can be a great help in keeping your files organized.

The layers in Photoshop Elements have a few extra options. On the top-left of the Layers window there's a button for creating a new layer. Next to that is Layer Effects; we'll ignore this for now but you should experiment with this function

at some point. Next to that is the Layer Mask – this is a black and white (or gray) selection of what should be shown of that particular layer.

Moving on is the Lock Layer button, which is great if you don't want the layer to accidentally move while you're working on it.

Lastly we have the Lock Transparency button, which is a special kind of great. If you select this, it stops you from adding more pixels to your layer, but allows you to change and paint over the existing ones (even if they are 50-percent transparent, this layer will keep it like that).

Step 4
First sketch

It's easy to get stuck on a sketch by worrying that it's not good enough; perhaps you think the lines aren't nice enough or something looks particularly wrong. But a first sketch is never meant to be beautiful. It's a base on which you can build, so don't take it too seriously – but don't rush it either. It's not for show, and it's not representative of the final art work, it simply acts as a road map directing you where to go.

Still, the first sketch is an important step because it will be the basis for the rest of the illustration. Things can still change (and will), but the basic composition is what the sketch shows, so make sure you have figured out the most important parts of your illustration in this step.

Step 5
Perspective, done simple

Perspective is an entirely special topic of its own. Some artists will study perspective for years and still not be an expert on the subject. It looks complex, and it can be frustrating – and once you realize the bend perspective of the eyes, your brain might just want to give up.

So to keep it easy, we'll go for one-point perspective in this illustration. This will lead our eyes to where we want them to go, without having difficult multiple perspectives to consider.

For one-point perspective, I draw a horizon line (shown in red in image 05). This line will be the height of the viewer's eye. Next, I pick a vanishing point – the central point where all the parallel lines will go to (shown in green).

We will use this as a guide, and make sure the whole composition works to support this single perspective.

> ❝ **We start by blocking in the big shapes and assigning them a value, so we can separate them from each other** ❞

Step 6
Blocking in

So we have the perspective and we have the general idea of what goes where. So now what?

Well, we start by blocking in the big shapes and assigning them a value, so we can separate them from each other.

For each separate part in the depth of the image, I make a layer. This means one for the background sky, one for the mountains and house, one for the ground between the mountains and the foreground, and one for the foreground itself.

I select each layer, make a selection with the selection tool (L) and fill it with a shade of grey.

The goal here is to make a nice value hierarchy that reads well. I want the eye to start at the character (darker on a lighter background) and be pulled towards the house.

Step 7
Gradients

I then select a layer, press the Lock Transparency button in the layer toolbar and select the Gradient Tool (G). I pick a slightly lighter and slightly darker color and fill the block with a simple gradient. I do this with all of the layers.

It usually takes me about ten tries to get it to feel right. This is only a simple step, and we'll go in and actually paint it later, but doing this already gives a good sense of where it will be lighter or darker.

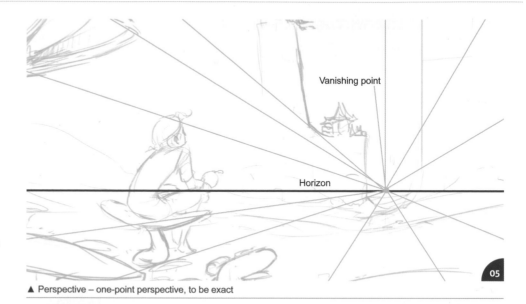

▲ Perspective – one-point perspective, to be exact

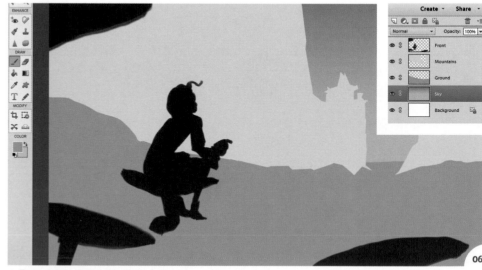

▲ From sketchy lines to big shapes

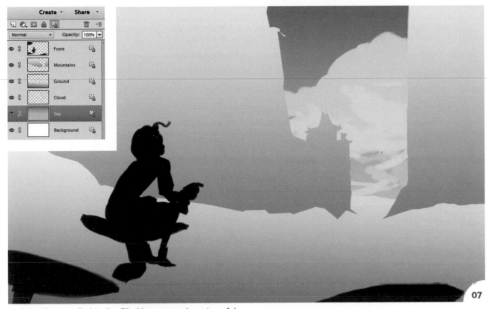

▲ A gradient applied to the filled layers – ugly, yet useful

▲ Destroying the gradient fill by replacing the smooth gradients with brushstrokes over the mountains

Step 8
Destroying the gradient fill

The gradients are an in-between step, and in the end we'll see nothing of our smooth gradients.

Make a new layer above the mountain layer, then hold Alt and click on the space between the new layer and the mountain layer. This will make the new layer a part of the Mountain layer, and allow us to stay only inside its limits.

We start by adding a hint of a texture to the layer using the brush (B) and playing with the smaller shapes within the big shape. The goal of the gradient is to give us a base to work from, so try to maintain the feeling of a gradient in the background mountains. Use it as a base to paint over using different sized brushstrokes of different values. Make sure you retain the sense of a tonal gradient in your marks.

We have to take care not to destroy the big shape or the overall gradient. It also doesn't have to be perfectly rendered, as long as it breaks up the large area.

Step 9
Ground texture

We will do the same thing that we did in Step 8, but now to the ground. As before, make another new layer and put it on top of the ground layer.

Because we are dealing with perspective, we have to create an illusion of depth on this layer. We do this by making sure that there is more detail – and in this case more hills – near the horizon and further from the viewer. This way the detail will increase exponentially closer to the horizon. It's almost an overlapping pattern of hills and values, where the darkest and the most detailed areas are near the vanishing point.

▲ Use value to give a sense of space on the ground texture

Step 10
Basic rendering

Here we continue what we were doing before, but on the rest of the picture. You can choose to push this step as far as you want. You can make it so that it's pretty much all rendered or keep it quite rough, depending on your style.

For my illustration I decide to keep it rather rough because I already know here that I'm not very happy about some things; for example the head of the character and the house on the hill. But these will be tweaked later.

Step 11
Lighting

As you can see in Step 10, I decided on a light direction that is coming from above, slightly to the back of the camera. This direction is great because it will make sure the mountains in the back are brightly lit, and the character in the front is both in the shadow and in the light. Having something both in the shadow and in the light can be a bit harder to get right; you can choose to put your character completely in the shadow if it gives you too much trouble.

Having a clear direction where the light is coming from helps define the three-dimensional space illusion. Because of this clear light direction, there is a clear shadow on the ground in the foreground. This tells the viewer a lot about the space this illustration is set in.

> **❝ Having your values in order is the most important thing; that's why black-and-white photography or films are always very beautiful ❞**

Step 12
Orange, orange and more orange

Before we move on, a small note on color. Color consists of three elements (from important to least important):

• Value (the light/dark relationship)

• Saturation (how colorful or gray something is)

• Hue (the base color, like red, green, blue, blue-green, and so on)

So, now that we have the value (roughly) down, let's move on to saturation.

We'll see why painting on the computer has such a benefit now. You want color? No problem!

Make a new layer (Ctrl+N) on top of all the other layers and set the layer mode to Overlay. You can pick this option from the drop-down menu next to Layer Transparency.

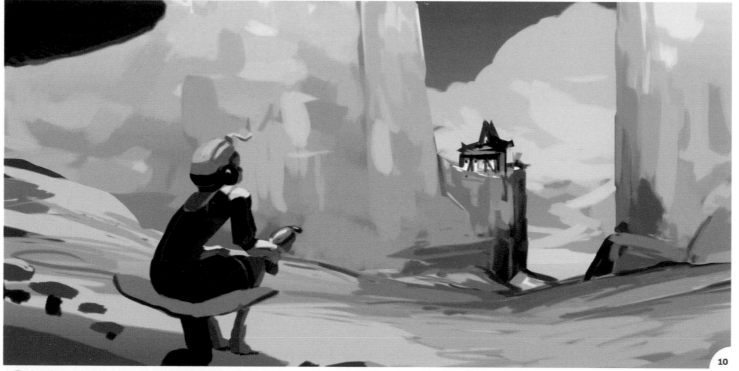

▲ Basic value rendering of the rest of the illustration

▲ Decide on the light direction and smooth some noise

▲ Color – it can feel like magic... and it is!

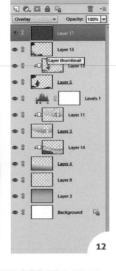

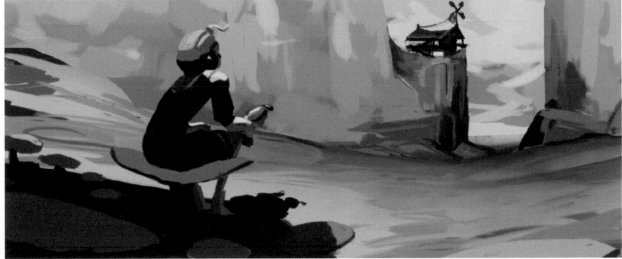

▲ Color? Some more contrast would be nice...

Now fill this layer completely with a dark orange (#a26036 is the color I use, but feel free to pick your own favorite).

Step 13
Gray + color = better

Having your values in order is the most important thing; that's why black-and-white photography or films are always very beautiful – they show the essence of the shapes.

Saturation is the next in line of importance. How much color or how little color does something have? An interesting illustration will have a nice balance between strong colors and gray.

So we make another layer (Ctrl+N), and put the layer mode on Color. This layer will only affect the underlying colors, which means in this layer we have no control over the values – but that's okay!

Now we pick a color from the canvas. We go to the color panel (left), and move the color selection to the left, so we get a gray version of our current orange color.

With this color selected, we can go and paint gray into the scene where we want it.

I decide that in general, the darker values should be a bit more saturated than the lighter ones – so that's my main purpose here.

▲ Some more color, please!

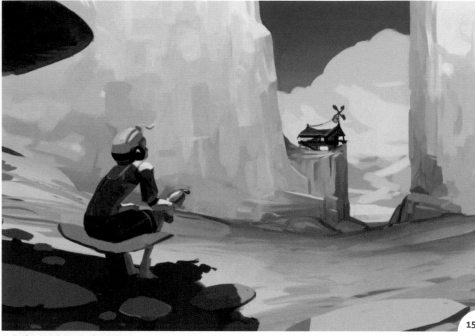

▲ Let's start the actual painting...

> **" Having all these things for our basis is great, but there comes a moment when you'll just have to start painting it "**

Step 14
Here comes the blue...
Our current illustration is still very much one color. This illustration really needs a bit of an extra push, so we make a new layer (Ctrl+N) and set it to Hue in layer mode. I pick #7984cc for the blue and fill the whole layer with it.

Next, I select Layer Mask and make it completely black so it's hidden, then pick a brush with white as the color, and start painting. You'll notice that the color only appears where you paint. Remember: you are painting a mask of what to show/not to show; you are not actually painting the color like this.

If you want, you can also just paint the color where you want it in a Hue or Color layer, but I prefer this first method because it keeps the colors limited.

Step 15
Can we paint yet?
Having all these things for the base in our image is great, but there comes a moment when you'll just have to start painting it.

I start with the rocks in the background. These are simple and very gratifying to paint.

The goal here is not to add as much detail as possible, but to keep the gradient consistent and create a nice-looking texture

on the back wall. It's a big shape that we try to divide into multiple smaller parts with different values and saturation. We keep the general gradient (light top, darker bottom) in mind throughout the painting process.

Step 16
Hills and details
The ground in this illustration is quite important, because it leads you as a viewer to the gap between the mountains, where you'll get more detail and have more for the eye to focus on.

The ground is lighter and less colorful closer to the camera and the character; the further back it goes, the darker and more colorful it becomes.

As you can see, hills (or differences in the height of the ground) become more and more common towards the horizon. This overlapping effect creates a sense of depth.

To add more sense of direction and movement to it, I try to keep the direction of the brushstrokes pointed towards the vanishing point as well. This will also help to lead the viewer's eyes.

Step 17
A new head
Sometimes you will find halfway through your illustration that you didn't quite solve everything in the sketch phase. This is normal. It's not great, but it is normal.

With my painting, I really don't like the head – I have no idea what I was thinking at the start. It can be hard to let go of something in a painting, but remember: don't continue polishing an area that's simply wrong. It's better to cut your losses, and try it again (it's digital, so you can keep trying for as long as you want). If you try again, it will almost always be better than your first attempt.

So here (image 17), I paint over the head and create a new one. Still not right, but better.

Step 18
Character focus
I often spend some time pushing one area of the illustration quite far before continuing with the rest. This helps me get a clear understanding of where the illustration is going, because it shows the relationships between values, colors and shapes.

In this step I spend some time polishing the character and cleaning up the edge between the character and the background. If you keep this clear and clean, the character will 'pop' out much more than if it's dirty and roughly done.

The great thing about a stylized illustration is that you can keep the shapes simple. For example, with this character I've almost completely ignored any folds in the fabric, kept the shading on the legs almost flat, and given each of the different elements their own color.

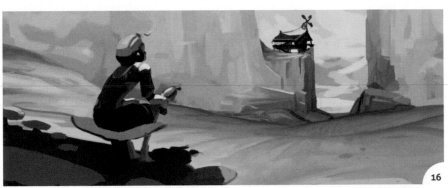
▲ The ground – a key element of the composition

▲ Changing an element of the image that just felt wrong

▲ Cleaning up the character

Step 19
Light and shadow

As you can see here, there are some different values and colors going on in this character. The area that is hit by direct light is brighter and paler than the shadow color.

Light doesn't stop once it has hit something. It bounces back, absorbing some of the color of the material it's hitting. That's why you often see a character or a person being lit from one side or another, even though there is no direct light shining on them.

So reflective light is often colored, and in this illustration the ground bounces the light back. This light is colored from the ground, and so becomes a more saturated orange.

Step 20
Painting the foreground

In this step I go over the foreground with a paintbrush and add some more color to it. I choose to repeat the blue color that is also in the sky and on the character's shirt to limit the amount of different colors used in the overall illustration. It's very easy to end up with a chaos of colors; it's much better to start with a few and add more later than it is to start with a lot and try to fix it too late.

I also clean up some of the shapes so they read more clearly for the viewer. There will be a step

later in the illustration where cleaning up is all there is to it, but we'll get to that soon enough.

Step 21
Details: where and how?

Now that you are actually painting this illustration, it's good to think about where you want to have more details, and where you'd like less. If you try to fill it all with details, you'll end up with a lot of noise and no-one will understand what you are trying to show. Details can be used like values and colors – it's all about the contrast in details that's important.

This illustration has relatively few details in general, but there will be places where I'll add some more in. I put more detail behind the character first, because if the character has more details and higher contrast than the background, it will pop out more.

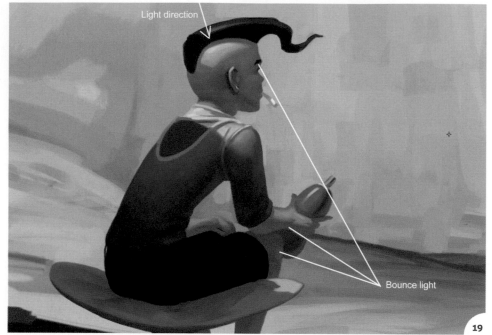

▲ A note on light, shadows, and painting them

▲ Adding more color to the foreground and cleaning up some of the shapes

I want to have more details towards the vanishing point too, because your eye will be pulled in that direction. If you pull someone's eye somewhere, make sure there is something for them to see.

Step 22
Another little change
So I'm sure you remember the head situation. I know it hasn't been resolved yet (we'll get there soon enough) but another thing that has been bothering me is that house.

At first, I make the roof red, which doesn't help improve it, so I paint the clouds in the background and give them more shape and definition. This helps the image as a whole, but the house is still wrong…

Step 23
A new house
The house has to be redone. There has to be more for the viewer to see and it just feels wrong, so I scrap it and paint a new one.

I keep the perspective of the house quite flat to keep it more simple and less confusing. I try to bear in mind the general light direction in order to create a readable shape.

At the moment I feel the house is lacking certain details, such as smoke and extra color, but we'll fix that a little later on.

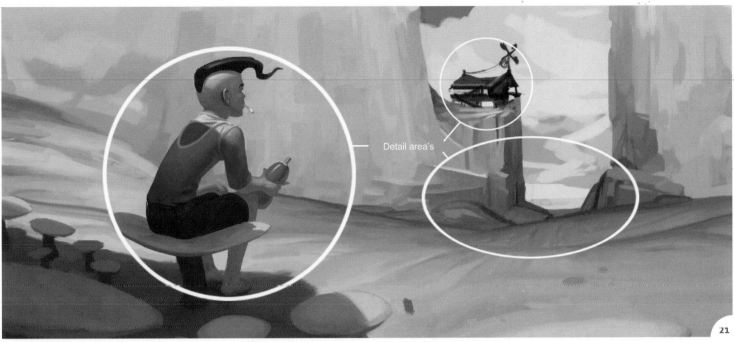

Detail area's

▲ Finding places to add in the detail to increase the impact of the image

▲ Polishing the background and making adjustments to the house

▲ A new house on the rocks, finally

Step 24
Another look

As I work on the house, I begin to feel that there is still something wrong with the character. The face is way better than the previous head, but the haircut still isn't quite right.

So I strip back the hair and decide to try out and experiment with some new hairstyles, not caring to much about making it pretty at this point. This is always a good idea if you're not sure where to go with part of an illustration.

As you can see in image 04, I end up with a short-haired girl smoking a cigarette.

> **Make sure the shapes are clear, the edges are defined or fuzzy as required, the colors are not messy, and the image reads well**

Step 25
Extra details

It's quite important during any illustration to take your time and clean it up. Make sure the shapes are clear, the edges are defined or fuzzy as required, the colors are not messy, and the image reads well. It's easy to skip this step, but this determines if the illustration is readable or not.

▲ Here we go again – back to the hairdresser!

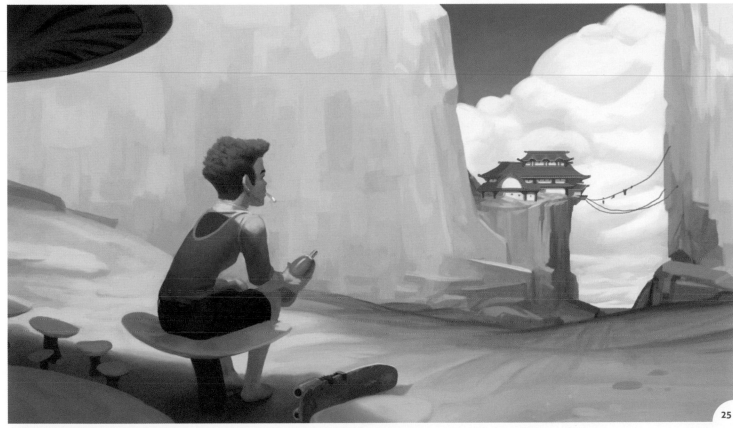

▲ Cleaning, polishing and a hover board

▲ Adding details, colors and small touches

I spend some time cleaning up parts of the mountain, the character, and the mushrooms in the foreground. I also add the hover board that I included in the sketch but completely forgot to add in the actual illustration.

For new things in an illustration, I usually use the colors already present in the image. Later I will change some of these colors and add more to them, but for now I try to keep the values and colors similar to what I have in the illustration already.

> **All these give a bit more for your eyes to look at and will force the viewer to look where you want them to look!**

Step 26
Details
Now that you have the elements in your painting and the major parts are where they should be, it's time to add smaller details. I add these little touches only in the places I want to draw the viewer's eye to. I won't add extra details to the mountain in the back, but rather on the character and near the house on the rocks.

In this illustration I add little flags, seams, detail lines, and so on. All these give a bit more for your eyes to look at and will force the viewer to look where you want them to.

Step 27
Colors and fog

I add some fog near the house in the back, and give the ground and mountain pass a little atmospheric perspective. This increases the depth. The best way to do this is to take a Round Soft brush on low transparency, pick a blueish color and very softly touch up parts that you want to push further back in space.

I also add a soft layer of dust on the ground in order to create a difference between this and the harsh, straight lines on the top.

> ❝ You can spend as long as you want adding things in or changing them; it can be very hard to say that an illustration is done ❞

Lastly, we carry out some small color correction, which will help to pull everything together. We can do this by going to the black-and-white circle icon next to the new layer icon on the right-hand side.

In this drop-down menu, choose the Photo Filter option, which has a unifying color correction effect. Choose a color that suits you; for example, I go for Warming Filter 81, with 20% density. You can then play around with it until it suits your needs. This is a great way to pull it all together in the final stages.

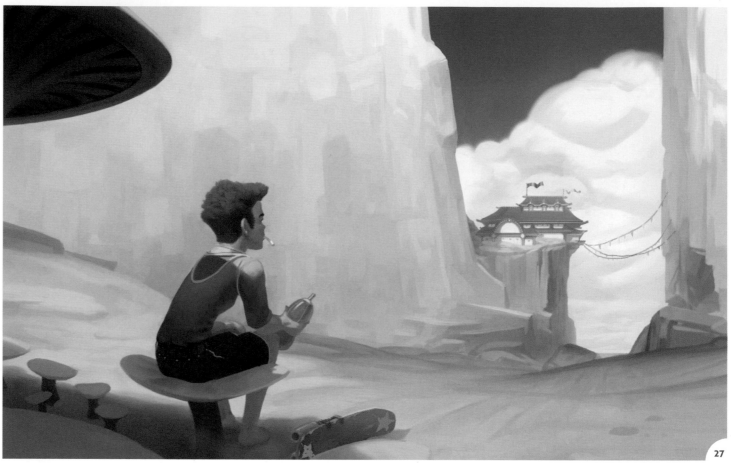

▲ Color correction and a little fog

Step 28
Done!

And then, you're done! Or not – it depends on your working style. You can spend as long as you want adding things in or changing them; it can be very hard to say that an illustration is done. A lot of things can, and perhaps should, be done differently to how I describe them. I sometimes work differently, too. There are dozens, if not hundreds, of roads that lead to Rome, each of them valid in their own right. As long as your attitude is playful and experimental, you'll find that you will learn the software and the skills to make top-quality illustrations before you even know it.

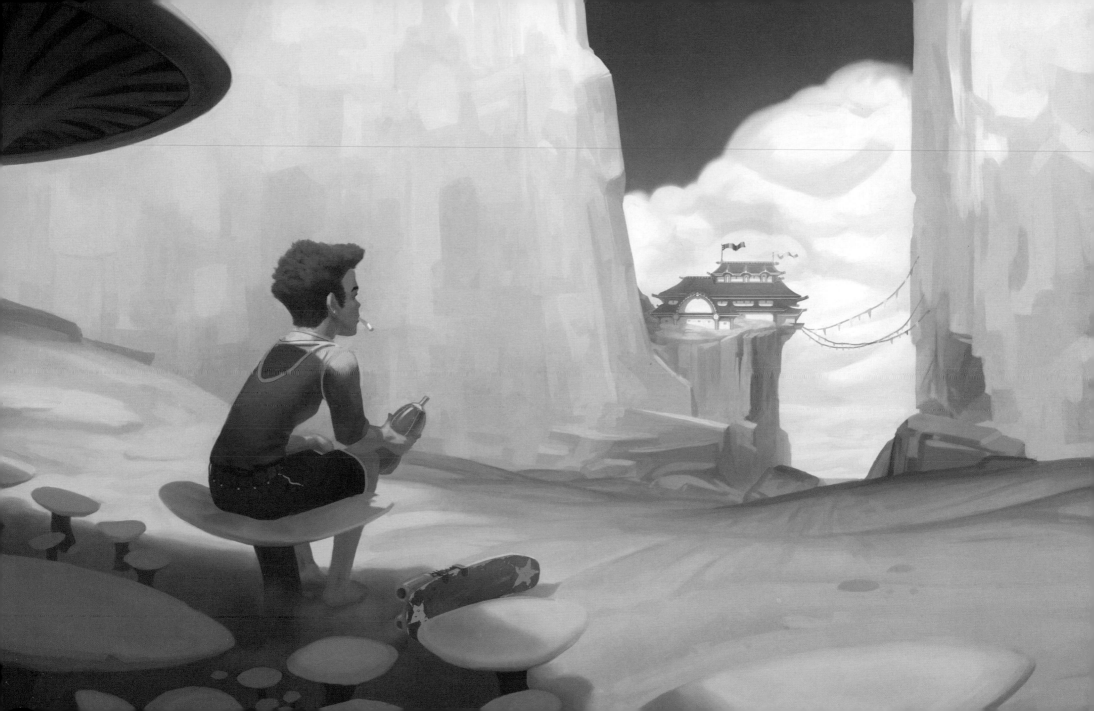

Speed-painting
by Eric Spray

For this tutorial I'll be using Photoshop Elements to create a speed-painting of an exterior environment. Compared to traditional media, digital painting is very fast and efficient – there is virtually no preparation time and no waiting for paint to dry, no mixing paint. For those who are starting digital painting with a background in traditional art, this will become more apparent after a few weeks of practice. Photoshop Elements provides a ton of tools and resources that will speed up the painting process as well.

First, for those of you who are just beginning your journey into digital art, speed-painting isn't about how fast you can paint. Speed and efficiency will come with practice. If you rush the painting process, or neglect the basics of design (composition, proportion, and so on), your painting will suffer in the end. What's most important is to enjoy the time spent painting and not think of it as a race.

Before I start any speed-painting I make sure I do a little bit of reference gathering. Even with a fantasy-based painting I still want to pull ideas from real-world references. What you think you see in your head can only take you so far, and you may come to a point where you need some visual aid to help resolve part of the painting. This can cause unnecessary frustration that can be easily solved by a quick online image search.

▲ Filling the void with an appropriate color

01

▲ Making the first shapes on the canvas to define the composition

02

Step 1
Starting out

Before starting this particular painting I decide to give myself a general theme. I really enjoy other-worldly landscapes with explorers wandering about. You have to paint things you're passionate about if you want to be motivated to paint. I love the sci-fi horror genre so naturally I'm going to paint images of that type. I'll walk through my process in a series of 29 images explaining the steps to reach the final scene. I have a few tricks for speed-painting in Elements that I will discuss in full as well.

First, I create a new file and set the editing mode to Expert. This mode gives you features like layers and the necessary tools tab that you'll use to actually paint. With the file open, the first thing I do is fill the white space. I hate

▲ Adding a little color and adding volume to shapes

03

04

▲ Adding light and shadow to the scene

05

▲ Using adjustment layers to add subtle changes to the atmosphere

looking at a white void – eventually all the space will be filled up, so the Paint Bucket tool is immediately used to address this.

My thinking is a dark interior setting, so I choose a mid-dark, neutral color for the fill. Generally I will start with a mid-value tone and introduce lighter and darker tones from there. Be cautious of your blacks though, as 100-percent black gives you nowhere to go.

Step 2
First marks

With the page filled, I feel comfortable starting to sketch out the composition. Keeping my brushstrokes loose and the brush size large, I want to lay down my broadest strokes first to quickly block out the scene. I lay in basic shapes as a foundation, with the intent of bringing in development details later, and generally focus on how I want the eye to move across the page – that's the mentality I always lead with.

Step 3
Massing shapes

Personally, I like to think in terms of volumes, not lines, when it comes to speed-painting.

Up to this point, I have not introduced any textural or abstract brushes. I have a default set of brushes (both custom and standard) that I like to use that make it feel more like traditional painting.

Step 4
Adding light

I am happy with the shapes I massed out, so I move on to pushing and pulling the lights and darks in the image. I also want to introduce a primary light source. I'm going for dark and ominous so I restrain myself from going too bold with the lights at first – I'll refine the light setup later.

When I started this painting, I knew I wanted the image to have a kind of grim blue/purple tonality. My personal art tends to be much more stylized and color-amped than the paintings I create at work. I'm not shy when it comes to color, though; usually I find myself having to pull it back.

Step 5
Adjustment layers

When it comes to adjustment layers I don't have a specific point during the painting process where I use them. In this instance, I just want to deepen the darks and push the color a bit more.

I use Soft Light layers more than any of the other adjustment layers. It has a really subtle effect – almost like a soft glaze that won't radically alter your image like Hard Light or Vivid Light will do. I recommend that you experiment and use the adjustment styles, but try not to abuse them. You might be overusing them if you have more adjustment style layers than you do painted layers.

Step 6
Brushes

Next, I move into the complex brush sets. These are based on real-world references I've found. I went into the painting knowing I wanted to paint a cave, so naturally I found some cool cave references. I looked for images of caves that were a bit more bizarre and unusual – less typical of what a standard cave looks like in my mind. One particular cave reference I found had an almost fungal quality. I liked how the shapes were more amorphous than chiseled and sharp, and it inspired quite a few ideas for my painting.

Step 7
Creating a brush

I want to create a brush from the references I've gathered, so the first thing I do is create a new file. I tend not to create brushes on top of the painting I'm working on, simply for cleanliness.

So after setting up a new canvas, I open up my chosen reference image and copy and paste the entire image onto a blank canvas in Photoshop Elements.

After reviewing the image and defining the shapes that stand out to me, I need to invert the areas I want to turn into a brush. To do this I go to Filter > Adjustments > Invert, as seen in image 07, or I use the shortcut Ctrl+I. Inverting the image isn't a necessary step, and is really only appropriate in this instance.

▲ Finding cave references to create a custom brush

▲ Preparing sections of the image before making a custom brush

❝When you look at your reference image you want to look for interesting textures, patterns, or shapes that stand out to you❞

Step 8
Preparing the image

Then I apply a Levels adjustment. I've found the best brushes are made in a high-contrast value range: as close to black and white without being distorted. This also allows for them to be used as special selection layers that will come in handy later. I use this technique superfluously, but to pull it off you need to have white space surrounding your dark shapes.

▲ Giving the image a stark contrast to make a crisp brush

Step 9
Selecting the texture

Next, I decide what part of the image I want to make a brush out of. I use the Lasso tool to trace around a specific section of the image, then drop down to Edit > Define Brush from the top bar.

Step 10
Finishing the brush

After naming your brush, it will be readily available at the bottom of the Brush set. I will create dozens of custom brushes for individual paintings, but consistently use the default Basic Brushes throughout, as well.

I almost always apply brush settings to new brushes I create. Fade, Spacing, and Roundness are the ones I usually play with. For bigger, more complex brushes I like to set the Spacing to be very wide, so when I paint it lays down more like a stencil. Also, Fade is a useful brush setting for ghosting brushstrokes into the background.

Step 11
Using the custom brush

So going back to the speed-painting, I create a new layer where I start introducing the new brushes. I lay down only a few strokes, which I then distort using the Transform tool. I use it to stretch the shape into a position to my liking. If you made your brush with white

space around it, as a clean stencil shape, you can make a selection that perfectly outlines the contour of the shape by holding Ctrl and left-clicking on the boxed preview window of the layer in the Layers tab.

From the selection I just made, I am now free to paint only within that shape. I use a very large brush to mark within the shape to introduce a bit more textural character as well. It also camouflages the stencil aspect a bit.

▲ Using the Lasso tool to select the area needed

▲ Applying Brush settings and naming the brush will finish the custom brush process

▲ Making marks with the custom brushes you have just made

Step 12
Adding highlights

The painting is very mid-value still, so I use a large, soft-edged brush to pull out some lights. I set the Brush mode to Color Dodge – a very fast way to brighten up a scene. Be conscious of the color swatch you're painting with, though – the closer the value is to white the more drastic the Dodge effect will be. To control the effect I choose a color in a very dark range. From here I continue to employ the same techniques over and over again to build up the painting.

In Photoshop Elements you can even save selections you've made to be loaded up later when you need them. Once you have a selection made, go to the Selection tab and choose

Save Selection. Next time you need it just go to the same tab and choose Load Selection.

Step 13
Flipping the image

Another good trick to help give you a fresh eye on your painting is to flip the canvas horizontally. With traditional media, you have to go old school and hold up a mirror to see the flip, but with Photoshop Elements it's super convenient to be able to work on the painting from both orientations.

Step 14
Adding more highlights

I saved out a layer selection earlier, which I decide to use to erase out some parts of the

▲ Adding highlights using either a soft-edged brush or the Lasso tool to create selections

▲ Flipping the image to highlight problems

▲ Adding more detail and highlights to the image

▲ Adding figures strategically through the piece to create depth

▲ Making the characters stand out against the dark background

reflection and add a little more high-frequency detail. I then follow this with another layer of Brush dodging to 'pop' even more light.

At this point I also realize that I need to re-evaluate the composition again.

Step 15
Characters
It's now time to introduce some figures into the scene. Up to this point, I have kept the composition a bit on the simple side, knowing that characters and other subjects might be introduced later. I wanted to make sure they reinforced the composition and were not just dropped haphazardly into the image.

I outline my ideas for the design in red. I set up a hierarchy of character placement and size so that one could lead as the dominant figure (the focal figure). This is a basic principle of design – having large, medium, and small shapes creates more visual interest. In this case, they are also staged to emphasize spacial depth and distance.

Step 16
Blocking in characters
After blocking in the figures I quickly realize that dark silhouettes against a dark environment have made it difficult to pick out the characters from the background, so I decide to give them white astronaut gear to make them pop out. This way, they look more legible from a quick read.

Step 17
Refining the characters

After adding the characters in white, I feel confident in fleshing the characters out a bit and adding a little more detail to them in general.

Step 18
Checking the image

I don't like to finish one area of a painting and never touch it again. I enjoy seeing all the parts of the image develop together. The idea being that if I decide I don't like a part of the painting, less time will have been wasted than if I spent hours modeling sections of it.

I am still a bit unsure about the astronaut designs, so I make a mental note to revisit them later on (possibly redesign them all together). At this stage in the process though, the composition appears to be working well from both orientations.

Step 19
Adding atmosphere

All the elements are in place, so it's a good time to start polishing some areas of the painting.

So after the flip, I start introducing some fog and atmospheric effects. I have a few brushes that are specifically designed for this, so it doesn't take much time at all to drop some eerie mist into the scene.

▲ Refining the detail on the figures in the scene

▲ Again, flipping the image to check the designs work well

▲ Adding eerie mist into the scene after checking its composition

▲ Adjusting the fungus texture detail into the foreground

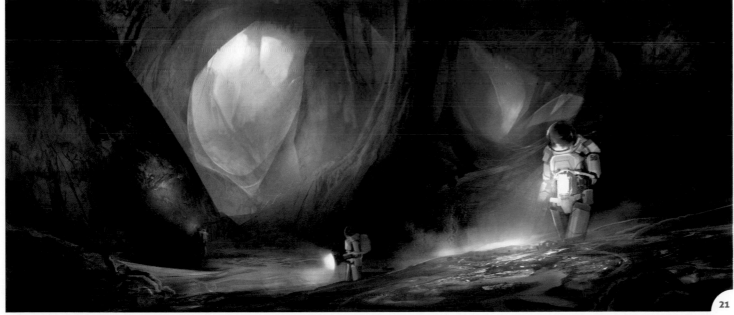

▲ Pushing the lights and darks to create a greater contrast in areas of the image

Step 20
The foreground

Moving from the background to the foreground, I continue polishing areas around the figures. I take a peek at some of the references I had gathered to get some detailed information for fleshing out the foreground. I mentioned earlier that the cave reference had some characteristics of fungus. I decide to play that idea up here and aim for a wet-and-spongy ground surface.

To help push the realism a bit more I drop in a small section of a photo. When I incorporate photos, I like to use them as style guides rather than to fill the space up entirely. I will paint out and over the photo so it blends in with the rest of the painting. Painting over photos you drop in keeps the image from feeling like a photo-collage and more like a digital painting.

Step 21
Adjusting lights

I continue pushing the lights and darks and expanding the value range up until the very end, although sometimes I have to dial back the contrast range with an adjustment layer if I push it too far.

I set my Brush tool to Dodge to quickly increase the light influence from the background. If the layer is merged, I will erase away areas near the Dodge so that shadows do not become too greatly affected.

▲ Toning down the hues to a more appropriate level

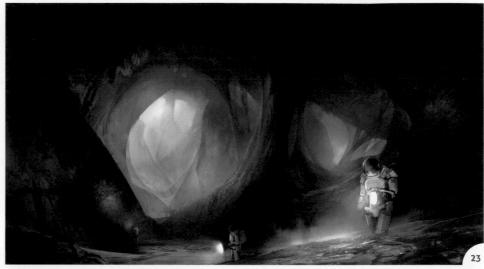

▲ Applying the Soft Light layer to make the purple seem less aggressive

Step 22
Tone control

I feel that the chromatic intensity of the painting has become too intense over the course of this tutorial. The purples appear exaggerated and are inching towards the 'candy' zone.

To remedy this, I copy and paste a merged layer of the entire painting and switch it to a Soft Light layer. I apply a Levels adjustment (Ctrl+L) to the layer to calm the intense contrast it creates. I then make a Hue/Saturation adjustment (Ctrl+H), and by setting the Hue/Saturation mode to Colorize, I am able to choose a new tonality that will influence the atmosphere of the painting.

Step 23
Applying Soft Light

This is almost like glazing in traditional oil painting. When I set the layer style to Soft Light, it influences the overall tonality of the painting and makes the purple seem less aggressive.

This speed-painting is interesting for me to see evolve. My focus for the first half of the painting was purely on mood, atmosphere, and composition, and the subject matter did not come about until much later. It was almost like building a stage for a play with no props or characters in the scene. Once the stage was constructed it was about placing subjects into the scene that would support

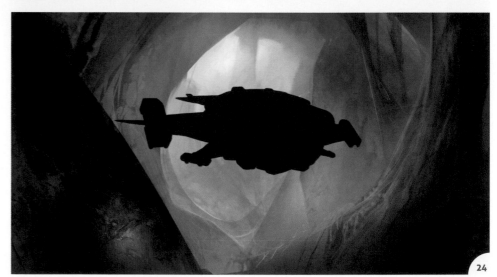

▲ Adding the silhouette of a vehicle to the scene

▲ Using the vehicle to add activity and dynamism to the scene

▲ Checking the detail on the characters

and strengthen the composition. Keeping the composition fairly simple in the beginning gave me the ability to add complexity as the painting developed. It really depends on the painting, but sometimes I will paint the figure in during the block-out stage. As long as you're always considering composition, the order in which you paint is not something to which you critically need to stay rigidly attached.

Step 24
Creating a vehicle

The last element I decide to add to the piece is a vehicle. I block out the vehicle in a solid flat tone to start. I will work with a big shape

and erase and paint around it until I find something I like. I go through a few iterations of silhouettes before locking it down.

From there, I create a selection of the shape to confine my brush to. This allows me to focus on massing out the vehicle in values and color, without redesigning the overall shape.

Creating silhouettes is a really important element of painting and it's fairly easy to practice.

Step 25
Integrating the vehicle

With an established silhouette, and after rendering shapes a bit tighter in the design, I hit the vehicle with an atmosphere, fog, and steam pass. This brings a bit of dynamism into the area, which before, was an inactive space, so to speak.

Step 26
Re-checking the characters

I decide to revisit the spacemen for a final pass and give them a quick quality check. I zoom into the image a bit to clean up some edges and iron out a few extra details.

With the characters a bit more fleshed out, I then do a quick pass of fog to soften some of the edge detail work I have just put in. At this point I am satisfied with the figures and feel comfortable leaving them as they are to the end.

Step 27
Checking the whole scene

I can now check the whole scene and review from afar. Things I ask myself include: Are the characters legible? Is there a clear foreground, mid-ground, and background? Does the composition move my eye around as intended?

Step 28
More detail

I think it's at a good point to round off and call complete; however, a few things bother me. The top half of the painting is all pretty evenly dark. To a degree, this is okay, but it needs some light information to help draw the eye back down into the scene.

As a quick solution to this I decide to introduce some hanging cave spores to the upper right-hand part of the scene. Placing them right above the dominant figure in the scene encourages the eye to one of the key focal points of the composition.

Step 29
Finishing touches

I finish off the painting with a Levels adjustment layer to maximize the range of darks and lights in the scene. I still want the painting to be dark and moody so I am conscious not to go too extreme on the lights. It's very easy to over-exaggerate these things when you're just moving a slider bar back and forth.

With the last adjustment layer set I consider the painting finished. Knowing when a painting is finished is a difficult idea in general. You kind of have to 'feel it in your bones' when you're done. With each sequential painting you create, you'll gain a more acute sense of this.

Along with digital painting, continue to work traditionally. Fill up those sketchbooks! Really, nothing beats paper and pencil when it comes to improving your skills.

I hope this tutorial gives some good insight into brush creation, layer selections, and painting modes that will help with future paintings you create. Keep practicing!

▲ Making changes after reviewing the painting from a distance

▲ Redirecting the viewer's eye by adding new cave spores to the scene, and checking it works with other elements in the scene

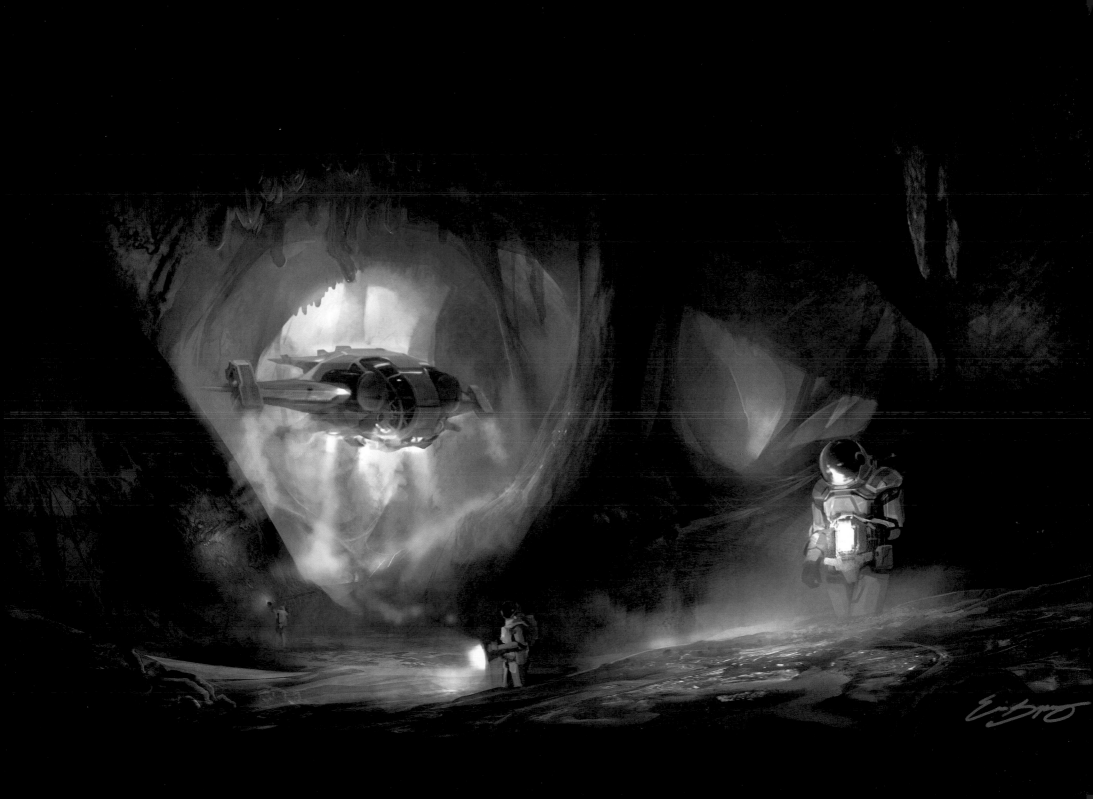

Using traditional sketches
by David Alvarez

In this tutorial, I have decided to sketch out the image of a buccaneer's headquarters in traditional media and will work through how to colorize the fantasy city scene in Photoshop Elements.

Step 1
References and shapes
The most important step before starting an illustration is to gather references. I would like to create an impression of used elements, patched up and assembled together to create a coherent architecture. The first thing I do, then, is look through photos and movies, and research other illustrations with similar themes.

With these researched ideas in mind, I can then focus on the composition of the image. I always consider and respect the rule of thirds. This suggests that we should avoid placing the horizon in the center of the image. The position and facing-direction of the character is placed according to this rule too – either on the left or the right of the page – in order to increase the drama of the scene.

I often begin by sketching out basic shapes on paper to focus on and draft out the main lines.

Step 2
Rough sketches
Still working on paper, I begin to draw a quick rough draft to fix and cement the composition and the main bulk of the architecture. I also add my main lighting intentions, though I only highlight the main source at this stage.

Don't hesitate to sketch out several thumbnail tests at this point to find the best composition for your scene. You don't need to include any fine details; a simple overview of the shapes and composition will work just fine.

Step 3
Developing the sketch
As the scene and ideas develop, I refine the drawing by sketching in the final lines for the architecture. These lines are the root of my illustration, and so details or adjustments should be added later.

Step 4
Scanning your image
Now launch Photoshop Elements in Editor mode, and click on the Expert option in the top bar. Expert mode allows you to have access to all the available editing options and settings, so you're free to use all the tools to create a digital painting.

To scan your drawing into Photoshop Elements, click on File > Import > WIA Support.

After clicking on WIA support, a window should appear. Click on the model of your scanner to select it, and click OK.

▲ Getting down the rough composition and volumes

▲ A basic line sketch of my chosen scene

▲ Stages of the line drawing and the final line sketch on paper, ready to be scanned in and colorized

In the scanner settings, under Type of Image, select the Photo in Color option as this generally scans in better quality and will help to better conserve the details.

Usually the scanner's Automatic Cropping function ignores details with a strong contrast, so it's not ideal to use when working with black-and-white sketches.

▲ Use File > Import > WIA Support to scan an image

▲ Some of the scanner resolution settings

▲ Cropping an image using the Crop tool options

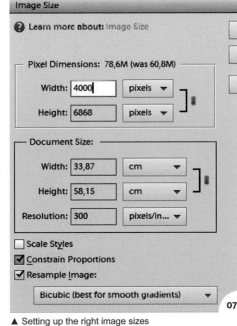

▲ Setting up the right image sizes

❝Usually clients need a specific format, but if you're working on a personal painting, I recommend you choose a 16:9 format (1920 × 1080 pixels)❞

Step 5
DPI

The resolution that you scan in with depends on the media that you're creating your image for – often printed images will need a higher resolution than a web image. As an example, I recommend that you set a 300 dpi minimum for your image in this tutorial, though ideally it should be around 600.

After your painting is done, I recommend you save a copy of your image and publish it with 72 dpi if you plan to put it online.

Step 6
Cropping

Your image should now have appeared in your Photoshop Elements user space, so we can now start work on it.

First, use the Crop tool to delete unused space. If you check along the bottom toolbar, you can select the Rule of Thirds option to activate a useful set of composition guidelines that will verify the correct placement of the elements in your scene.

In addition to the Rule of Thirds option, you can find other several options in that menu to help you really refine the composition of your piece.

Step 7
Image sizing

You may need a certain sized image to work with, so to change the size, move to the top toolbar and click on the Image menu. From there, choose Resize and then Image Size.

Usually clients need a specific format, but if you're working on a personal painting, I recommend you choose a 16:9 format (1920 × 1080 pixels), or a corresponding proportional size to allow an easy upload to the web. You are then free to set the sizes of your image to correspond with the required format.

In the opened window, choose the size of your work. For this tutorial, the requested format is a width of 4000 pixels, so I click on the right unit (pixel, inch, and so on) in the window and check Constrain Proportions to conserve the ratio.

If you resize an image you can also change other options, such as the Resample Image option. In this menu, the Bicubic, Nearest or Bilinear options are a few different ways to preserve the hard edges and gradients in the scene when you resize your illustration. Experiment with the different results.

Step 8
Layers

We can now work with layers to begin refining the image digitally. First, go to the Layer panel. If the panel is hidden, hit F11 on your keyboard. Double-click on the layer named 'Background' to unlock the layer. Rename the layer to something appropriate. Layer-naming is not a convention but you should label layers to help both yourself (and clients) understand the order of an image.

Step 09
Cleaning up the image

To have a clean line on your image without any gray values, create a new adjustment layer and name it 'Levels'. To do this, click on the button on the right side of the interface (image 09 – 1).

A window should open showing the Levels of the image. Move the black-and-white value to gray (image 09 – 2). This is not a mathematical value; good values simply depend on your visual judgment. Level adjustment is very helpful in helping boost the contrast in your image and preserving any details in the lines, and actually works better than simply adjusting the brightness/contrast in this case.

Step 10
Coloring lines

Now the lines are clear, we can begin adding a little color. As part of my usual practice, I will colorize my lines to fit with the given/

decided mood and theme. So to start, I create a new layer, choose an appropriate color in the Color Picker and fill the layer (Alt+Del). You could paint directly with a smooth brush to enrich the color variations here, or you could simply fill the canvas with a gradient.

Step 11
Clipping mask

A very important layer function in Photoshop Elements is the Clipping Mask. This allows you to preserve any adjustments you make to a specific layer. To influence only the lines on the layer with my previous colored canvas fill, I left-click and hold Alt between Line layer and Levels layer, and do the same with the Layer color/Levels. You can now adjust these levels or make other adjustments without collapsing the layers.

I would recommend this as an excellent time to save your work. Remember to save regularly.

Step 12
Color

To begin coloring the image, we need to create a new layer (I name it 'Color') and add it in *under* the Line layer.

First, we begin coloring while conserving the lines because it's important to determine the mood before under-painting. Feel free to get inspired by the photos and painting references you gathered at the start of

the tutorial, to determine and refine your atmosphere and appropriate color scheme.

Step 13
Loading brushes

When you have determined your chosen color scheme, you can begin to think about how to apply the colors to your canvas.

Before starting to apply any color, you can load my brush pack created for this tutorial (**3dtotalpublishing.com/resources**). This tool pack has a range of brushes that were specifically made for you to create the kind of effects I'm trying to produce.

To load the brushes into Photoshop Elements, go to the Brush Tool options, and click on Brush to show the Brush options menu. Select Load Brushes, and load the 'Rez_3Dtotal.abr' file.

▲ Naming layers to organize your image

▲ Cleaning up the lines in the image using Levels

▲ Adding a layer of color to colorize the lines

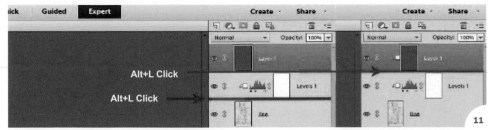

Alt+L Click

Alt+L Click

▲ Finding and using the Clipping Mask

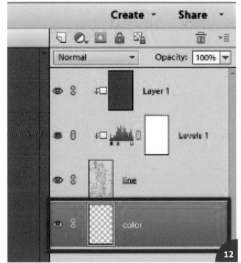

▲ Setting up a color layer to begin adding color

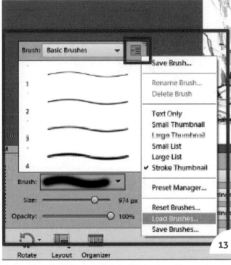

▲ Loading the brush pack into Photoshop Elements

Step 14
Light sources

At this point, we should determine the key light, or the main light source in the scene. I want to create the golden rich atmosphere you see at sunset, so I place the sun lower in the sky and adopt an orange/pink light hue.

❝I use orange as the dominant color here. You can paint with any color, but each one area will have a bit of this dominant color ❞

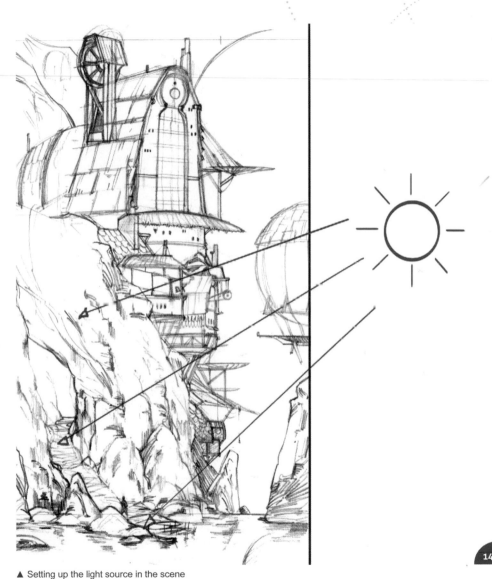

▲ Setting up the light source in the scene

▲ Adding in a violet base color on the background

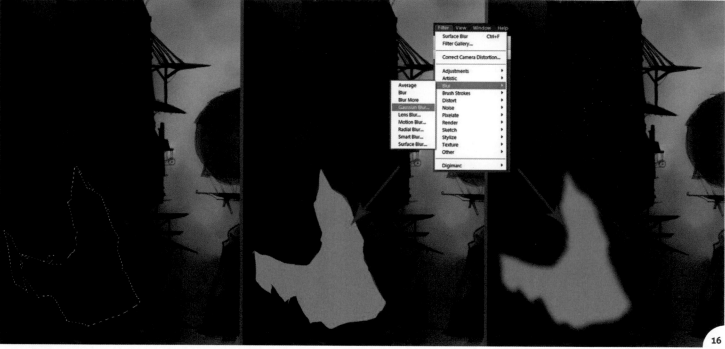

▲ Selecting and filling an area of the scene to establish highlights

Step 15
Background color

I usually use a blurred brush to start adding in the color. I apply complementary colors to the scene to keep the harmony in the image: I use violet for the scene background and orange for the architecture. This is a deliberately limited palette that allows me create a decent harmony.

I then fill different elements of the scene with a Hard brush and blend different parts with a Smooth brush to establish a nice color harmony in the scene.

I use orange as the dominant color here. You can paint with any color, but each one area will have a bit of this dominant color.

Step 16
Light pass color

Now the base colors are established, I can begin to work on the light and dark tones.

First, I create a shape for my light tone. I use the Lasso tool (L) a lot when creating light tones. You can change the Lasso mode by pressing L several times, to switch between the Lasso, Polygonal Lasso and Magnetic Lasso functions in the menu.

I make my selection in the image and fill the area with my light color (Alt+Delete). I then apply a Gaussian Blur filter with 10-pixel value (Filter > Blur > Gaussian Blur).

Step 17
Layer modes

I then change the mode of my light color layer to Overlay. To do this, go to the right-hand panel and select the Overlay option from the drop-down menu. I use the Overlay mode a lot in my lighting and texturing layers; you should play with different modes too, as there are no hard-and-fast rules for using each type. You may also get a few pleasant surprises when inverting the color.

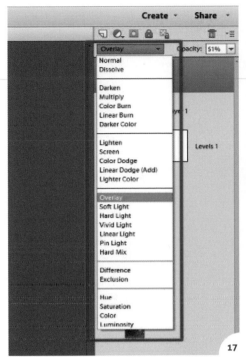

17

▲ Adding the Overlay layer mode to the Light layer

18

▲ Applying the shadows with the Lasso tool and the layer on Multiply mode

19

▲ Painting over the basic lines and blocked colors

Step 18
Shadows

Now the light tones are established, I repeat the same process for my shadows.

After creating a new layer, I choose the areas for the shadows and select them with the Lasso tool. I then fill the areas with color and put the layer onto Multiply mode. I then set about changing the Opacity too, to match my original intentions.

In terms of color, I never use black or gray for shadows because I think color or light reflections on shadows can be used to preserve your color harmony.

Step 19
Lighting the foreground

It's time to get serious now and start to define the more detailed areas of the piece. First, I create a new layer over all of the previous color layers. I will use this layer to begin painting in detail over all of the original drafted lines in the scene.

I start on the foreground because it is the main area of interest in my scene. I light the rocky areas around my character at the forefront of the scene in order to force the reader to look here first and then follow him up the stairs. Localizing detail like this helps to guide the viewer's eye from here on through the image in the order that you wish.

 I imagine this building like a steampunk cathedral with lots of windows and a big chimney that is used to supply energy to the headquarters 𝟗

Step 20
Adding details

I decide to add a boat wreck in the foreground to introduce and accentuate the depth of the image. I create a dark shape in the foreground to make a dark/light contrast and to help draw the viewer's eye and focus towards the character on the stairs. I also add a new element on the rock itself to accentuate the perspective. This is a balcony that suggests that the character is being observed by someone/something above.

These new elements help tell a little story about the scene, and accentuate the feeling of insecurity in my hero.

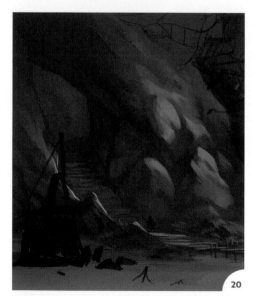

▲ Adding new story-telling details to the scene

Step 21
Color details

After painting the boat wreck, I continue to work on adding shapes, filling areas with the Blur brush, and adding color variations.

I also decide to add windows on the main building on top of the rock. I imagine this building like a steampunk cathedral with lots of windows and a big chimney that is used to supply energy to the headquarters.

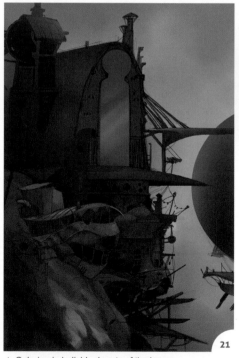

▲ Coloring in individual parts of the image

▲ Adding the elevator and its details to the scene on a new layer, and repeating the process with the ropes

Step 22
Working on the elevator

Thinking about the story and functionality of the building, I decide that the energy is provided by a boiler. This is positioned on the side of the building with a lot of pipes attached to the wall.

From the idea of the boiler, I imagine an elevator on the side that helps the inhabitants load

the wood. To create this elevator, I create a new layer and draw the silhouette with a Hard brush. When I finish, I Ctrl+click on the layer to make a selection. I then paint in the section and add detail and color variations. When I'm finished, I press Ctrl+D to deselect the area.

I repeat the process with the ropes and different elements in my image.

Step 23
Guiding the viewer's eye

To properly guide the viewer's eye directly to my desired focal point (the character), I add light sources at the foot of the rock. This allows the viewer to experience the scene in the same way that my hero does. To add these lights, I create a new layer with Color Dodge mode

enabled. I then paint yellow areas with a Blur brush, and change the Opacity layer (20%) to avoid creating a burned appearance.

▲ Creating sources of light to draw the viewer's eye

Step 24
Special effects and finishing touches

Again, I repeat my favorite process: I create a selection, fill the area using a blurred brush with Opacity variations, and finally apply a Filter.

We will be applying a Motion Blur to the scene. To do this, go to the top toolbar and click on Filter > Blur > Motion Blur (I apply a distance of 20). Apply Motion Blur in the same direction as the smoke. Then repeat this process in separate layers to build up a good smoky texture, playing with the Opacity to complete the effect. The goal here is to unify the image and suggest that a conduit network exists inside the building.

To finish the illustration off, I add fog to the foreground to reflect the colors of the sky and water.

I also add rim lights around objects affected by the lights in the foreground or the low-setting sun. Finally, I paint red petals around the character, using the same process I followed when creating the smoke.

There is nothing else left to do now except to create a Levels layer to adjust the overall contrast, and then it should be finished.

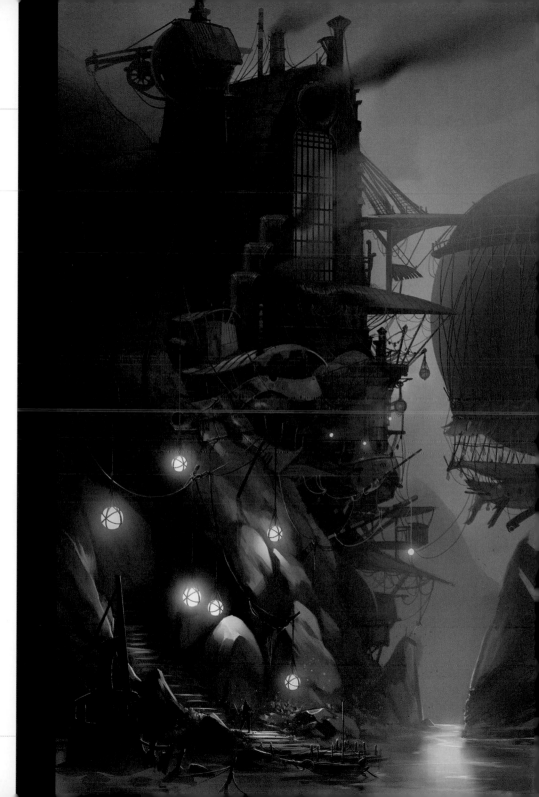

Cartoon critters

by Dave Neale

In this beginner's tutorial, I will explain my process for painting a gharial (a kind of crocodile) using Photoshop Elements. I will demonstrate how you can achieve great results with this software, which incidentally, is an excellent option for a beginner or professional, who may not want to pay for the price of the full version of Photoshop.

I will show you one of the approaches you can use to create a character from start to finish, and I'll try to explain my thought process and why I make various decisions. I feel like all tutorials should always be prefaced with the caveat that even with all the steps explained, there is a lot of practice and learning that backs up the decisions made when producing any art work; so even though I explain all stages of the painting, this can't replace the time it will take you to learn your art fundamentals (such as perspective, anatomy, color theory, and so on). I'm still on my journey with these things too, so if your results don't immediately match those here, don't worry. Practice, practice and practice some more and eventually you'll be able to create great artworks using these techniques.

" I have short-cuts programmed into my Wacom tablet, and I suggest you set up your shortcuts in a way that suits your needs "

Step 1
Setting up a document

After opening up Photoshop Elements, you'll notice that you can work in one of three modes: Quick, Guided or Expert. The first thing I do is set it to Expert.

The next task is to look for the Layers palette, which I find by going to Window > Layers (or shortcut F11). I work in layers as it's easy to move things around, delete specific bits I don't like, and generally control what I'm doing a little better. Everyone has their own comfort level with layers, and I'll explain mine. I make a new layer by clicking on the new layer icon in the top left of the Layers palette, or use the shortcut (Shift+Ctrl+N).

I won't be telling you about all the shortcuts that I use, but as a rule I find that if I need to do something often enough, I will always find the keyboard shortcut for that action as it can save a lot of time when you're constantly flicking between different tools. I have shortcuts programmed into my Wacom tablet, and I suggest you set up your shortcuts in a way that suits your needs.

I then start sketching ideas. The brief I was given was to 'create a cartoon-style character', so I just have fun at this stage, sketching and exploring the concept.

01

▲ This is often the most enjoyable part of creating any image; the important thing here is not to get drawn into details

02

▲ I define the form and refine the drawing until I'm happy that I have a good guide for my painting

My approach to creating characters is very personal, as it is for most people. Everyone has a style that has been developed over years of consuming visual material, copying other artists, and working out what style you enjoy working in most. For me, exploring proportions is the most appealing design method.

I favor cute, stubby, pudgy critters. I love urban vinyl, graffiti, and cartoon illustrations that really push proportions, and my work is influenced by these (and countless other things I've seen and experienced). All my design decisions are based on proportions. Should the arms be long or short? How far apart should the eyes be, and how big? Where should the arms be placed, and how wide apart? I'm not saying I know exactly how a creature will turn out when I start, but in all my decisions I'm trying to get the most pleasing result based on my personal tastes. I think as long as you're thinking 'does this look cool to me?' then you're on the right track.

Step 2
Refining the sketch
Once I'm happy with where the sketches are going, I can start to refine my preferred sketch.

Because I'm going to render the final piece in a kind of semi-realistic lighting setup, I decide that I need to adjust the pose so that the character will sit on the ground in perspective, rather than in the side-on view I had in the

thumbnail. This is an important thing to remember when you're designing a character like this – what might work as a 2D image doesn't always translate into a more 3D style.

Step 3
Structure
I ink the rough sketch using the default Hard Round brush. I find it easier to paint when I have a lot of the design and form details defined before I lay down any color.

I'm thinking in three dimensions at this point. I can turn the character around in my head, see what's behind him and feel him sitting on the ground. This is important if you are then to create the lighting from imagination because you need to think at every point: If this thing was in front of me, where would the light fall?

Step 4
Blocking in
I change the layer mode of my line art to Multiply in the drop-down box on the Layers window and also turn down the opacity so I can use my lines as a guide without them getting in the way.

Blocking in is a great method for both digital and traditional artists. When you are working digitally though, you have the added benefit of being able to lock a layer you've blocked in to create a mask, or an area of your painting that you can paint inside. The

▲ The final line art I will use as the guide for my painting

benefit of this is that you only have to define the silhouette once and you can then simply paint inside of that blocked-in area or layer.

Here you can see that I create layers for the eyes, teeth, digits, spikes, and body.

I can then use the Lock layer tab at the top of the Layer window (fifth icon from the left) to preserve these areas.

▲ Working in layers will give me a lot of control later when I come to rendering the character

> **Brushes aren't a magic wand to make everything look like your favorite artist's work, but they can be a great way to create some quick visual interest**

Step 5
Custom brushes

Because the default brushes are a little limited, I decide to import some Photoshop custom brushes – and to my delight, these work! Brushes aren't a magic wand to make everything look like your favorite artist's work, but they can be a great way to create some quick visual interest and variation.

I import a set that Levi Peterffy gave me (you can find these and more on his site at **www.artoflevi.com**), and use these when I'm blocking in to give me some interesting and varied edges.

Step 6
Lighting the image

Lighting an image or a scene involves choosing a light direction – this seems obvious but is definitely worth mentioning. I choose my light direction based on what I think will make a nice set of cast shadows across my character's body and tail. For example, if I wanted to make the character sinister I'd light him from below; I might choose to have two light sources or to make it really dark and moody.

I define the shadow by creating a light layer and then painting in the shadow with a layer mask (third icon from the left in the Layers window). This allows me to erase and – also crucially – to paint back in the light layer. Masks can be a useful tool when you want to paint out bits of a layer, but want the added option of painting areas of that layer back in if you feel like you've taken too much away.

Step 7
Coloring from grayscale

I lock all of my layers, and in the Enhance > Adjust Color > Adjust Hue/Saturation window I tick the Colorize box and use the sliders to color the gharial in hues that I feel work as a base for my painting. I'm not thinking of the final colors here, I just want something other than gray that I can use as a starting point for my painting.

Step 8
Color variation and interest

I loosely base my colors on reference images of gharials that I discover online, but for the moment I mainly just throw colors down in a way that I feel looks nice. I try to vary the hues and the saturation as well as the values without pushing these elements too far. Making these choices well comes with practice, and I do not by any means feel like I have this fully mastered. I do my best, however, until I feel that the colors are about where I want them.

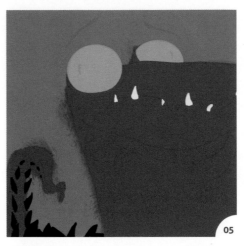

▲ Photoshop custom brushes allow me to achieve a traditional look and create interesting edges

▲ The light direction is your choice to make – what mood are you going for? Now is the time to decide

▲ I use the Enhance > Adjust Color > Adjust Hue/Saturation tool a lot to work with or tweak my colors

You'll also notice that I add an arrow above the gharial to remind me where my light source is coming from. I find this helpful as it can be easy to get too drawn into rendering an area nicely and forget that the lighting needs to work overall. Consistent lighting really helps to sell an image. Even if your viewer can't tell specifically that the lighting is inconsistent, they will be able to subconsciously tell that something isn't right.

> ## 44 Learn what works in the world and bring some of that into your artwork 77

Step 9
Which color to choose?

Color choices are a minefield; we have so many choices with every color we choose that it can be totally overwhelming. The very best advice I've ever had on color is to paint from life and photos, and to practice. Learn what works in the world and bring some of that into your artwork. There are rules such as brighter areas often being less saturated as they become brighter, or colors not staying the same hue as they change in value, but these rules can be broken and can change depending on the lighting scheme. There isn't enough space in this tutorial to talk about color, so the best advice I can give is to practice and to learn from what you see in life.

Here I'm trying to achieve some hue variation, so I throw in purples and blues with the greens.

▲ Rules of light and color theory help, but sometimes intuition is just as important

I know this will work best if they are isolated splashes rather than big washes of these colors. You'll notice that many objects will have shifts like this if you study from photos or real scenes, and so I use this knowledge in my images.

Step 10
Adding a shadow layer

One of the layer modes I use a lot is Multiply. You can select this mode by using the drop-down menu at the top of the Layers window. Multiply allows you to add darker areas on top of the layer or layers below, without obscuring details you've painted in already.

In addition, I often clip my shadow layer to the layer below, so that the shadow only affects the layer below. To do this, select the top layer and go to Layer > Create Clipping Mask.

Here, for example, I create a shadow layer above the body layer and paint the shadows cast by the head, the mouth, and any other areas that are in shadow. I do this with a desaturated greenish-yellow, and this allows me to quickly get an idea of the shadows, which will be the base onto which I paint more details.

▲ Color choices should be made with relationships and harmony in mind

▲ Layer modes are your friend and a wonderful addition to the digital artist's arsenal

▲ Artists used to look at their paintings in a mirror or upside down to get a fresh eye on a piece – working digitally makes this much easier to do

▲ Explore all the tools that can make your workflow more efficient; sometimes it's as much about problem-solving as it is about painting

Step 11
A different perspective

It's easy to stare at an image for so long that you become blind to mistakes, so flipping it upside down and left and right is a great way to get a fresh perspective on the piece. It helps you to see the image as a collection of forms rather than a whole character and this allows you to spot some of the things that you might have missed.

Step 12
Overlay layer mode

The Overlay layer mode is a bit like Multiply, but can also work the other way, meaning that you can paint in lighter areas over those that you have already painted without losing any details. It can be a tricky layer to master because the different colors you paint with can produce varying results. However, if you take the time to play with it – and also use the Hue/Saturation color adjustment sliders to explore the different results – it can be a really useful tool.

In this image, I use the Multiply layer to paint in some detail. I added a subtle, slightly lighter area on the eye directly around the pupil, which is a specific biological feature that I noticed while studying a number of reference images of gharials.

▲ Layers are a digital artist's friend; they make life a lot easier and your painting a lot more controllable

> **Using layers is a really good way to control any changes you make and separate out elements that would be better kept apart from other areas of your image**

Step 13
Useful layers

Using layers is a really good way to control any changes you make and separate out elements that would be better kept apart from other areas of your image. I typically use layers with a Clipping Mask on the part of the image I'm currently working on, in order to play with ideas and test things out. Once I'm happy with those elements I can merge down the layers (Layer > Merge Down) and keep my document from getting overrun with hundreds of layers.

I also like to keep my layers clearly named if I'm not planning on merging them down. Firstly, this helps you to keep track of things yourself, and secondly, if your image is produced for a job it allows clients to see what's going on when you send them a PSD (Photoshop) file.

Step 14
Slogging it out

I think it's easy to get into the mindset that painting should come easily and that we should know exactly what we're doing from start to finish. After all, we came

▲ Do your best to confront problems

up with these things in our heads so all we have to do is get them out, right?

This is the part of most paintings where I'm second-guessing myself, trying to solve problems I don't have the answer to and occasionally bashing my head against a wall. You can't be too precious at this point; if something is bugging you, change it. Even if it's a massive change and you lose something you spent ages on, I think that if you did a job well once, you can do it again. Being able to backtrack and not be precious over parts of your image that you're attached to will really pay off in the end.

Step 15
Think of the whole

I've been thinking about details for a while now and have stared at this piece a little too long, so I'm starting to lose some perspective. In order to

▲ It's easy to get caught up in details, but if your image doesn't look good overall then pretty details won't fix that

get a fresh look I merge everything together (Ctrl+Shift+E, or Layer > Merge Visible), copy that layer, then undo that action (Ctrl+Z). I then paste the merged layer on top of all of my other layers. I then apply a Gaussian Blur (Filters > Blur > Gaussian Blur). This will give me an overall first impact impression of what my viewers will see, without all of the distracting details.

I decide that I need to bump up the brightness in some areas, so over the top of that layer

I make a new layer, fill it with black, set that layer mode to Color Dodge and then paint onto the layer with a brush set to 10% Opacity. This is a neat trick to apply light to an image. It works in a similar way to the Overlay mode, but that can have a better effect on how the color transitions into light. Applying light this way can easily give the impression of an overexposed photograph, so ensure that you use it subtly. Give it a try yourself and hopefully you'll be pleased with the results.

Step 16

Final adjustments

I'm getting to the point where I'm pretty happy with how things are looking. One of the last things I do is to adjust the background by throwing a photo texture behind the character. This is one of the textures I use a lot – it's pretty flat, but gives a little bit of visual interest and color in place of the plain gray I've been working on. I also use the Rounded Rectangle shape tool (found in the Tools palette) to create a background shape I can use to clip my background elements to and give the image a nice border.

Step 17

And I'm done!

Overall I'm pretty happy with my gharial. I think I could have potentially paid a little more close attention to the lighting direction, but I think I got the personality and form across reasonably well, which for me, are two of the things I strive for most.

I hope you've enjoyed reading about my process and found some useful tips here. Using Photoshop Elements has been a really interesting experiment for me, and though it did have a couple of slightly annoying quirks, it's a pretty versatile tool for any digital painter and is entirely usable as an alternative to the full version of Photoshop.

▲ Placing a character on a background isn't the most important thing to consider, but it can affect the impact of the piece

Working with photos

by Benita Winckler

In this tutorial we will have a look at using Photoshop Elements and working with photos. As the name suggests, it features some elements of Photoshop, and as a real Photoshop lover, I have to say: try the big version if you can! But until then, Photoshop Elements will serve as a smooth (and not to forget, cost-effective) introduction to the full package. The techniques you are about to discover can be transferred seamlessly to Photoshop later. So nothing is wasted and you'll be making miles already.

To set a nice working example for the next steps, we will look at the creation of a simple, yet atmospheric, landscape painting. We will explore some of the following processes:

• How to come up with ideas: An important task – especially at the beginning of a painting

• How to use some basic techniques to find a good composition

• How to kick-start a color scheme: A creatively chaotic approach to turn shades of gray into harmonic colors

• How to use the secret of the foreground plane (or 'how to cast a spell on your viewer')

• How to use photographic materials while still keeping it painterly

At the heart of this tutorial lies a technique that will demand a bit of practice to fully appreciate it: Using photographs for coloring and texturing. To me, this is where working digitally can really show its unique strength, compared to working traditionally. This tutorial is aimed at total beginners, so along the way I'll also be explaining some technical basics (keeping it as short and sweet as possible!).

Step 1

Collecting reference images

Before we start the painting, let's make sure that we have as much information about the topic as possible.

To get a good feeling for the atmosphere of an image, I like to do a search in my personal photo library as well as on the internet. It is important to only use photographs that you have either shot yourself or that are taken from a free library, such as free textures from 3dtotal (**freetextures.3dtotal.com**) or CGTextures. Collect nice shots of mountain forests, tropical landscapes, rocks, and save them in named folders so that you can easily access them later.

Step 2

Describe the idea with words

Now that we have fed our minds with reference images, we have a good visual sense of what our project is about. But before we dive into the painting part of this

▲ Collect reference pictures and save them to individually named folders

▲ A decorative scribble of some concept words

tutorial, let's have a more detailed look at the significance of a strong written concept.

Words are like little spells as they immediately create an image in the mind. Having some concept words to refer to while painting can help you stay on topic. If you feel stuck with ideas for your image, try describing it with words – you might see something that wasn't there before.

Step 3
Starting Photoshop Elements
Whenever I open up an unknown software package I haven't seen before – my first thought goes something like this: 'OMG. Buttons. Lots of them.' Here comes the good news, though: start up Photoshop Elements and you will be faced with just two of them. Feeling relaxed? Okay, let's have a look.

One says Organizer (this must be the place to go for organizing images). One says Photo Editor; this sounds arty – click it). The Photo-Editor screen will open. We will skip the Organizer section for now and come back to it a bit later. The next step is to create our document.

Step 4
Creating a new document
Click File > New > Blank File (shortcut: Ctrl+N). In the prompting dialog box select Preset: Web, and set the Size to 1600 × 1200 and the Resolution to 72 dpi (pixels per inch).

▲ The welcome screen gives two options

Don't worry too much about these settings right now though, as this first document will only serve as a canvas for the thumbnail sketching. Since we will not be printing this sketch and will just be working with it on screen, we only need 72 dpi. Once we switch from the sketching into the refining phase, we will be able to change all the settings to define a higher resolution such as 300 dpi, which is needed for printing.

Choose a name, for example 'thumbnail_sketches', and then press OK.

Step 5
Attention: Saving the file
Now, there is a little hindrance I want to show you: For users with fresh installations it seems that trying to save the file can cause an error to pop up. Photoshop Elements wants you to use the organizer first before you can save an image. Do as the dialog requests.

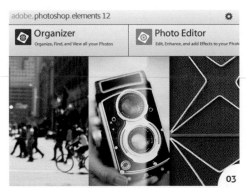

▲ Creating a new blank file in screen resolution 72 dpi for the thumbnail sketches

In the Organizer's menu choose Manage Catalogs, hit New, and assign a name.

In the next step we will import our reference material into the catalog that we have just created. I know this is still all very technical – but bear with me! Now quickly switch back to the Editor and save the file.

Step 6
The Photoshop Elements Organizer
You don't *have* to use the image Organizer that comes with Photoshop Elements. Apart from the initial setup I just described, I would

▲ Trying to save an image without using the Organizer first can lead to an error message like this

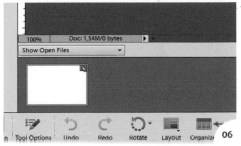

▲ Click the Organizer button to launch the Organizer

suspect that you will never have to touch it again if you don't want to. It's certainly helpful to have some sort of organization system, but image collections have a natural tendency to get bigger over the years – the handling becomes increasingly time-consuming.

Let's look at how the Photoshop Elements Organizer can make our lives easier. You will discover some very useful techniques for sorting and managing a library.

Step 7

Importing reference images

Click Import > From Files and Folders (image 07a), then navigate to the folder you want to import, select all images in there and hit Open. Repeat this process for the other folders and images. Now there will be no more waiting for thumbnail generation, as once imported, they are all there to look at – even if you imported a ridiculous amount of photographs.

To remove an image from the catalog, right-click then select Delete from Catalog. The Organizer will ask if you want to just delete it from the catalog, or delete it from your hard disk as well (image 07b). Leave the checkbox empty to avoid deleting your original photo source, too.

Step 8

Assigning star ratings to images

Zoom in by pulling the zoom slider on the bottom left. Decide on a nice rock image, then right-click it and select Ratings > 5 Stars. Change folders (on the left where it says My Folders) and choose a few more images from various folders for five-star ratings.

Now it's time to compare some five-star images! Click the five gray star icons at the top of the screen to activate them. All images from your current folder that have been rated with five stars will be displayed. Use the Zoom tool to display them at the proper size.

▲ Importing the images into the Elements Organizer database

Step 9

Ready to paint in Expert Mode?

Now that we have organized our image material, let's switch over to the Editor. A click on the Editor icon will open the Photo Editor. Whenever an icon features a small arrow, it indicates that there are more options available. For example, I have Photoshop installed so it shows in the list.

Now let's have a look at the Photo Editor interface. First, make sure that Expert mode at the top is selected. On the left-hand side is the toolbar, with important tools such as Pan and Zoom. You can also use shortcuts to access these tools – try them out!

• Ctrl+Spacebar = Zooming in
• Ctrl+Alt+Spacebar = Zooming out
• Spacebar = Panning

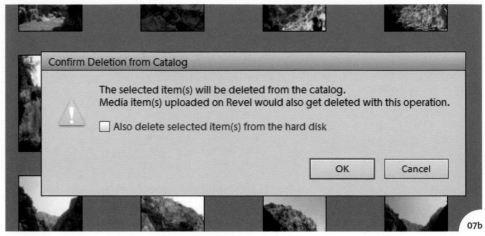

▲ Leave the checkbox empty or your original file will get deleted as well!

▲ To assign a rating, first right-click in the image and then select Ratings

▲ Click the Editor icon at the bottom of the Organizer screen to switch over to the Photo Editor

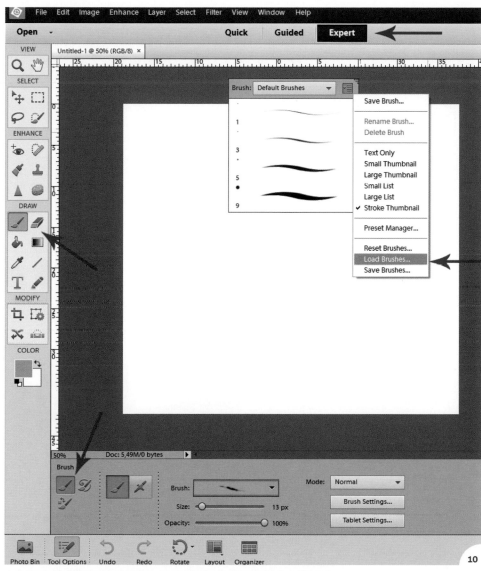

Step 10

Importing a custom brush set

What do we need for painting? Right, first of all: brushes! If you already have some Photoshop brushes available, you can easily load them with Photoshop Elements – my own custom brushes can be downloaded with this book (**3dtotalpublishing.com/resources**). Creating custom brushes is a fun and useful to learn.

To load your brush set, click the Brush tool (top-left icon in the Draw Tool palette), right-click on the canvas to bring up the Brush Tool menu, and select Load Brushes. There we go. And if you want to get back to the original brush settings, simply hit Reset Brushes. Always try to remember to save your old brushes in case you want to keep them.

Step 11

Choosing a brush

Enough technical stuff for now – let's start drawing! First, right-click the canvas to bring up the Brush panel. Select any nice, small brush you like. If you have loaded my brushes, you could select 015.bmp#1 in a small size (choose the Text Only mode to find it in the set). This has a nice, natural pencil feel to it. To change the size of a brush, simply use the slider in the Tool Options area at the bottom of the canvas.

▲ Collections of Photoshop brushes can also be loaded into Photoshop Elements

▲ Click the menu icon to see the options for saving, loading and displaying brushes

Step 12

Thumbnail sketches for the composition

Now you have selected your favorite brush, set it to a small size (I use 2 pixels). The color is not important for now, so you can use default black.

Now go ahead and draw some small rectangles, which represent the box boundaries of our image. The goal is to explore the composition and divide each rectangle into interesting spaces. Thumbnails don't need to be pretty or clean; the important thing is to keep them really tiny with no detail. At this stage we are only concerned with the distribution of shapes. To Undo, hit Ctrl+Z, and to Redo, hit Ctrl+Y. Finally, redraw promising compositions in new rectangles.

Step 13

More thumbnail sketching

Keep sketching until you find some nice compositions. We need a mountain in the distance, a vast jungle in the middle, and for the foreground we want some elements to invite the viewer into the picture – for example some steps leading to a resting point.

The center of interest needs to be clearly visible and later on it will receive the most focus, but as mentioned before, don't put any details in yet.

I start blocking in some values with a basic, Hard Round, larger-sized, pressure-sensitive brush. Avoid soft brushes for now.

Step 14

Using the Eraser

Each new sketch helps to refine the idea for the composition. Even errors can sometimes lead to surprising ideas.

If you need to erase something, use the Eraser tool or hit E on your keyboard (hitting E repeatedly will cycle through the other Eraser tools – notice how the Tool Options panel at the bottom of the page changes accordingly). When using the normal Eraser tool, you'll see that it erases back to the color of the background. You can change this by clicking the overlapped background color swatch on the left.

Step 15

Setting up a new layer

Until now we were drawing directly onto the blank canvas, but working with layers is where the real fun begins. The Layer palette is located at the right side of the screen. You can use the shortcut F11 to toggle the display, or use the Layers icon on the bottom-right of the screen. Hiding the panels will come in handy once we are working on the large image.

Hit New Layer at the top of the panel to create the new layer. It will be placed right above our background canvas.

▲ Draw some tiny thumbnail sketches to get a feeling for the composition of the image

▲ With small-sized sketches you are forced to focus on the design and overall impact of the image first

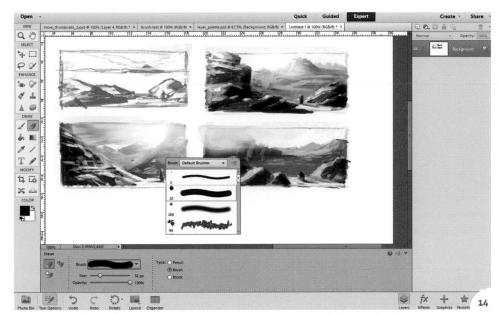

▲ You can use the eraser like a brush – right-click the canvas to select a brush from your brush set

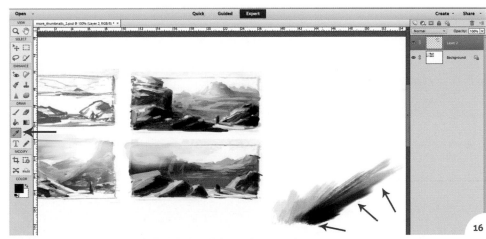

▲ Select the color-picker tool and click into the painting to choose a value

▲ Press F11 to hide/show the layer palette and click the new layer icon positioned at the top

▲ Access the Layer menu as shown here; you can rename it by double-clicking it

Step 16
The Color Picker

Let me introduce you to the color picker (shortcut key: I). By now you should have different shades of gray on your canvas. If not, quickly select a pressure-sensitive brush (right-click the canvas and select one) and paint some strokes onto the new layer. Use a good variety of black, darker, and lighter grays.

Now hit the I key to select the color picker tool. Click on an area of the image and the color/value underneath will be picked up for you to paint with. Now hit B. Repeatedly clicking B will cycle through the different brush tools. Here we can use the standard Brush tool.

Step 17
Working with layers

I hope you are now feeling more comfortable with the selection of brushes and sizes, as well as with painting and erasing on our new layer.

You can create as many layers as you like in your image; you can paint on them, duplicate them, or change their position in the stack by dragging them, merging two layers or flattening the image to get one final layer. To delete a layer, click the little garbage bin on the top right.

It's always a good idea to keep a safety version by copying a layer. That way you can experiment on the copied version instead.

Step 18

It's all about the design

So now we have our background canvas with our initial grayscale drawings in front of us. We also have some more layers with rough sketches on them.

At this point, you may wish to create a new layer on top of a line art sketch and experiment with values to fill them with. Is there any composition in particular you would like to keep? Select a pressure-sensitive brush with a hard outline (when sketching, a hard, outlined brush can prevent us from soft decision making – the design comes first, fluff comes later). Pan your chosen image into view and start painting on the new layer on top of it, filling the shapes with bold brushstrokes.

Step 19

Using the Marquee tool

In image 19 you can see my final composition. It's rough and unrefined, and not pretty at all – but that doesn't matter! We will go over the areas and polish everything up into shape soon.

Now select your favorite composition sketch with the Marquee tool as shown here. It doesn't matter if there are some drawings overlapping in the selected area. Hit Ctrl+Shift+C to make a merged copy (or select Edit > Copy Merged). This copies a merged version of all layers inside the selection rectangle.

▲ Use hard-edged brushes on the initial design, as using a soft brush can result in bad legibility

▲ Select your favorite composition sketch with the Marquee tool – the little 'marching ants' indicate the selected area

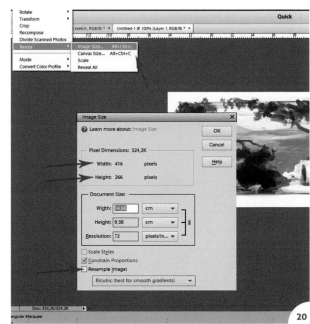

▲ The new document will be resized to a higher resolution

▲ Next, quickly clean up the border areas with a few brushstrokes. Now we are ready for the colors!

Step 20
Using the Resize document function
Select File > New > Image from Clipboard. This will create a new document with the exact same dimensions as the element you just copied. Notice how the new file is sitting in its own tab next to your original image. Hit Ctrl+Tab to switch back and forth between the two images.

We will resize the image now as it is far too small for the next step of the painting. In the menu, select Image > Resize > Image Size.

Here, check the Resample Image checkbox. Change the Resolution to 300 (300 is for print resolution; 72 is for screen purposes) and for the Pixel Dimensions Width, enter 2500.

Step 21
Changing the canvas size
Before we add colors, let's quickly crop the canvas so that the format fits our content better. One way to do this is by selecting Image > Resize > Canvas Size to enter exact pixel values. Alternatively, we can do it freehand using the Crop tool. We will go with the freehand option. From the toolbar on the left, select the Crop tool (located in the Modify section), drag a rectangle for the new format and hit Enter – the image is now cropped to the new format. Next, quickly clean up the border areas with a few brushstrokes.

Step 22
Using textures for basic colors
This step has a chaotic feeling to it, but it will lead to cool results! In the Organizer section, open some reference images showing foliage. Select one and click the Editor icon – the image will open in a new tab in the Editor. Now grab the Lasso tool (L) and draw a selection around a nice texture area. Copy (Ctrl+C) and paste (Ctrl+V) in your sketch. Now you have two layers: your grayscale sketch and the new layer with the texture on top.

▲ Once the Editor icon is clicked, the selected image will open in the Editor

Select the texture layer and switch the Layer Mode from Normal to Overlay. See what happens? Now repeat these steps with more textures.

Step 23
Refining the chaos

Our image is a mess: we've got photos overlapping our design, green bushes in the sky, and hard edges from where we cut with the Lasso. So let's refine this…

With a soft Eraser, remove the hard edges and all texture parts that make no sense – just keep the good bits. Create a new layer at the top (set the Layer mode to Color). Color pick (shortcut key: I) directly from your image, or decide on a nice color by opening the color picker from the toolbar. In your Color mode layer, start painting. The layers beneath will appear in the new color.

Step 24
Painting on the overall image

Hopefully your image is nicely colored and alive now, with some promising spots here and there.

If a layer has become too dark or saturated, use Ctrl+U to fine-tune the hue and saturation. Next, merge all the layers (Layer menu > Flatten Image), or keep this version with all the layers and continue the work on a new file. Hit Ctrl+A to select all, then copy merge (Ctrl+Shift+C), and create a new document (File > New >

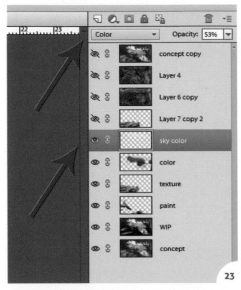

▲ Painting on layers with different layer modes – the layer modes are an endless source of fun!

> **❝Let's isolate our planes. We need a foreground, mid-ground (a valley and mountains) and a background (the sky)❞**

Image from Clipboard). Grab a basic pressure-sensitive brush and paint right over the textures to refine (or push back) certain structures.

Step 25
Preparing the planes

As you can see, not much of the abstract wilderness has survived the repaint and everything is still missing the details. The

▲ Take inspiration from the textures – but use your brushes to rigorously paint the image as you see it

▲ All areas of the image have been refined further. Things are much clearer now!

areas have been kept rather clean, but we will have another round of texturing soon.

First, let's isolate our planes. We need a foreground, mid-ground (a valley and mountains) and a background (the sky). Choose the Selection brush (shortcut: A), which allows you to paint your selection. Either subtract or add to the selection via the Tool Options panel below.

Step 26
Painting and texturing the foreground
Select the foreground (including the area with the figure). Now copy the active selection of your foreground by hitting Ctrl+C, then hit Ctrl+V. This selection will be pasted into a new layer on top of your first layer. Rename it: 'Foreground'.

Now let's talk about the magic of the foreground plane. The foreground is closest to the viewer, so we'll put some overlapping structures there on purpose (here I have chosen trees and liana vines, from left to right). This kind of thing helps to emotionally engage our viewer. The viewer interacts with the image and will hopefully become curious about the things they can only glimpse at.

Repeat the steps for the mid-ground and sky. Ensure that you keep the foreground the topmost layer, though.

Step 27
Painting and texturing the mid-ground
When selecting the mid-ground, just keep an eye on the horizon line and mountains. To simplify things, we keep the number of layers at three, though there is no real limit – you can divide your image further, stacking rows of hills on layers as you see fit.

Select a texture featuring treetops in a jungle valley and copy and paste it onto a layer above. Carefully fine-tune the detail with the techniques mentioned in the previous steps.

To get the fog effect shown in image 27, I cut out parts of the valley and paint the white mist on a new layer just beneath it.

26

▲ The foreground layer as it looks without the mid-ground and characters

27

▲ Notice the mismatch of the horizon values in the mid-ground – this will be adjusted in the next step

Step 28
Painting the sky

Our sky lies beneath all of the layers. Let's have some dramatic clouds with sunlight streaming in from the left. Use a soft gradient as a basis and keep it lighter towards the horizon.

If you need to alter the value of the mid-ground hills for a better fitting with the sky value, use the Clipping mask. To do this, create a new layer directly on top of the mid-ground layer, hit Ctrl+G and your new layer will be clipped to the one beneath it. Now paint your alterations on it and they will be neatly cut to the area of the mid-ground.

Step 29
Refining the image

You might still have lots of areas where the photo textures and sharp outlines are too dominant. Check out these lovely tools to help you get better results – don't overuse them, though. The one that looks like a finger is the Smudge tool (R). The Clone Stamp (S) allows you to clone and stamp parts of your image elsewhere in the scene. To use the Clone Stamp tool, hit Alt and click to define the source point for the cloning, then you can stamp away. The source area will be stamped to the new area.

You could also change the brush tip for each of these tools if you wanted to create a variety of different painterly effects.

▲ The mountain has been repainted and textured, and the horizon line fits much better now

Step 30
The final image

Now you could either flatten the painting or keep the layers for easy editing later (which is useful in case a client wants to request any last-minute changes).

Let's do the final check: All textures have been integrated seamlessly into the illustration in a painterly style – the result looks mostly homogeneous, which is really important. We also have a sense of depth in the image. The viewer is led into the image towards the center of interest, which now features a shaman girl. And that's everything!

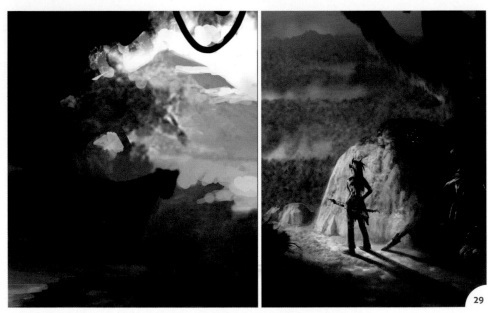

▲ Having two centers of interest is a bit too much for the viewer, so the jaguar is removed

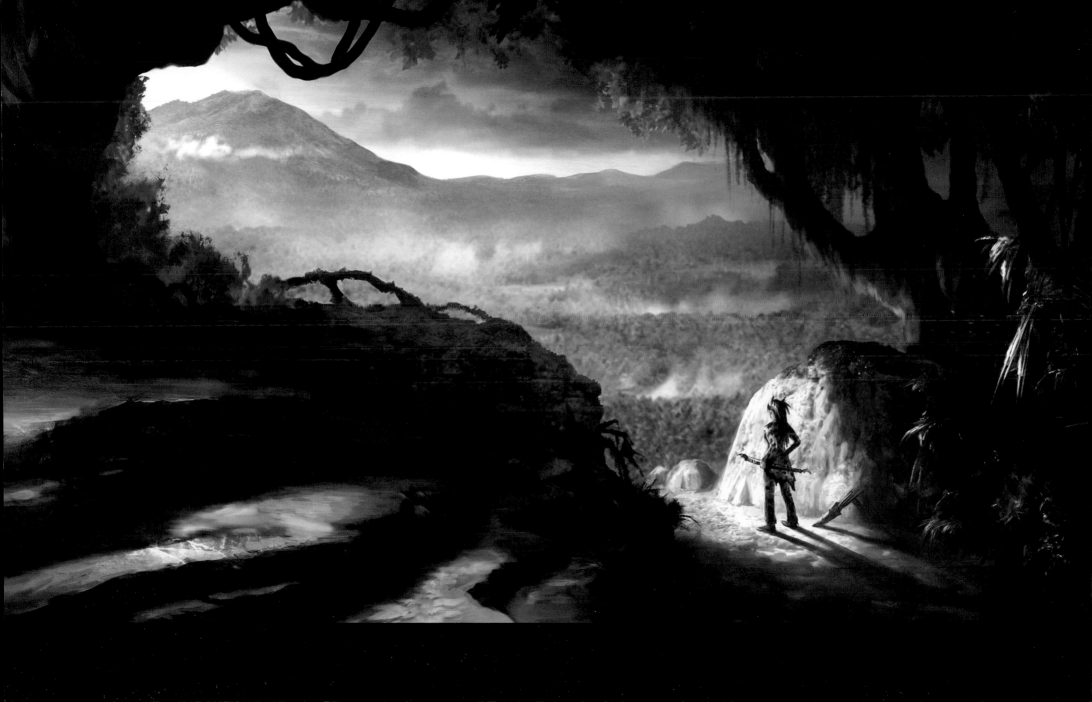

Quick tips

Discover how to refine the detail in an image using these quick texture tips

After learning the basic tools, honing your understanding of basic art theory, and establishing your style, all that's left is to refine the details in your image.

Refining the texture and detail in a scene is crucial for creating a high-quality image. As a beginner artist, it's always useful to practice your ability to create convincing textures, as without this skill, a scene can simply look unfinished.

To help you develop your skill in texturing, this section provides tips on creating a wide range of common textures that you'll likely need to reproduce at some time in your artistic career.

Starting with natural landscape elements, such as clouds and trees, and working through to fabrics, skin and feathers, this is a fantastic resource for artists to refer to when adding texture detail to artwork.

Cloud
by José Gómez

Step 1
Setting up

In your Default Brush menu, choose Pen Pressure, select a brush with a fluffy texture and apply a base color to the background.

The best way to start is by making a sketch – nothing complicated. You must draw at least a basic idea for your piece. The image here is a clear example of a simple sketch that I would use to begin the process.

Step 2
Silhouette, color and shadow

Create a silhouette of the cloud shapes using white on top of a blue base, then add shadows under the cloud. Use your sketch as a reference.

Apply these strokes with brush Opacity at 100%, and then lower it to 45-50% as you progress. This will help you match the colors and slowly build them up; with each stroke you add, the color darkens.

You can use a darker blue tone to create the shadows. Remember to keep in mind the single source of light (in this case, the light comes from the sun above).

Step 3
Highlights

In a new layer, add some white areas to indicate the highlights. The shadows and darker areas of the cloud should remain as a plain matte color. When adding highlights, change the brush size to add texture. Slide the brush from the bottom up in a U-shape to create movement.

Step 4
Refining the forms

In a new layer in Multiply mode, take a shade of blue from the sky and apply it over the cloud, paying attention to areas where the sun does not reach directly, like the sides and underside.

After merging all the layers, use the Eraser (E) to clean the excess areas, and then again, using the white brush, you can apply new, more refined forms on the final cloud.

Step 5
Final touches

By selecting Alt with the brush you can copy the tones you want, apply more colors to the whole scene and create volumes with various shades of blue.

To finish off, we can duplicate the cloud layer (Ctrl+J) and use the Multiply mode with less than 30-percent opacity to create a higher contrast.

For an even better contrast, select the background layer and apply a Gradient (G) that creates a light blue at the bottom of the image and moves to a dark blue at the top. This will highlight and define your clouds.

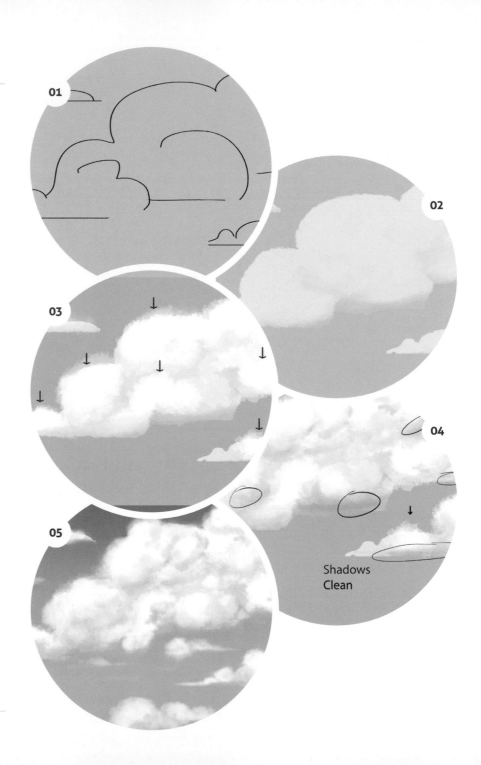

Storm clouds

by Abe Taraky

Step 1
Choosing a brush

When painting clouds, choose a brush with a texture that conveys large and loose strokes.

Use reference photos of clouds to understand the different shapes a storm cloud would make and what color scheme would best create the dark and ominous mood of a storm. Use these photo references and various brushes to help your painting reflect reality.

Step 2
Creating atmosphere

To create an atmosphere for the clouds, pick two or three color shades and make large, broad strokes with your brush set at a lower opacity. Then raise the brush's Opacity level to a full 100%, and select a darker, more saturated color to paint a general silhouette of the clouds.

Storm clouds are generally dark, with rounded shapes that recede into elongated and slender shapes as they trail further away towards the horizon.

Step 3
Highlights

Decide on the direction of your light source: where it originates and where it travels to. Paint the light in a single direction, to show that it is peeking out from behind the clouds.

Use the Dodge tool at 100% and paint certain edges of the clouds to highlight them. Try to resist painting clean or straight edges, but rather make light strokes on selected portions of the clouds.

Step 4
Dark shadows

Boost the volume of the clouds by adding shadows: color-pick the darkest portion of the clouds with the Color Picker tool and adjust it to be even darker, and less saturated. Brush the shadows along the spots that are closest to the light source. To further darken the shadows, use the Burn tool at 50%.

Step 5
Lightning

The lightning is the brightest light source in a mass of dark storm clouds. While your clouds are all painted in one layer, create a new layer for the lightning. Make sure to gauge the distance of the lightning and how it would fit in the composition.

Next, draw thin, jagged lines from between the cracks of dark clouds. Go to the Layers menu, and underneath Layer Style, select Style Settings. To add an outer glow, select white from the Color Picker and adjust the size and distance of the effect to best resemble your photo reference.

The ocean

by Kamil Murzyn

Step 1

Painting the background

First, start by selecting the bottom half of the canvas with the Rectangular Marquee tool (M) and fill it with an appropriate water color – this will be our ocean.

Create a new layer underneath and paint some sky over the upper half. You can use gradients to set up sky colors quickly, and then – on a new layer – paint clouds using a Chalk brush.

Step 2

Making waves

A perfectly flat water surface would act more like a mirror and so possess colors that show whatever the surface is reflecting, while a wavier ocean has a more natural water color.

To begin adding waves, first create a new layer and pick the base water color you filled your lower image with. You can now shift the hue, saturation and color values a little (in the Color Picker window) and draw horizontal lines on the surface of the water. Holding Shift while drawing the lines makes them perfectly straight. To create depth, remember to draw thinner lines further away from the viewer.

You can also make more opaque marks and add a little variation over the surface of the water. Repeat this process a few times with slightly different colors.

Now let's play a little with blending modes – you can find these just above the layers list. Try different modes to see what effects you can achieve with different settings.

We can also smooth the created texture a little using the Motion Blur filter (Filter > Blur) using a vertical angle and high blur amount. This trick will stretch the painted strokes along the water.

Step 3

Breaking waves

The next step is to add breaking waves. You can start by painting any shadowed areas with Chalk brushes. Use a darker, more saturated blue – be sure to set the pen sensitivity to an appropriate size in the Tablet settings menu.

Step 4

Adding highlights

Now we can try to re-create the bumps on the surface of the ocean, where the waves rise and break. First, change the color to a lighter, less saturated color hue – much like the color of the sky – and then paint in your highlights. Where the wave break is a little higher, paint in more foam.

Step 5

Final touches

For the final touches, I darken the water closest to the viewer, paint a distant ship and some birds in the sky, and add a soft sun glow.

Fog

by Bram 'Boco' Sels

Step 1
Reference image

I tend to use a lot of fog in my paintings because it's a quick and easy way to create depth and atmosphere in a scene.

Keeping in mind that I want to create a brush, I browse through my reference folder and look for an image with some isolated clouds. For this quick tip I create a brush out of a picture I took while I was on vacation in France.

Step 2
Isolating textures

Once you find a similar image, open it up in Photoshop Elements, go to Expert Mode and use the Lasso tool to loosely select the cloud you want to make a brush of.

Right-click on the selection and use Feather (about 20 pixels should do the trick) to blur out the edges of the selection. Copy the selection using Ctrl+C, and choose File > New > Image From Clipboard.

Step 3
Preparing the image

What Photoshop Elements does when you define a new brush is check your image for the information that isn't pure white, remembers that and stores it as a brush, so you are able to use it later on other images. Imagine it as a cut-out potato stamp.

You will remove everything that is white on the 'stamp' and only print what is darker, so we want a desaturated cloud (Enhance > Convert To Black And White) with lots of pure white surrounding it.

That's the tricky part because the background is in fact darker than the cloud itself. So instead we'll try to make the background as dark as possible and then invert the image. To do that, add a Levels adjustment layer (above in the Layer menu) and move the sliders so that the background is entirely blacked-out but the cloud itself remains intact.

Step 4
Inverting values

Now invert the image by adding an Invert adjustment layer, which flips the values around. Your cloud might look a bit weird now because it's not as white and fluffy as it was before, but keep in mind that this is just the 'potato stamp'.

Step 5
Finishing the brush

Now choose Edit > Define Brush, and voilà! When you next select the Brush tool you'll find your very own cloud brush at the bottom of the brushes library.

Rock
by Cyril Tahmassebi

Step 1
Setting up
Before you create your texture, go to Expert Mode at the top of the interface in Photoshop Elements. This allows you to have full use of all the tools available in this software, and it's very important for you to have control over aspects like layers, filters and so on in your work. The more tools you have, the better you can create.

So to start my rock texture, I begin with a simple photograph that gives me enough flexibility to customize my very own texture.

Step 2
Color Balance
When you use photos from your library, sometimes you'll find you have big differences between the color and light in your photograph and the effect you want to create. It's important to unify different elements, such as shadow, mid-tones and highlights in your photos when creating textures for painting.

To do this, I use the Color Balance and Brightness/Contrast tools for optimal colorization and integration of my texture (in the top menu: Enhance > Adjust lighting > Brightness/Contrast). In this image, I use the brightness and contrast functions to create a more appropriate tone for the texture. I then use Color Balance to push my customization even further.

Step 3
Painting in textures
I use a Soft Round brush with a low Opacity to begin painting in adjustments. After working the texture with a few brushstrokes, I then decide to put another texture in the corner of the image to accentuate the noise and continue painting the textures.

Step 4
Reassessing adjustments
Feel free to keep referring to your Brightness/Contrast levels throughout the creation of your image. Choose levels that you think are necessary for your texture and the future integration of your painting.

You can also play with the tones (shadows, mid-tones and highlights) and adjust them to your liking. In this image, I apply Curves to accentuate the contrast and deepen the shadows (Enhance > Adjust Color > Adjust Color Curves).

Step 5
Final touches
For the finishing touches, I use the Sharpen tool to define and sharpen up my final image.

Grass

by José Gómez

Step 1
Starting out

We're going to create a grass effect by combining different Brush options. First find the Wet Media brushes in the Brush panel; use brush #5, add base colors and use the Lighting tool (O). Then set your brush to the following:

• Hue Jitter: 19%
• Scatter: 61%
• Spacing: 19%
• Brush size: 23% to 30%

After modifying the brush, create a surface using light and dark shades of green on your background. Try to leave areas of land visible to make the ground look more realistic – this is important no matter what style you work in.

Step 2
Creating density

After you have done the lawn, duplicate the layer (Ctrl+J) to obtain a more uniform green. If you still have a highly charged green scene, simply use the Eraser with the same brush texture and lower opacity, and erase parts to downgrade your color density.

Step 3
Varying foliage

Add a new layer and draw a different type of vegetation over the green base. This will be the taller area of vegetation, so you can fashion

the strands almost as bushes. Use the Eraser and create patches in the surface, creating a view through the leaves to the bottom layer.

Step 4
Creating grass strands

Head to the default Brush panel and pick one of the first brushes to create grass strands. Try using a lighter shade than the base grass, so the grass strand is highlighted above the surface. With the Eraser on low opacity, erase the stark horizon line so it blends better with the ground. Now use the Lighting tool to illuminate (O) and apply light to some of the leaves/strands. The light should touch the top surface of each strand.

You will now need to create a new layer below the vegetation layer. Select the grass-shaped brush and change the Hue Jitter to 0%, then draw several sheets over your image and duplicate the layer for a slightly stronger color.

Step 5
Finishing touches

Finally, use a brush to clean up and erase areas to your taste, then duplicate the same layer and set the layer to Overlay with an Opacity setting of 20%. This will add extra strength to the color, highlights and shadows.

If you like, you can add a gradient to the background environment, or some extra detail like trees or clouds in the sky.

01

02

03

04

05

Trees
by Nikola Stoyanov

Step 1
Tree skeletons

A very inspirational and alien-looking place is the Namibian desert, with its black, dried tree skeletons and saturated orange dunes. After browsing through a lot of internet references, I feel confident enough to lay down a sketch and decide on my composition for the entire scene.

I usually position any important elements following the rule of the thirds, and also draw attention to them by pointing towards them with different elements – for example, prominent branches on the tree.

Step 2
Managing layers

Layer management is important for editing a composition. Because of the lack of groups in Photoshop Elements, you can separate your main elements by creating a blank layer, painting it in a single color (so you can spot it easily on a thumbnail) and giving it a proper 'group' name.

After that you can link all the layers that are supposed to be in this 'group' by clicking the link icon of every layer and they will move together as one. This (and also keeping your key elements in the foreground, middleground and background separated) will help you organize and therefore adapt and refine your composition easily.

So to start creating a tree, I define the tree silhouette in the foreground. I use the Charcoal brush from the Natural Brushes set, because of its many bristles (they help to define a convincing bark structure). I also choose a Hard Round brush from the default brushes set as an Eraser – erasing helps define smaller branches and any tree imperfections.

Step 3
Background silhouettes

On a separate layer in the background, I paint several tree silhouettes to give a sense of scale and depth to the image.

Step 4
Refining detail

I switch back to the tree in the foreground and define a more polished bark structure with the help of a custom brush called 'Aufgenommener Pinsel 1 1', created by Sergey Kolesov (**http://pelengart.blogspot.co.uk**). I also paint the roots and some reflected light onto the tree, to help it blend into the scene.

Step 5
Fitting the scene

I try not to define the tree very much, because it is more of a supporting element in my painting and I don't want to draw much attention to it.

Vines
by Juhani Jokinen

Step 1
Custom brushes
In the following steps we will create jungle vines in Photoshop Elements. You can use the excellent default brushes included in Photoshop Elements to create the vines, but for the purposes of this tutorial, I will be using my own custom brushes.

It's important to experiment with any available brushes and their settings to get a grasp of how they work. It's also useful to turn on the Opacity in the Tablet settings menu.

Step 2
Base color
The best way to start is to get rid of the white of the canvas by applying a base color. When this is filled in, you can roughly sketch in the basic shapes of your vines. Nothing complicated, just a simple arrangement of shapes. The details will come later. You can also select the shapes and use a textured brush to add a little bit of variety inside the silhouette of the vine.

Step 3
Leaf detail
Next I use a leaf-shaped brush to start adding some detail to the vines. It's easier if you look at references of how real vines work at this point. A certain amount of randomness is key in selling natural elements to the viewer.

I also add smaller vines among the bigger shapes to add detail and interest. After I'm satisfied with the general shapes, I use the same selection technique as in the previous step to add texture and lighting to the vines.

Step 4
Lighting
Now it's time to start adding some lighting and highlights to the vines. I choose a simple Chalk brush and go over the vines, adding lighter values here and there to make the shapes read better. It's also important to choose and stick to one direction of light on your image.

Step 5
Refining the light
For the finishing touches, I create a Color Dodge layer, and with a soft brush and dark-brown color, paint in areas of light on the vines. Make sure to erase the light from the shadowed side of the vines, otherwise your vines can end up looking too flat.

When I finish the lighting, I refine the shapes of the vines using a layer mask and painting in with black.

Dirt
by Lindsey Wakefield

Step 1
Base color

Dirt is pretty easy to paint once you get the hang of it. The only rules I stick to for making dirt textures are: keep the colors fairly desaturated, make it gritty, and always make it sit below your feet.

With that in mind, I start by making a new blank file by going to File > New > Blank File and make the dimensions 1000 x 1000 pixels. This will be copied over to my painting and essentially is going to be my own ground texture.

Now I take a very large Chalk brush with a mid-toned brown and start covering the white canvas thoroughly. The largeness of the brush helps cover areas quickly, and is already giving the ground a blotchy, gritty texture.

Step 2
Adding shadow

Now with a smaller version of the Chalk brush with the Opacity set to 30%, use a darker color than your base to begin creating shadow on your ground.

In a stormy and cloudy scene there is going to be very little contrast, and with that in mind, I start painting the shadows.

When painting shadows, think about what makes up the ground. There is always a lot

of dirt, but there is also a lot of rock, hills, holes and so on. Adding those kinds of details gives more realism to the piece.

Step 3
Using the texture

With my texture in hand, I copy and paste it into the painting I am creating. Using the Transform tool (Ctrl+T, or Image > Transform > Free Transform) I can transform my dirt to the size I want it to be in my new image.

Holding the Ctrl key while transforming enables you to freely transform, and allows more versatility when it comes to perspective.

Step 4
Placing the texture

I can now move the texture in the image. Be sure to have an idea of your horizon line, and aim towards your vanishing point. It doesn't have to be perfect; it just has to look right.

Step 5
Blending

Finally, I gradually erase and add parts to the texture in the image in order for it to look natural and blend more successfully with my painting.

01

02

03

04

05

Lava
by Cyril Tahmassebi

Step 1
Overlay and Lighten

Layers are a great way to experiment with different tools in Photoshop Elements. You have a sort of large digital laboratory with which to practice and apply different effects to create different textures. You can use layer modes on brushes, or images that you import from your library – or any number of combinations of these tools to really perfect your effects.

There are several modes for your layers in Photoshop Elements, but the layer modes that I use often are the Overlay and Lighten blending modes. I apply light to the parts of my images I wish to accentuate or revive colors on, while trying to moderate the intensity.

You can also embed textures in your image, which can give you new lights and color variations. Feel free to experiment and use any of the layer types Photoshop Elements offers – they can create a lot of interesting effects.

For the first step in creating lava, I choose an image with grain and some carvings, and then I start to superimpose another texture on my image. I take care to erase the parts that I don't want to feature in my image, or that don't work as a whole, and play around with the opacity of the layers to find combinations that create interesting effects.

Step 2
Painting in the lava

I then begin to paint fresh textures onto the photo texture and customize it to make the lava effect. I use a combination of various images with Lighten and Overlay layer modes to try and find some interesting combinations.

Step 3
Using filters

I take the time to play with different tools that Photoshop Elements offers, such as Curves and Color Balance, which give me the opportunity to play around with some ideas. I change my color tones to something hotter, and I balance the image out with blue shadows to keep a sense of realism.

Step 4
More adjustments

I continue with this same process, painting the texture and playing with different filters. I still play with the layer modes like Lighten and Overlay to apply highlights to the lava.

Step 5
Finishing touches

The texture is well advanced now, so I make the final adjustments to the saturation and tone using the Hue/Saturation tools. Once I am satisfied with the whole image, I reinforce my texture by applying a Sharpen filter.

Dry earth
by Cyril Tahmassebi

Step 1
Reference image

To begin creating a dry, cracked earth texture, I first choose an appropriate reference photo to use from my library of images.

I then choose a Charcoal brush with the same tonality as the main hues in the image; this adds a great noise texture which simulates the ground nicely. I then begin to paint over certain areas with the Charcoal brush and mask out parts of the image to find an interesting composition.

Step 2
Hue and saturation

Adjusting the Curves and Saturation levels helps control the color and light areas in the image. So when I think I can push my image further, I use the shortcut Ctrl+U to access the Hue/Saturation window.

In this window, you should see different options, such as Hue, Saturation and Light. These options are very useful when integrating the new paintings and patched photographs to my texture, creating an overall uniform texture.

Step 3
More texturing

After adjusting the Hue and Saturation levels, I continue to paint and add sections of images to my texture. For this, I use a Soft Round brush on the image to create a sense of unity.

Step 4
Curves

I then begin to play with the Curves tool on my texture. You can find this tool directly on the filter on the top menu bar.

This process is very cool as you are able to control your tones and push your color and contrast a lot further. In my image, I am able to accentuate the entire texture by adjusting the curves alone.

Step 5
Finishing touches

I then add the finishing touches to the texture by using the Sharpen filter to sharpen the detail in the image. And it's done!

Mountains

by Juhani Jokinen

Step 1
Brushes

In this quick tip, we will create mountains using Photoshop Elements. This software has a great range of default brushes to use, but in this case I have used my own set of custom brushes to create the image.

Be sure to experiment with default and custom brushes and their settings in this software to understand how they work. It's also useful to turn on Opacity in the Tablet settings menu before you start the painting.

Step 2
Shaping the mountains

The first step is to define the basic shapes of your mountains. I quickly paint in a simple background and go over it with the basic Chalk brush to create the shape of my mountain range.

Pay close attention to the silhouette and edges of your shapes. The key to nice mountains is slight exaggeration and natural asymmetry.

Step 3
Lighting

Now that I have my general shapes set up, I can start defining the 3D shape of the mountains.

The key here is choosing your light direction and sticking to it. In this case, the light comes in from the top left hits the higher mountain on its left side, and casts a shadow on the smaller mountain.

The best way to render this is to select the shape you created in the previous step and go over the shapes with large brushes. It's useful to study reference images of real mountains to get a grasp of the general shapes that work well.

Step 4
Color Dodge

I continue refining the shape and details of the mountains using basic brushes.

In this step, I also use a Color Dodge layer to begin taking the lighting a bit further. You can use a Color Dodge layer by creating a normal layer and setting the blending mode to Color Dodge. When creating lighting effects like this it's usually best to use dark colors with medium saturation.

Step 5
Final touches

For the finishing touches, I intensify the lighting with more Overlay and Color Dodge layers. I also clean up the contour of the mountains and paint in some atmospheric haze to suggest distance. You can easily do this by painting in light colors with big soft airbrushes with low opacity.

Sunlight
by José Gómez

Step 1
Creating the base

Here, we will cover how to create a sunlight effect in a natural environment. First, locate the Brush tool, and in the Brush panel set the Pen Pressure to One Texture. Locate the Lighting Tool (Ctrl+O) for later, and add a blue sky base.

Find a soft brush with a size of 2100 pixels, and apply it to the image. In researching references of the midday sun, you will see a strong light in the center and a softer line around the edge.

Step 2
Recreating the rays

Create a cross shape then go to the top panel and select the Filter button. Select the Blur > Gaussian Blur function. Now modify the pixels to the right, to set the light (80% is almost perfect for the effect we want here).

After this, copy the layer (Ctrl+J) and with Ctrl+T, rotate the picture and create a perfect new cross diagonally over the original one. This will give the impression of light rays. Finally, set it to Overlay layer mode.

Step 3
Sun reflections

In a new layer, with a large Hard Round brush with Opacity set at 50%, draw two circles. These lens flares make the sunlight effect seem real. Take the sun and lights layer, make them

smaller (Ctrl+T) and move them up higher in the scene. You can also now add some landscape to the lower part of the image.

Go to Options and select a textured brush in the Pen Pressure panel. Set your Hue Jitter brush settings to 40% – this combines the two colors you have in the right-hand palette. Then choose a light and dark shade of the same green color and create your vegetation (with light and shadow). Now create a layer above the sun layer and make the longest leaves with a Normal brush – the leaves nearer the sun are darker because of the light they receive.

Step 4
Highlights

Now you can add highlights to your vegetation. Make a layer below all previous layers and with a lighter shade of green, lighten the leaves around the top of each strand. Then with the Light option (Ctrl+O) give a touch of shimmer where the light hits directly.

Step 5
Shadows

In a new layer in Multiply mode, use a mid-green tone and create the corresponding shadows on the floor. If the shadows are too dark, lower the layer opacity. The areas closest to the viewer should be darker.

Moonlight

by Bram 'Boco' Sels

Step 1
The reference image

To create moonlight, I took a picture of a sheet of iron that was standing outside my apartment. I was mainly interested in the unusual texture of the surface and how some of the spots almost resembled the craters in the moon. Anything can be used as a texture, but this rusted iron material was perfect for me.

Step 2
Adding texture to a scene

In Photoshop Elements, select the Elliptical Marquee tool (you can change the Rectangular Marquee into the Elliptical Marquee tool in the options along the bottom palette).

Select a circle in the photograph that isn't too big but has enough detail to be interesting. Then right-click on it and use a 5-pixel feather to soften the edges a bit.

Finally, copy your selection and create a new image. Give your new canvas a dark-blue background and paste the moon on top.

Step 3
Creating a glow

Now create a new layer above this layer and set its blending mode to Color Dodge. Use a Soft Round brush with the same blue color as the background to paint the glow on top of it. You can see the effect in image 03.

Step 4
Refining the glow

Repeat that process once more to create another layer of light so that the glow gets more intense the nearer the center of the moon it is. Don't overdo it, though. Color Dodge can quickly blow up your values and destroy the sense of realistic soft moonlight here, so use it sparingly.

Step 5
Stars and clouds

Using the same technique, it's easy to add a spattering of stars dotted around the moon to liven up your image of the night.

The same goes for clouds that move back and forth in front of the moon. It's that sort of subtle detailing that makes an image a lot more interesting to look at.

> **Color Dodge can quickly blow up your values and destroy the sense of realistic soft moonlight here, so use it sparingly**

01
02
03
04
05

Dusk/Dawn

by Kamil Murzyn

Step 1

Starting out

Here I want to show you how to quickly paint dusk or dawn. If you look at any photograph, you can see that the core factors for creating the right mood are color and the softness of light and haze. The difference between dusk and dawn is very subtle. I would say dusk has a more red or magenta hue, while dawn scenes have more haze and fog coming from the dew after a cold night. Photo references will be your best friend when deciding these attributes.

The main tools I use to achieve a good look are as follows: the Gradient tool, some chunky hard-edged brushes for the landscape on the horizon, fluffy brushes to create clouds, and a simple soft brush.

Each of the following steps should be painted on a new layer (Crtl+Shift+N). So let's start with creating a simple, lightly saturated gradient moving from warm to cold. You can find the necessary tools on the left bar under Draw > Gradient Tool, or by pressing G and clicking the Edit button on the bottom toolbar. After the setup, click OK and draw a vertical gradient with the mouse.

Step 2

Painting clouds

The next step is painting some clouds using a soft, fluffy brush. When doing this, try to pick

colors that are created with the gradient using the Color Picker (shortcut: E). You should paint the clouds lower in the image, and the colors closer to the horizon should be more saturated.

Step 3

Painting in the landscape

Now let's paint the landscape. Pick the bottom color of your gradient and make it much darker (but not black).

Using a hard-edged brush with Pen Pressure set to Opacity (you can find those options under Draw > Brush tool, under Brush settings and Tablet settings), paint some shapes that inspire a sense of depth.

Step 4

Adding the sun

Now add some more detail to the clouds, and give them greater saturation and definition. You can also add some highlights around the edges to give the impression that they are illuminated by the sun. Finally, using a large, soft brush, add some really big dots to create the sun and haze effect.

Step 5

Final touches

For those final touches, you can tweak the colors using an Adjustment Layer (top panel > Layer > New Adjustment Layer) and add some contours to the clouds with a soft brush.

Shadow

by Sara Biddle

Step 1
Shadow and light

When painting shadows, successful execution is not so much about the application technique or having the 'right' brushes, as it is the idea and portrayal of the shadow itself.

Shadows always follow an appropriate pattern opposite to the light source. So, in order to determine where the shadows will fall, we must first have the chosen direction for the light source in mind.

The intensity of the light source will also affect the shadow – overcast or diffused lighting creates soft, delicate shadows. Bright, intense lighting creates dramatic, sharp shadows. These rules apply to all objects, but in this case we'll demonstrate using the skin.

Fill the skin area with a flat base color and apply darker shadow tones that oppose the light source, such as around the eyes, under the nose, near the cheekbones and lips. The entire neck area is escaping the light as well, but the shoulders are revealed.

Step 2
Color

Colors can be applied with your favorite brush. Here, I've used a round brush with Opacity set to Pen Pressure in the Tablet settings, to better control the blending.

Step 3
Highlights

Highlights are the opposite of shadow, so really emphasize the highlights in your scene to make the shadows 'pop'.

Shadows are also generally saturated, so take the opportunity to make them stand out and give life to the rest of the skin.

Step 4
Defining shadow

Where a shadow is cast on the skin from another object, such as the nose, the shadow will appear to have sharp edges. The form shadows, such as the cheekbones, are much softer. Shadowed areas, perhaps on the neck, can be better seen because of the light that bounces from the body being reflected back onto the skin, also creating soft edges.

Try to observe this happening in life and understand the cause and different effects it creates. Playing with little details such as these in your work can create a much more realistic effect.

Step 5
Final adjustments

If your shadows seem a little flat or unspectacular, very gently use the Burn tool with the Range setting set to Shadows over the shadowed areas, for a little extra kick.

Space and stars
by Sara Biddle

Step 1
Setting the background

When we look up at the night sky, there are many, many stars, all of different sizes and grades of scintillation; some stars look distant and some closer to us. It's this logic that we'll follow to imitate the night's beauty.

We'll just need two brushes to make up our starry night sky: a standard, soft-edged round brush preset, and a custom-made star brush made up of small dots of different sizes and opacities (you can find downloadable custom brushes online or simply create your own). This way, we won't have to do it all by hand – though it can certainly be done that way, too.

Start by filling the background with a dark blue (almost black) using the Paint Bucket tool. Grab a round brush in an even darker blue or black and make some areas slightly darker for variation in color, keeping the transition of color very soft and flowing.

Step 2
Adding stars

Once happy with the background, you can use a custom-made star brush in a light color to gently paint in a sparse layer of stars. (You can use the techniques learned in this book to create new and interesting custom brushes.) Keep it interesting with areas of dense coverage, leaving other areas almost empty.

Step 3
Creating depth

Next, use Filter > Blur > Gaussian Blur with a Radius just high enough to make the stars look slightly out of focus. Cover over some of the stars with the background color using a round brush in a large size, enhancing those nicely prepared areas of clusters and emptiness we've already started on.

Finally, use the custom star brush once more with a bright color to make some new stars – perhaps even bigger than before. This random layout and placement of the stars creates a more realistic impression.

Step 4
Color variation

Now we can add in some color variation. First, select a round brush and lower the Opacity to barely visible. Pick vibrant-yet-dark saturated hues in pinks, purples and blues and lightly brush over sections of the sky.

Step 5
Levels adjustment

To finish, use a Levels adjustment (Ctrl+L) to enhance the highlights and shadows, moving the black and white sliders toward the center. Use your own judgment here to decide what looks good. For extra sparkle, you can add in some finishing touches by hand with a standard brush.

Distant birds

by Juhani Jokinen

Step 1
Brushes

In this tip, we will discuss painting a flock of birds in Photoshop Elements. I have used my own custom brushes to create this example, but the default brushes in Photoshop Elements work just as well. Make sure to experiment with the brushes and their settings to get a grasp of how they all work.

It's also useful to turn on the Opacity setting in the Tablet settings menu before you start.

Step 2
Outlines

First I sketch the outlines of a few birds that I'm going to paint. I use a simple round brush with the Opacity setting turned on. I try to vary the shapes of the birds as much as I can to avoid repetition.

Make sure to keep an eye on reference images of birds during the painting process. It's always beneficial to have good reference images handy when painting – especially if the subject is new to you.

Step 3
Blocking in

Next, I quickly fill in the silhouettes of my birds and start planning the shadows. I use a simple Chalk brush for this part of the process.

Step 4
Shadows

Now it's time to start blocking in the shadow shapes that will define the birds. Keep an eye on the direction of the light to make sure it stays consistent.

I try to make the birds appear as three-dimensional as possible. It's a common mistake to paint birds as flat shapes against the sky.

Step 5
Highlights

In the final step, I work on the smallest details and put in my lightest values. I always like to start from the mid tones then paint in the shadows and save the lightest values for last.

The very last step is to go in with a small round brush and paint in the smallest details. One useful trick you can use to try to add a bit of contrast at the end of the process is to duplicate the layer with the birds and set it to Multiply. Then lower the Opacity of that layer to something around 50% for the best results.

Rain
by Kamil Murzyn

Step 1
Setting the scene
For this quick tip, I will show you how to add rain to a painted scene. To achieve a good result all you need is a simple brush and a few adjustments to the layer modes and filters.

Start with a Soft Round brush and add some base colors to indicate the sky and forest. After that, add some contrast and darken the bottom of the forest using a Gradient on a new layer set to Multiply. Using Hue/Saturation (Ctrl+U), add more saturation towards the bottom of the scene.

Step 2
Refining the background
Using the Color Picker, I choose a color from the scene and, after selecting a simple Chalk brush, I begin to roughly sketch out some trees.

I spend more time on the forms at the front right now, so they appear more detailed. Eventually, I add some terrain.

Step 3
Adjusting the tone
With Layer > New Adjustment Layer > Hue/Saturation, you can lower the saturation and tone of the whole picture to create a more convincing rainy weather mood. Using a soft brush with a very low opacity allows me to add fog over distant parts of forest.

Step 4
Creating depth
Create a new layer and, using simple soft brush, draw many vertical lines. Don't worry about the color, as we will shortly set this with options in the Hue/Saturation panel. Pick Filter > Blur > Motion Blur and stretch the painted lines a bit, creating the illusion of motion.

Duplicate this layer a few times, select one of them and press Ctrl+T, or go to Image > Transform > Free Transform. You can now make a smaller version, flip it, and rotate it. This way you can create several rain layers that give the impression of distance (which should contain smaller raindrops), for the middleground and foreground.

Now, with the Hue/Saturation tool, set the value of each layer. Don't stick to very bright colors only; make some of them a darker gray to create a more believable effect.

Step 5
Adding overlays
Change the rain layer modes to blend better with the background overlay. The Soft Light/Hard Light options usually offer the best results, but feel free to experiment with others, too. You can also use Filter > Blur > Gaussian Blur to smooth the rain out a little more. It's a good idea to blur the closest layer the most, to create a simple focal depth effect.

Snow

by Bram 'Boco' Sels

Step 1
Gathering references

To create a snowy effect, I use a standard snow image I have pre-created and copy it into any paintings I need to. There are ways to create snow using just filters in Photoshop Elements, but using filters quickly makes an image look artificial, so I prefer using photographic textures because they have a randomness about them that you can't create with filters.

To start, I go around the garden and look for things that resemble snow particles. I also want them to be easy to sift out using the Levels technique. It's always a good idea to plan ahead this way as it saves you a lot of time later on. I end up with a picture of some mold spores on a rock wall.

Step 2
Check the Levels

Once you have the image imported into Photoshop Elements, add a Levels adjustment layer to the texture and move the sliders so that the background is completely blacked-out.

Step 3
Isolating the snow

Add a new layer on top and use a Brush to paint away unwanted or weird patterns highlighted in the texture. It's also good to paint out snow at the edges of the photo so you don't end up with any half-formed, flat-edged snowflakes.

We're going to use this texture image as a Color Dodge layer, which means everything that's perfectly black will become transparent. Other values will brighten up the lighter pixels.

Step 4
Adjusting the texture

Now if you hit Ctrl+A (Select All) and Ctrl+C (Copy), you can paste (Ctrl+V) the image as a new layer into any image you want to add snow to. It's that simple.

In the layer menu, select Color Dodge as the blending mode for that layer and play around with it. Paste a few more patches of texture in and move them around, resize them, rotate them or blur them (Filter > Blur > Gaussian Blur) to create variety in your scene.

Step 5
Creating realism

Keep in mind that snow follows the rules of nature so try to create a direction in which your snowflakes are falling. You can use this movement to direct the eye of the viewer towards an object. An image will be more dynamic when you make your particles fall diagonally, rather than straight down.

Fire
by Tommy Kinnerup

Step 1
Creating the base

This tip will show you how to paint fire using Photoshop Elements. First, open up Photoshop Elements and press the shortcut keys Ctrl+N to create a new document.

Set the width and height of this new document to 4000 pixels and the resolution to 300 dpi. Leave the rest as it is, then press OK.

In your Layers window, select your background layer and set it to black (Ctrl+I). Then create a new layer on top (Ctrl+J), and select a brush in your Tool Options window or by pressing B. Choose a semi-soft-edged brush with an approximate size of 900 pixels.

Now you can start to paint your image of fire. First, pick a dark orange/red in your Color Picker window and start putting some big, rough brushstrokes down to get an overall sense of movement. We will use this base shape to add detail later on.

Step 2
Brushes

Create a new layer and select a brush with sharp edges and a soft transition between the edge boundaries. The reason we use this brush is that it will give you the silky look that mirrors the actual realistic appearance of a flame.

Pick a brighter orange for this step. At this stage you can also look up some references to help guide you with the flow of the lines.

Step 3
Refining the texture

Now repeat the previous step, but this time on a new layer and using a brighter orange.

Step 4
Creating the light

It's time now to take advantage of our digital tools in order to make the fire glow like a light source. For this, we'll use the helpful layer blending modes.

First, create a new layer and set the layer blending mode (in the drop-down menu in your layer window) to Color Dodge. Chose a yellow color and start painting in the areas where edges collide, or where the light source is strongest.

Step 5
Rendering

The final step is to render the fire out to get a unified feel and a more painterly look.

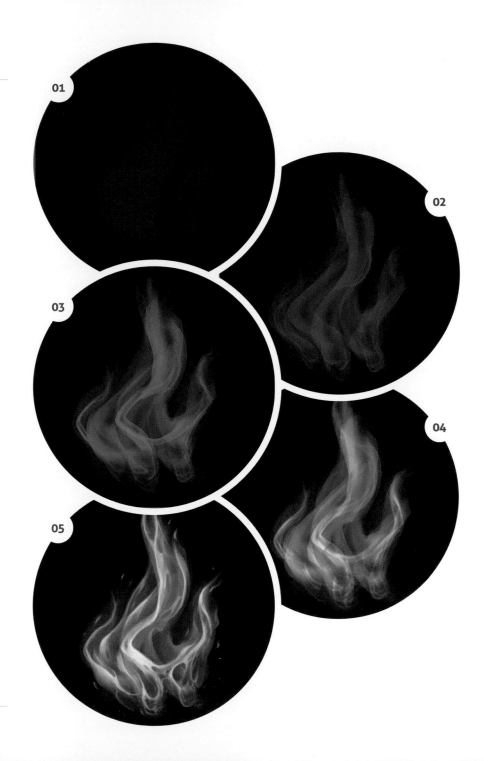

Explosion
by Tommy Kinnerup

Step 1
Orange base
This tip will show you how to paint an explosion in Photoshop Elements. First, open up Photoshop Elements and press the shortcut keys Ctrl+N to create a new document. Set the width and height to 4000 pixels and the resolution to 300 dpi, then press OK.

Pick the Paint Bucket from your Tools window, or by pressing G, and fill your background layer with a bright-yet-cool gray.

Then create a new layer on top (Ctrl+J), and select a brush in your tools window, or by pressing B. Choose a semi-soft-edged brush with an approximate size of 400 pixels. Now you can start to paint an explosion.

Pick a bright orange color and start by putting some big, rough brushstrokes down to get the overall 'mushroom' shape of the explosion.

Step 2
Creating volume
Now create a new layer in your image and pick a darker orange to paint with. You can use this darker tone for creating volume and defining the different smoke plume sections of the explosion.

At this stage you can also look up some smoke and explosion references to work from.

Step 3
Color variation
Now select a hard-edged brush in order to create the darker spots of smoke and debris. Create a dynamic-looking shell on top of the outer plumes of the 'mushroom'.

You can also bring in color variation by adding other shades of orange and gray, to make it look less monochromatic.

Step 4
Adding light
Now create a new layer and set it to the Color Dodge blending mode. With a yellow color, you can carefully brighten up the orange parts that are visible between the gray smoke brushstrokes.

Step 5
Final touches
The final step is to render the explosion out and to soften the borders up with more light-gray smoke.

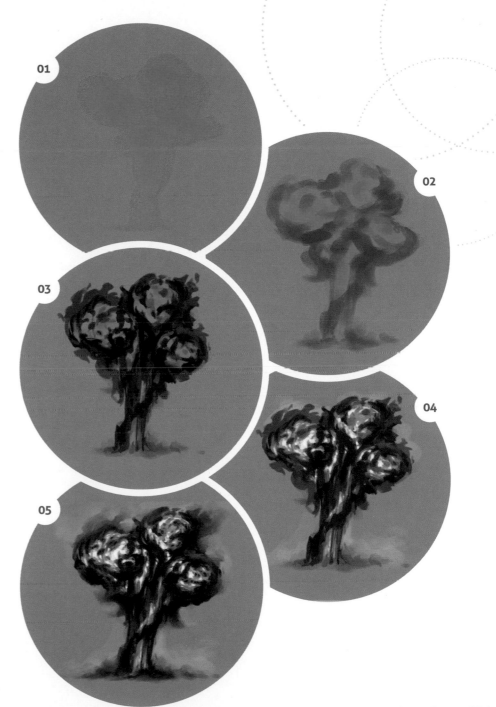

Smoke

by Tommy Kinnerup

Step 1
The base layer

This tip will show you how to paint smoke in Photoshop Elements. First, open up Photoshop Elements and press the shortcut keys Ctrl+N to create a new document. Set the width and height to 4000 pixels and the resolution to 300 dpi, then press OK.

In your Layers window, select your background layer, and set it to black (Ctrl+I). Then create a new layer on top (Ctrl+J), and select your brush in your tools window, or by pressing B. Choose a semi-soft-edged brush with an approximate size of 1500 pixels. Now you can start to paint smoke.

First, pick a dark desaturated purple in your Color Picker window and start putting some big, rough brushstrokes onto the canvas to get the general shapes of smoke.

Step 2
Brushes

Next, create a new layer and select a brush with broken or ragged edges. This type of brush will help you easily create that scattered, unformed look that smoke has, rather than having to add such detail manually with a smooth brush later.

Now pick a brighter gray color and start by adding light and volume to the smoke. You should look up references to guide you here.

Step 3
Translucency

Repeat the previous step on a new layer, but this time introduce more color variation to get a sense of translucency to the smoke texture. You should begin to build up layers of texture to create the smoke effect.

Step 4
Overlay blending

To make everything 'pop' even more you can create a new layer set to the Overlay blending mode. This is a good way to bring some color forward and increase the contrast to create depth. Color-pick from the areas where you want to add more contrast.

Step 5
Final touches

The final step is to render the smoke out and define the areas of interest, such as highlights or shadow.

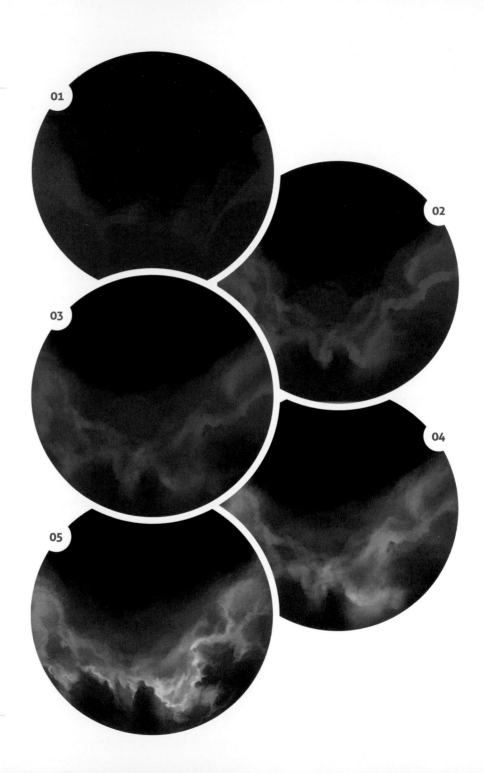

Artificial light

by Carlos Cabrera

Step 1
Painting artificial light

Creating artificial light is easier than you think. In this case, I think artificial light will look pretty interesting underneath some leather material.

You'll enjoy creating this texture because we'll need to use more of the tools in Photoshop Elements, and we can test the limits of our creativity to make a very cool and supernatural light. It's marvelous fun to create quick and simple sketches in this program – the tools are very easy to use and you can play with all the presets and effects to create new images.

I recommend using the Impressionist brush to make very cool effects. To start, create an image of bound and broken leather (see page 191). Then cover a little area with another color (I use green) with a Hard Round brush, using a size of 90 pixels and an Opacity setting of 80%.

Step 2
Color Dodge

Once you've covered the area with green, use the Color Dodge tool and paint over that area to burn the color until it becomes white. This allows us to create the brightness of the light.

Step 3
Atmosphere

You can also spread a small area of that same color around the ball to create a mystical,

magical effect. Use the Color Dodge tool again to create the same effect in other areas.

Step 4
The magic glow

Select the area with the Lasso tool and use Move (and press Alt) to move the selection and then copy the brighter areas. Then go to Filter > Blur > Blur to make a smooth effect, and change the blending layer to Lighten to create a more intense light.

To create the magical glow effect, we add a new layer, set the blending mode to Screen, and paint a green glow inside the brighter areas with a soft Airbrush at 30% Opacity. As you can see, the Screen blending mode on the layer simulates a great glowing effect with just some quick and simple strokes.

Step 5
Final touches

You can also add some green flames and little sparks on a new layer with the same blending mode. Every extra effect you add is going to make your illustration more detailed.

If you add sparks, add wind too. Don't paint the sparks in one direction, but rather make random strokes in different directions or use the Scattering preset on your brush to simulate the same effect. Now that we've finished our artificial light, we're ready to apply it to a full illustration.

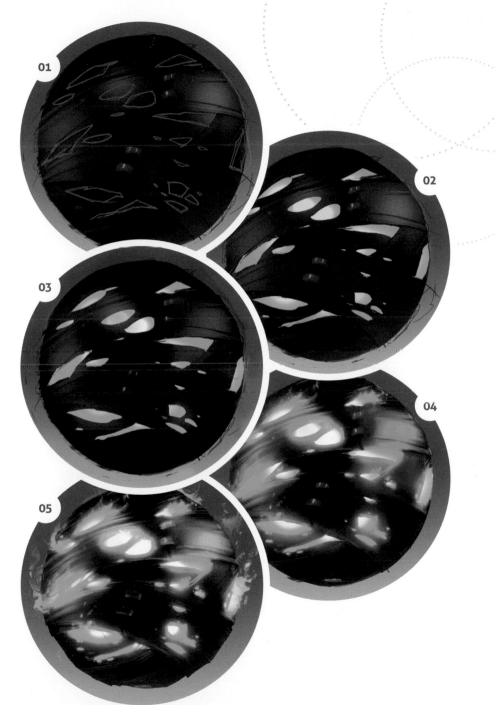

Water

by Abe Taraky

Step 1
Base ocean

To create the water texture in an ocean scene, first determine the perspective of the water so that it matches with the sky.

Although the horizon of the ocean is typically parallel to clouds that recede in the distance, a slight skew will enhance a staged lens effect and match the curvature of the clouds. This can help create a more dynamic mood in your scene.

Step 2
Water brush

A brush that mimics the ripples of liquid, or drops of water, is best used while painting the ocean. While on the water layer, use the Lasso tool to make a ragged and random selection that will imitate waves.

Use this water brush to paint over the selected area. Then deselect the selection and adjust the texture effect by going into the Image menu and selecting the Transform feature. Adjust the texture to fit the perspective of the ocean.

Step 3
Rocks

To add a little drama and movement to the river or ocean in your scene, you can add an obstruction for the water to interact with, such as a series of rocks or a beach.

Step 4
Crashing waves

To create the waves against this rock I have added, I use the Lasso tool once more and make a shape that looks like water impacting on the rock. Then I use the water brush once more to fill in the selection.

Step 5
Foam

To create more motion and intensity on the waves, use the Smudge brush and blur the edges of the wave. This will show the solidity of the liquid dissipating upon impact.

Finally, for an added effect, speckle in some foam and water drops by increasing the brush size and selectively painting on certain edges of the crashing wave. This extra detail also helps direct the eye towards the focus of the painting.

❝ To add a little drama and movement to the river or ocean in your scene, you can add an obstruction for the water to interact with ❞

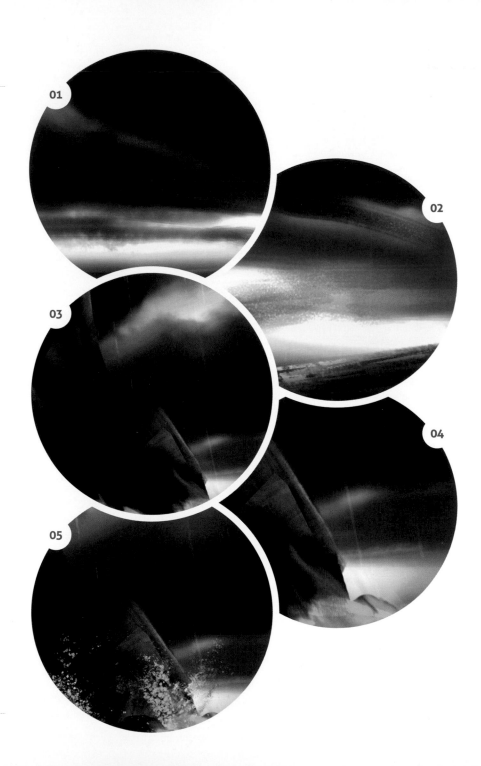

Sand

by Tommy Kinnerup

Step 1
Shadow

This tip will show you how to paint sand in Photoshop Elements. First, open up Photoshop Elements and press the shortcut keys Ctrl+N to create a new document. Set the width and height to 4000 pixels and the resolution to 300 dpi, then press OK.

In your Layers window, select your background layer and set it to black (Ctrl+I). Then create a new layer on top (Ctrl+J), and select your brush from the tools window or by pressing B. Choose a semi-soft-edged brush with an approximate size of 1400 pixels. Now you can paint the sand.

First, pick a dark gray-purple color which will represent the shadowed parts of the sand. Start by putting some big, rough brushstrokes down to define the sand formations.

Step 2
Light

Create a new layer and select a dark-yet-warm gray to represent the lighter parts of the sand. By placing small sand dunes down, you can help to define the angle that the light is coming from. Be sure to keep the brighter colors near the tips of the dunes.

At this stage you can also look up some references to get a better understanding of the color differences between light and shadow when dealing with sand and painting sand dunes.

Step 3
Adding texture

Repeat the previous step on a new layer, but this time use a texture brush that can give you the grainy texture of sand.

Step 4
Adjusting the contrast

When you are happy with the level of detail in your image, it's time to increase the color contrast to make the sand look more yellow. For this you can create a new layer and set the blending mode to Overlay.

Step 5
Final touches

The final step is to render the sand out and to add some rocks and imperfections to make it look more interesting and realistic.

Chainmail

by Nikola Stoyanov

Step 1

Making a chainmail link

I create a new document and paint something that very roughly resembles a chainmail link, using a custom brush called 'Aufgenommener Pinsel 1 1' by Sergey Kolesov (**http://pelengart.blogspot.co.uk**). I then use this to create a custom brush.

I keep the left side of the chainmail link darker and the right side lighter – this will help me later when creating the volume of the chainmail. Keep in mind that the lighter the color of the preset, the more transparent the brush will be.

Step 2

Creating a custom brush

I then select everything (Ctrl+A) and go to Edit > Define Brush From Selection to define the chainmail brush. I have created a chainmail brush, now all I have to do is fine-tune it and use it properly. I click on the Brush Settings in the Tool Options menu, and pump up the Spacing until I find a good enough result. Then I save my brush by going to Brush > Properties (top-right icon) > Save Brush. A pop-up window appears, so I name my brush and click OK.

Step 3

Knitting the chainmail

To create proper chainmail, I 'knit' it row by row. After each row I open the Brush Settings and flip the angle (from 0 to 180 degrees and back).

Using the brush for creating proper chainmail is a time-consuming and sometimes exhausting process in Photoshop Elements, because of the limited brush settings, but nevertheless the results are equally as good as the creations with the more powerful versions of the software, so arm yourself with patience to 'knit' digitally.

Step 4

Adding volume

After I've painted enough of an area, I duplicate the layer several times in order to make a more opaque silhouette of the chainmail. I merge all the layers up to the one before last. I then make the last layer lighter with a Levels adjustment, click on the layer thumbnail (to make a shape selection), and add a layer mask. I can then merge it with a new blank layer.

Doing this several times thins the shape, leaving only part of the chainmail link lighter, and therefore creating a volumetric texture.

Step 5

Adding shine

I convert the layer blending mode to Linear Dodge to achieve a shinier metallic look, and paint over it on a separate layer to blend it more nicely with the surrounding.

A new layer with a Clipping Mask (Alt+click between the layers to create it) helps a lot in the over-painting process.

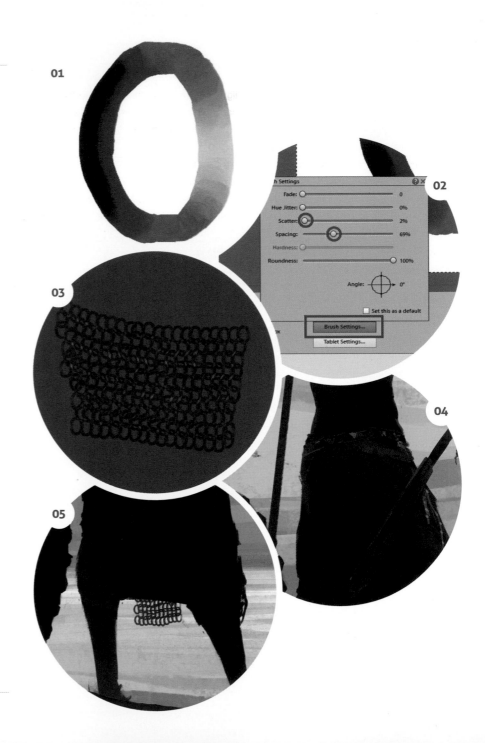

01

02

03

04

05

Rusty metal
by Cyril Tahmassebi

Step 1
Starting out
I begin with a photo from my own base collection and set an appropriate tone and foundation for my extra effects. Feel free to erase parts of your base image to keep only what you want to include for your texture.

Step 2
Painting detail
I select Expert Mode and begin using layer modes in Photoshop Elements. I first set the layer mode to Overlay and paint directly onto my texture to accentuate the rusty effect I want to give my image. I can then start to add in some scratches with a round brush on a low opacity.

Step 3
Tonal tweaks
When creating a texture, sometimes you need to apply some filters and effects directly on the elements that make up your texture.

Here, I make some light adjustments to the overall Brightness/Contrast and use Curves to optimize the areas of color and light in the image.

Step 4
Selective adjustments
There is a great function in Photoshop Elements that allows you to select specific areas of your image to make more selective changes. To do this, select the area of the image you want, create a new layer and apply the following shortcuts: Select All (Ctrl+A), Copy (Ctrl+Shift+C) and Paste (Ctrl+V).

With this trick, you can make different changes and have better control over the various filters, tones, contrast, brightness and color balance.

Step 5
Selective adjustments
Once I've completed the steps above, I use various filters to adjust the tones of the texture. It's important to give the texture the right effect, so I ensure that I play around with layer modes and filters in order to achieve the most appropriate combination of settings.

I then reinforce the lighting and contrast to highlight the relief areas in my texture. For a final touch, I use the Sharpen function, which gives more clarity to the texture.

Shiny metal

by Nikola Stoyanov

Step 1
Finding a brush

Some of the basic properties that create a convincing metallic look are reflectivity and glossiness, so I'll focus mainly on these.

First, I load a new brush palette by selecting the Brush tool and opening the Tool Options panel. I then select Brush, move to the properties panel, click Load brushes, and search for the ABR brush file.

I am a big fan of Sergey Kolesov's work (**http://pelengart.blogspot.co.uk**) and like using his free brushes for multiple purposes. I'll be mostly using his Aufgenommener Pinsel 1 1 and 13 brushes, as they have a nice, bumpy texture.

Step 2
Color tones

The metallic surfaces have to reflect the environment. Keep in mind that the surfaces facing upwards will reflect mainly the sky and will have a mostly bluish color. The surfaces facing down will reflect the floor. I have a desert sand scene here, so the metal will have a warm tone.

Step 3
Brushstrokes

The grainy brushes help achieve a slightly satin finish on the metal. It's generally always good practice to follow the shape of the object with your brushstrokes.

I am constantly picking colors with Alt+click while using the Brush tool; this helps me get smoother transitions and blending between different shapes and colors.

Step 4
Metal shininess

To make the shiny metal look more convincing, I add a nearby element for it to reflect. In this case, I add a roll-bar reflected in the front of the vehicle, a fender reflected in the side door, a headlight, and a tire reflected in the hood.

I don't want to make the metal appear totally reflective because it would look like a mirror, so I avoid making really defined reflections.

The more blurred the reflection is, the more matte the metal texture will appear. Keep in mind that the reflection blur is perpendicular to the surface of the object, too.

Step 5
Adding contrast

I also add small details like chamfers, bevels and construction lines for more believability.

To add an element of contrast I leave some areas of the vehicle with a matte finish. I even add rust and some welding marks to create a more realistic effect. Lastly, I boost the shiny parts by painting over the metal on a separate Color Dodge layer.

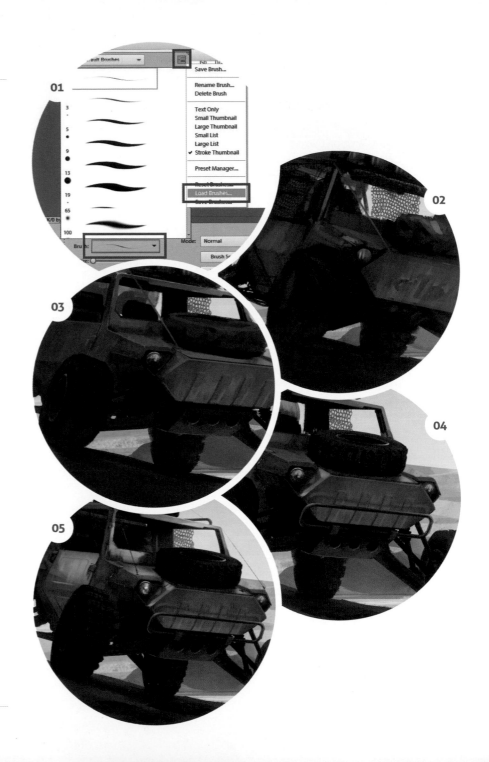

Brick
by Bram 'Boco' Sels

Step 1
Getting started
To make brick walls I first create a convincing tileable texture. These can be a bit difficult to wrap your head around at first, but once you get the hang of them they can be a very powerful tool.

The idea behind a tileable texture (or pattern) is that you create a square tile that can endlessly repeat itself. The right side of the image should seamlessly connect with the left side of the same image. This goes for the top and bottom, too.

Step 2
Copy the texture
Start with a photograph of a wall and use the Rectangular Marquee tool to select the square you want to create a pattern of (hold Shift while selecting and you'll get a perfect square). Try to select a part of the wall that has full bricks in it and straight lines. Copy it and create a new image for it.

Step 3
Mirroring
An easy trick to make the borders of the tile seamless is by copying half of the image and mirroring it to the other side. Do that by adding two guides at 50% horizontal and 50% vertical (View > New Guide). Now, when you use the Rectangular Marquee tool,

it will snap to the guide. So select the left side, copy and paste, move it to the other side, and Flip Horizontal (Image > Rotate). Do the same for the top and bottom, too.

Step 4
Adjustments
You'll notice that some parts of the tile will turn out a bit weird. Some bricks in the middle might look too small, or the sides might have unnaturally big chunks of cement. As long as you stay away from the borders, though (you matched them up, so they should be fine), you can change anything you want *inside* the tile.

Select some good bricks and copy and paste them to replace of the 'wrong' ones. It's a bit like a puzzle, so play around with it. Also keep an eye open for bricks that have weird shapes or markings; try to camouflage them because, in a pattern, you'll quickly notice those weird things repeating.

Step 5
Final touches
When you're happy with the pattern, click Edit > Define Pattern and you'll have your very own pattern stored in the library. Now when you create a new layer and choose Edit > Fill Layer and select your pattern, the whole layer should be a big brick wall. Use Image > Transform > Perspective to warp the layer – and start building.

Tires

by Nikola Stoyanov

Step 1

Creating tire patterns

To create a convincing tire, I first have to make a proper tire mark pattern. I start by looking up a lot of pictures of tires on the internet to get a better idea how the markings look.

I create a new document and, after several tries, I am satisfied enough with the simplified-but-convincing tire pattern I've painted with one of the simple default brushes.

Then I select everything (Ctrl+A) and go to Edit > Define Brush From Selection. I tune the spacing in the Tool Option menu, and then save it.

Step 2

Shaping the tire

In the meantime, I've painted the basic shapes of the tires again, using the Aufgenommener Pinsel 1 1 brush from Sergey Kolesov's sketch brushes set (**http://pelengart.blogspot.co.uk**). This brush has nice texture and dynamics, and can be used for many different purposes.

Step 3

Fitting the pattern

I set up the angle of my new tire pattern brush (from the Brush settings) to match the angle of the tire's surface, and make a stroke on a separate layer, following the tire's curve. It's normal not to get it right the first time, so I usually Ctrl+Z and repaint until I'm satisfied

with the result. There is no roundness brush setting in Photoshop Elements, so I manually flatten the first and last patterns of the stroke – that way it matches the tire's perspective.

Step 4

Merging the pattern

I make a new layer and Ctrl+click between the layers to create a Clipping mask. This way I can only paint within the shape of the tire marks. Another way to do this is to click on the Lock Transparent Pixels icon above the layers panel.

Either way, I paint inside the tire marks with the Aufgenommener Pinsel 1 1 brush until I blend them well enough with the tire behind them.

Step 5

Finishing touches

I then paint some volumes, small details and dirt that seem appropriate on separate layers.

After I'm done over-painting I merge the layers so I don't have too many layers open that are hard to manage.

Finally, once I'm done with the whole image, I can then use some adjustment layers, like Levels, Brightness and Contrast, and Photo Filter, to add all the finishing touches. I also like to add some Noise and Chromatic Aberration from the Correct Camera Distortion filter for a more cinematic feel.

Leather

by Carlos Cabrera

Step 1
Base layer

To create the texture of leather, first draw a circle with the Ellipse tool. Paint it with a black color using a Hard Round brush with a set size of 400 pixels and Opacity at 30%.

Then sketch with another color – this can be red or orange – the lines that will help you decide the direction and position of the creases.

Step 2
Shed some light

Now we can add a new layer to paint the highlights. Select a Soft Round Airbrush with a size of 400 pixels on Lighten mode, and paint highlights on top of the material. Finally, change the blending mode of the layer to Soft Light.

Step 3
Shapes

Insert a new layer and start painting over the material with a Hard Round brush – Opacity can be set to 35%. It is important that you do not deselect the first selection you made on the material until you finish the illustration, because you can control the creases and the Gradient tool more easily with that initial selection.

Step 4
More lighting

We can now use a Hard Round brush with an Opacity setting of 50% to create the detail in the highlights. First we need to cover the lines that we sketched in previously, so if the lines are close to the light source they will become even brighter now. You can indicate this in your texture by using a light gray color, (if you use white, it won't look so real).

Step 5
Color and detail

To add color, create a new layer and use the Transparent Gradient tool. Use a brown color from the base on the top of the image, but change the blending mode to Overlay.

We will now make the material wrinkle around the 'ball' shape to create realistic creases and show tension in the leather. Again, in the lighter areas, we will add in some gray light reflections and refine the texture of the leather.

If you want to accentuate the wrinkles, you can use a Hard Round brush with an Opacity setting of 60% and a black color. With this brush, you can draw quick lines under the creases to create the shadows.

Fabric
by Juhani Jokinen

Step 1
Brushes
In this tip we will discuss painting a fabric texture in Photoshop Elements. I have used my own custom brushes for this process, but Photoshop Elements provides a set of equally good default brushes that work just as well. Here, you can see some of the brushes in my set (image 01). You can find pre-made custom brushes to download online, or you can create your own custom-made collection.

It's a good idea to experiment with the brushes and settings in the software to get a grasp of how they work. You should also turn on Opacity in the Tablet settings menu.

Step 2
Blocking in the shape
First, I create the basic shape of a flag using a simple Chalk brush at full opacity. Don't focus on details at this point – the most important thing is to get the overall form to read correctly. It's useful to keep an eye on reference images of flowing fabric to get a feel for the shapes and forms you can create with brushes in this initial stage.

Step 3
Shadows
I now paint the shadow shapes into the flag's contours using a Clipping Mask. This allows me to paint inside the shape of the flag without

worrying about staying within the edges. I can paint freely without worrying about the edges.

At this point I'm using a square-shaped brush with the Opacity setting turned on in the Tablet settings menu. I try to find a pleasing and realistic arrangement of folds in the fabric and paint the shadows in appropriate places.

Step 4
Highlights
After defining the shadow shapes, it's easier to see where the light should fall. I pick a warm, slightly orange color to get a nice contrast with the shadow color.

It's a good rule of thumb to have cold shadows if your light source is warm, and warm shadows if your light is cool. I'm using the same brush as before and am still painting with a Clipping Mask to stay inside the shape.

Step 5
Detail
To finish this flag, I start working on smaller details and blend the colors a bit more. I add a number of smaller folds to add a little realism and break up the edges with small cuts to add interest to the shape. I use mainly simple round brushes to create this effect.

Feathers

by Lindsey Wakefield

Step 1
Make a basic shape

To begin, we are going to create a new layer. Then, using the Lasso tool, make a selection that resembles the rough shape of a generic feather.

Now that we have the shape, we must decide on the color. Choosing black, I fill in the shape with that color using the Paint Bucket tool.

Step 2
Base color

With the base shape established, I can then select a medium-to-large Airbrush with the Opacity set to 50%.

Step 3
Creating the shaft

Making sure that the feather is still selected, I begin to airbrush in the lighter values using a slightly off-white color to do so.

We are going to create a gradual gradient to represent the matte surface (which means it absorbs light more than it reflects) of the feather. This will make up the majority of the feather.

Now that we have the body of the feather down, we can move on to the central shaft. Unlike the barbs of a feather, which have a matte surface, the central shaft has a much smoother surface and reflects more light.

Using a small Hard Round Airbrush, we'll create a darker line that goes down the center of the feather – this will represent the shaft.

Now, using the Dodge tool and selecting a small Airbrush with Opacity at 50%, we are going to bring out its highlights.

Step 4
Creating detail

With the body of the feather complete, we can finally create the details. On the main body of the feather, we'll start painting the streaks (called 'barbs', or 'barbules') that flow to the tip. We don't need to paint a lot – or all – of them, just enough to suggest that they are there. You can even erase and show parts of the feather where the barbs have pulled apart.

Use the Hard Round Airbrush and begin making soft streaks on the tip, as well.

Step 5
Finishing off

That was only one feather; you can repeat these steps as many times as you need in order to create a bird's wing or tail. You can even make a custom brush of your feather and play with the settings to scatter them realistically. In the end, just make sure that all the feathers you create overlap to increase the realism of your creature.

01

02

03

04

05

Hands
by Sara Biddle

Step 1
Sketch it

Hands are a complex human feature and many artists – even the pros – often struggle with their intricate and graceful design. A good place to start painting hands is with a simple sketch.

Your own hands can provide a multitude of reference gestures when flexed and moved. When combined with a mirror or two, these single-perspective views can be multiplied into many more using the different angles and views that mirrors can offer an artist.

A common way to interpret the mystery of hands is by simplifying them into basic shapes. Block in the simple shape and gesture, and then add the details, such as the bony joints and fingernails.

Once you have a solid sketch to go by, create a layer underneath and use a hard-edged round brush to fill in the shape of the hand. Lock Transparent Pixels on this layer by pressing the forward-slash key (/).

Step 2
Shadow

Switch to a soft-edged round brush now and begin adding basic colors to the hand, keeping in mind the direction of the light. Add darker, saturated colors for shadows and lighter tones for highlights. Be sure to include the curvature of the fingers influenced by the bones underneath.

Step 3
Finer detail

After the base of the hand is set up, decrease the diameter of the brush and begin working on the finer details.

We fill the nails in with a light pink and add some highlights to them with the Dodge tool. Add a dark shade to separate the fingers from each other, and also on each side of the nail to enhance their natural curvature.

Step 4
Finger joints

The finger joints also need attention, so we'll paint just enough to vaguely imply them. Sometimes subtleness like this is really important, as overdone joints can sometimes end up looking strange.

The knuckle bones are also implied – take a look at your own hand and admire how they work, and then apply the study to your work.

Step 5
Refining the nails

Extra length can easily be added to the nails. In this case, I make a layer underneath the hand and extend the nails out. Select the hand layer, then merge the nails and hand layers together with the Ctrl+E shortcut.

Creature eye
by Carlos Cabrera

Step 1
Sketch the eye of a fantastic creature
To start, choose a Hard Round brush in Normal mode. When you decide which colors you will be using for the eye, you should start to paint with an Opacity of 60% and brush size of 78 pixels, leaving space for the bright areas. As it's a rough drawing at this stage, you don't need to put many details in.

Step 2
Mixing colors
You can use the Smudge tool with an Opacity between 20% and 35% to start mixing the colors before adding any shadows.

Upon reaching the mid-toned colors, lower the opacity by choosing a soft Airbrush at 40% Opacity to paint with, leaving space for the bright areas (without reaching the outline).

Step 3
Shadows and the iris
To create the iris, add a little darker color in the center of the eye – but don't cover all of the light area at this stage.

When adding the darker colors, you can add some lines around the iris to add a little more realistic detail, and to help with one of the effects we'll be creating later. You can also use an almost-black color to mark the darker shadows and the iris, so it won't look too bland.

Step 4
Refining the texture
You can add a Layer Mask now, selecting the iris with the Lasso tool and filling it with a middle tone using the Paint Bucket tool. If you then put the layer in Overlay mode, it will create a more interesting shade.

Choose the soft round Impressionist brush with a size of 61 pixels and Opacity of 21%. Apply this brush in Darken mode to the shadows, and in Lighten mode to the brighter areas. When we have the base texture down, we can then apply the highlights with a brush blur, using the Normal brush with an Opacity of 46% and a size of 100% in Hard Light mode.

Step 5
Final details
For the final details we will use black for the iris outline and the eyelid, faint green tints to give it some extra lighting, and white lines for detail.

We can then add the details to the lachrymal and, with a Chalk brush at 60 pixels, create the wrinkles around the eye and lunar spots to make a realistic skin texture surrounding the eyeball.

Hair
by José Gómez

Step 1
Creating hair

To start, first draw a shape. You can draw any shape you like here, but try to follow the shape of the hair by creating a hair-like sweeping movement.

Step 2
Shading and guidelines

Now, in the same layer, go to Layer Options in the top of the panel. There are five options here to choose from – click the first (right-hand) small square-shaped button. This allows you to only make marks inside your shape.

Choose a soft brush and size it at 1600 pixels, then take a darker shade (or black with 30% Opacity) and place the shadow around the sides. The light in this case goes across the middle.

Now having already identified the main light and shadowed areas, we draw a line from the start to the end of the piece – these will be our guidelines around the hair.

Step 3
Drafting detail

On a new layer, and with a normal hard-edged brush with a light-yellow hue, we draw some highlights with short strokes that flow with the hair. These first strokes guide us when adding more prominent highlights later on. Finally, lower the Opacity of the layer to about 60% so that the light is not as strong. You can also add a little more freeform hair, drawn to your liking. Finally, merge all the layers.

Step 4
Refining the highlights

Now illuminate the image using a soft brush and create new, larger lights in the strand. On a new layer, add new freeform hairs from the top of the strand to the bottom. Finally copy everything into a single layer (Ctrl+J).

Now you can create the last lighting sections. Create a new layer and add new highlights to the strand, as before, until you're happy with the lighting. Then lower the Opacity of the layer to 50%, duplicate it and attach it to your previous duplicate. Move the Opacity back to where you can see highlights again.

After that, with the Lighting tool (O), highlight only the final details of the last layer – this should create a nice, varied hair texture.

Step 5
Color adjustments

If you want better color contrast, merge all the layers into a single layer, duplicate it and set it to Overlay mode. Then turn down the Opacity to 42% to create a little more texture in the hair.

If you apply these techniques on a larger scale, you can create an entire head of hair.

01

02

03

04

05

Lips
by Sara Biddle

Step 1
Sketching first

There are all sizes, shapes and textures of lips. Everyone is different, yet there's still common ground between us as we share certain characteristics.

Take a moment to think about what type of lips you would like to paint – full, thin, curved, straight, wide, narrow – and then sketch them.

After you've determined the size and shape with a sketch, make a layer underneath to paint on, so that we can still use the sketch as a guide. As we paint, the guide will become less and less necessary, and can be hidden.

Step 2
Painting lips

To make our lips, the ordinary preset round brushes will do the trick nicely. We'll pick one with a soft edge to start, and add in some color. Flat color will do at first, and then we can build up the form with darker shadows and lighter highlights from there.

Keep the light source in mind as you apply colors. Since our light source is from above, the upper lip and the corners of the mouth will be mostly in shadow, in this example.

Continue to color-pick and apply colors that enhance the form with light and shadow.

Adding some highlights to the bottom lip will bring the shape out nicely.

Step 3
Texture

Once the color and light have been established, it's time to start thinking about what the surface of the lips is like. Dry lips will have dull highlights and a much more wrinkly texture, and glossy lips will have less texture and extreme highlights.

In this case, we're going for a glossy look, so choose a hard-edged round brush, which you can find easily in the Brush Presets.

Step 4
Glossy highlights

Continuing with the Hard Round brush, add little dots in the lit areas along the topmost edge of the upper lip and along the middle of the bottom lip. This will give the impression of slight texture on a shiny surface.

Step 5
Finishing touches

With such glossy lips, the highlights will reflect light, so add some dull highlights to the inside of the top lip, too. As a finishing touch, you can also very gently add vertical strokes to the lips for a little extra texture.

Fur
by Carlos Cabrera

Step 1
Creating fur
First open a new file. Now with the Ellipse tool and a Selection Mask, we make a circle in the middle. With a Hard Round brush, set the Opacity at 80% and the brush size to 150 pixels, and then paint the selected area.

Step 2
Rough detail
We can now adjust the size of the brush to 40 pixels, set a new angle of 61 degrees, and modify the roundness to 28%. And we're now ready to paint the fur.

Step 3
Adding color
Before we start the fur, we need to use an Airbrush to add color and smooth the fur of our fantastic creature. Remember: you can make the fur longer or shorter – it all depends on what you want to draw.

Step 4
Adding tone
To begin, we need to add a new layer to the file with a low opacity setting. Select the Lasso tool and create a new selection in the area that you will cover with the darkest shades. Use the Gradient tool to fill this section.

Now repeat the action with the next darkest shade, and so on until you reach the lightest

tones at the top of the image. You can see that now you've made a few shadows, this helps to create a realistic fur effect.

Next, add a new layer and change the blending mode to Overlay. Use the Gradient tool with the middle tone that you are using to blend the color.

Step 5
Detail
To create the individual strands, select a Hard Round brush and choose the following settings:

- Roundness with a size of 45 pixels
- Opacity: 68%
- Angle: 49 degrees

This will make a slim brush that can be used to sketch in the fur. Use a different color tone to create different shadows and highlights in the fur, and don't forget to apply a rim light to make our fur seem more real. To make it fluffier, we can smooth the hair with an Airbrush set to a low opacity.

Now we have our fur finished and ready for the final detail, press Ctrl+D to deselect the mask, and paint random strokes at the edges to make the hair appear real and 'feathery'.

Scales

by Kamil Murzyn

Step 1
Setting up the base

Start by creating the base for a dragon's body and background. Use a soft brush – or the Gradient tool – to achieve simple shading, and establish the starting colors.

I want warm light from the top and cold light from beneath, so I create an orange/green/blue gradient. The scales of reptiles or fish are often very colorful, so don't worry about keeping it basic here, and add some crazy colors if you like – just be sure to keep the main gradient visible.

Step 2
Rough scales

I create a new layer and very roughly draw the shapes of the scales over the surface. The decision on the final shapes will depend entirely on your tastes. Personally, I like very diverse and irregular patterns.

Step 3
Refining the texture

Now create another layer, pick a hard-edged brush and start to build up the lighting. Using the Color Picker (press Alt while in Brush mode), sample colors from your gradient and paint a warm yellow light on the top edge of each separate scale, making it less apparent as you move toward the bottom. Then do the same thing with a cold bluish color, but move in an opposite direction; paint it more

clearly at the bottom and move toward the top with less pressure. Add some more saturation in the middle of each scale, too. This will create the illusion of translucency.

Think about what and where your light sources are. Painting reflected colors is a very easy and effective way to create clear solids and give depth to the texture. I personally play around some more with the colors before moving on to adding the highlights in the next step.

Step 4
Adding highlights

Next, to add the highlights, choose a very bright color. Highlights should never be pure white or gray as these colors are very situational and not very natural. Instead, focus on the corners of the color palette, but almost never touch the edges.

Use your chosen highlight color to create smooth highlights near the edges of the scales. Do the same with a darker and more saturated blue light from underneath.

Step 5
Finishing touches

For the finishing touches, paint a ridge of sharp talons and use adjustment layers to improve the contrast (Levels) and overall color (Color Balance).

01 soft color variations

02

03 warm light

more saturation

cold light

04

05

Dragon muscle
by Abe Taraky

Step 1
References
To paint muscle, its a good idea to start by choosing a range of references from photos of subjects with clear muscle definition.

From the references I've gathered, I can see that the dragon's neck closely resembles the muscles seen in a typical boa constrictor.

With these in mind, I re-create those shapes on the canvas using my preferred brushes. It's a good idea to paint with the flow of the muscle to create a smoother, more realistic impression of muscle texture.

Step 2
Local color
Now I can begin to refine the texture by painting in the 'local colors' of the dragon. Local colors serve as the base colors on your image that you can later begin to add shadows or highlights to. In this case, I choose a red-orange tone.

Step 3
Highlights
Because of the way muscles pull the skin taut, they generally show less texture and tend to have a smoother reflection of light.

With this in mind, use the Dodge tool, set to 50% Opacity, and paint the large section of muscles hit by the light source.

Remember that muscles ripple beneath the skin and will twist or bulge according to the pose of the subject, so be sure to include these in appropriate places on your subject.

Step 4
Texture
A smooth brush with feathered edges will add more detail on the surface of the skin.

Use the Color Picker to select the colors of the dragon's environment, and paint with a low opacity on the skin of the dragon. This will create more volume and believability that the dragon actually exists in his environment.

Darken the shadows by using the Burn tool at 60% and painting on top of the new colors.

Step 5
Final touches
Finish by using a Smooth brush at 100% Opacity and paint in any extra details that the skin and muscle might need to have.

Reptile skin
by Lindsey Wakefield

Step 1
Establish a base
Scales can be tricky for beginners because the sheer number of them on a reptilian body is overwhelming in itself, but I am here to help. It is one of my passions (and obsessions) to draw scales on creatures, and I have learned a lot of dos and don'ts when it comes to painting them.

To begin, make sure that you have a solid base that establishes your form and values. Scales are a simple concept but can be difficult to grasp for beginners, and the best way to grasp the concept is to simplify it. Take a look at the wing in this image: when you simplify the shape it is nothing more than a long cylinder shape. With this idea in mind, I am able to imagine where my scales will lie.

Step 2
Marking the scales
Once the form and values are established, you can begin the fun part of painting in the scales. There are many types of scales (snakes, crocodiles, lizards and so on), and it is up to you to decide what kind of scaly pattern you are aiming to paint.

For me, iguanas are great as a scaly reference – and also what I had in mind for this painting. My image shows the iguana-type effect I am trying to create on my dragon painting.

Step 3
Rough scales
Since I have my base values established, I block in my scales using a Hard Round Airbrush set to 50% Opacity. I follow the form of the body to create a sweeping series of 'blotches' that conform to the natural shape of the wing/arm and muscle.

Step 4
Shaping the form
Try to make the scales have form too; they aren't flat and have a shape of their own.

Here I repeat the scales up and down the arm, wedging the scales into one another, just like they would in real life (if it existed). Keep it loose and unrefined at this stage – the details are soon to come…

Step 5
Details
Now here comes the juicy details. I shrink the Hard Round brush right down to 2 pixels, set the Opacity to a full 100%, and then begin detailing.

I imagine where the light would hit the creature and add detail and further define the scales until I am happy with the results.

Breakdown gallery

Browse through images created in Photoshop Elements to inspire your own creations

When researching for inspiration, you'll find an overwhelming collection of excellent digital artwork online. It can be easy to get discouraged by these as a beginner artist.

To encourage and inspire your work, we asked several artists to provide a series of images created using the techniques featured in the previous chapter, along with some work-in-progress shots. Here you'll be able to follow the progression of each image visually, and understand how each of the components covered in this book combine to create a great image. With artwork from Bram 'Boco' Sels and Juhani Jokinen, you'll be able to see how you can use Photoshop Elements along with the techniques revealed throughout this title to create excellent, top-quality images.

Sunny landscapes
by José Gómez

01

02

03

04

©José Gomez

Moonlight scenes

by Bram 'Boco' Sels

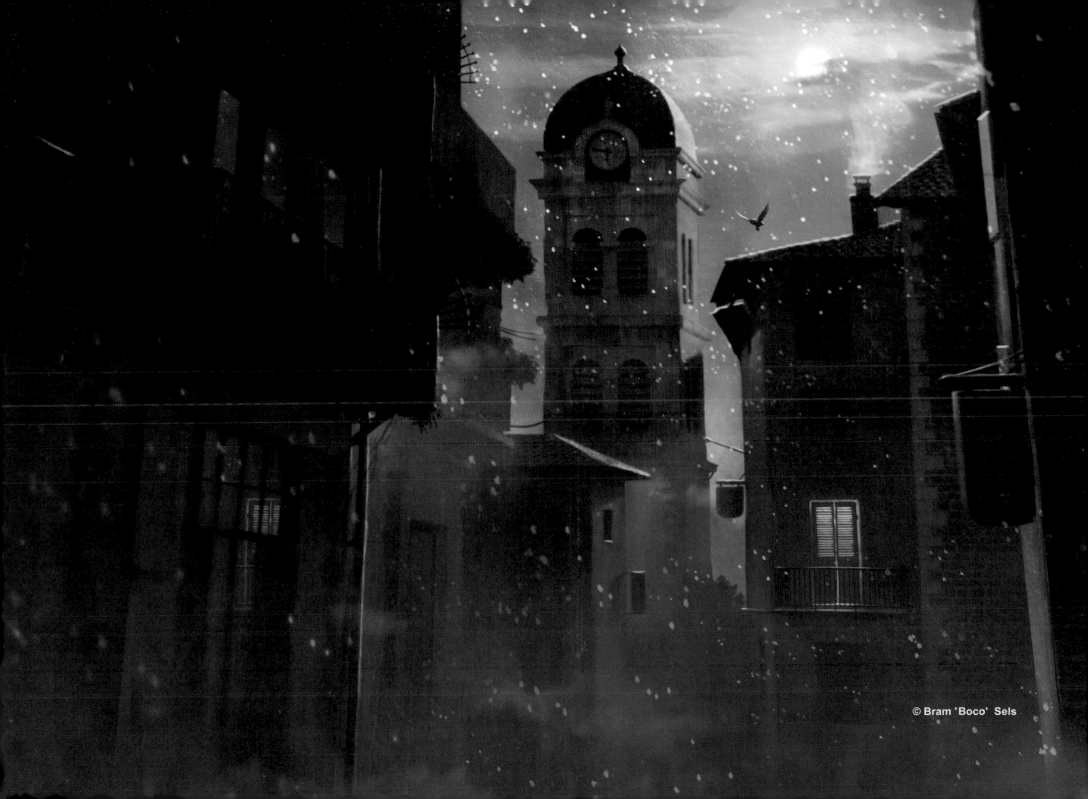

© Bram 'Boco' Sels

Rocky terrain
by Cyril Tahmassebi

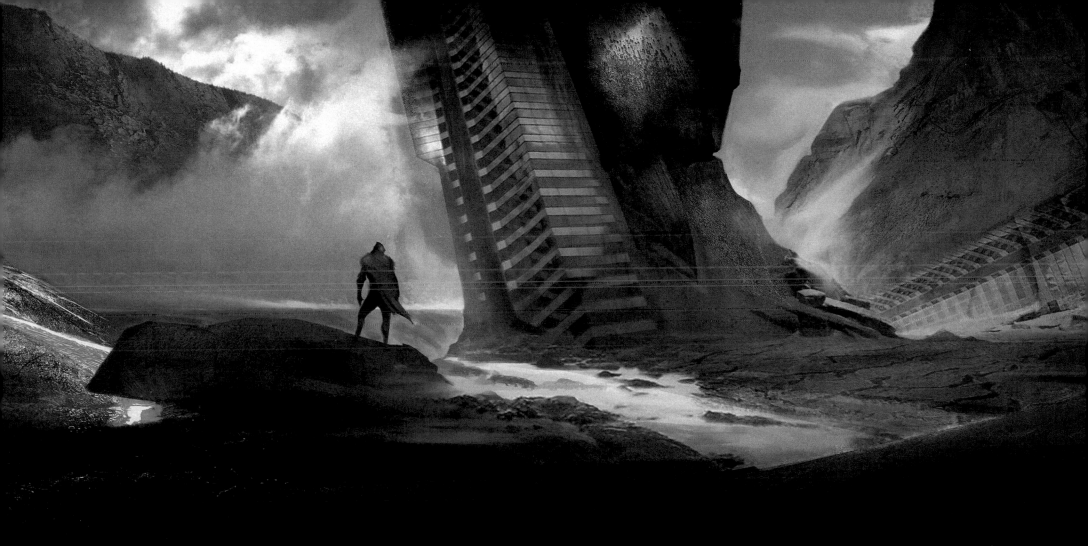

Fantasy reptiles
by Lindsey Wakefield

01

02

03

04

Ethereal characters

by Sara Biddle

01

02

03

04

Stylized water scenes
by Kamil Murzyn

Mythical creatures
by Carlos Cabrera

01

02

03

04

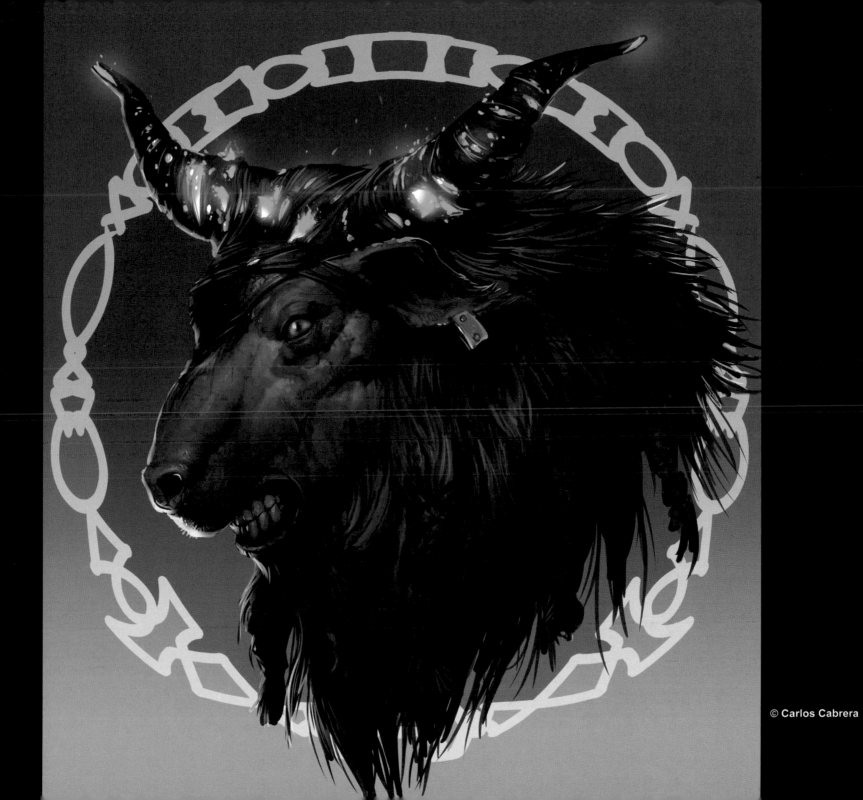

Desert lands

by Nikola Stoyanov

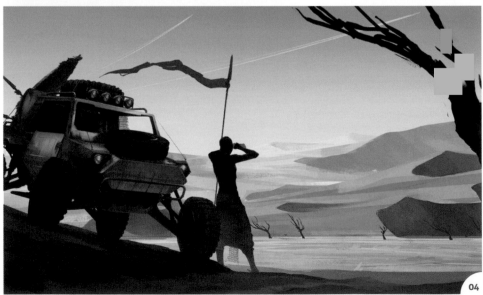

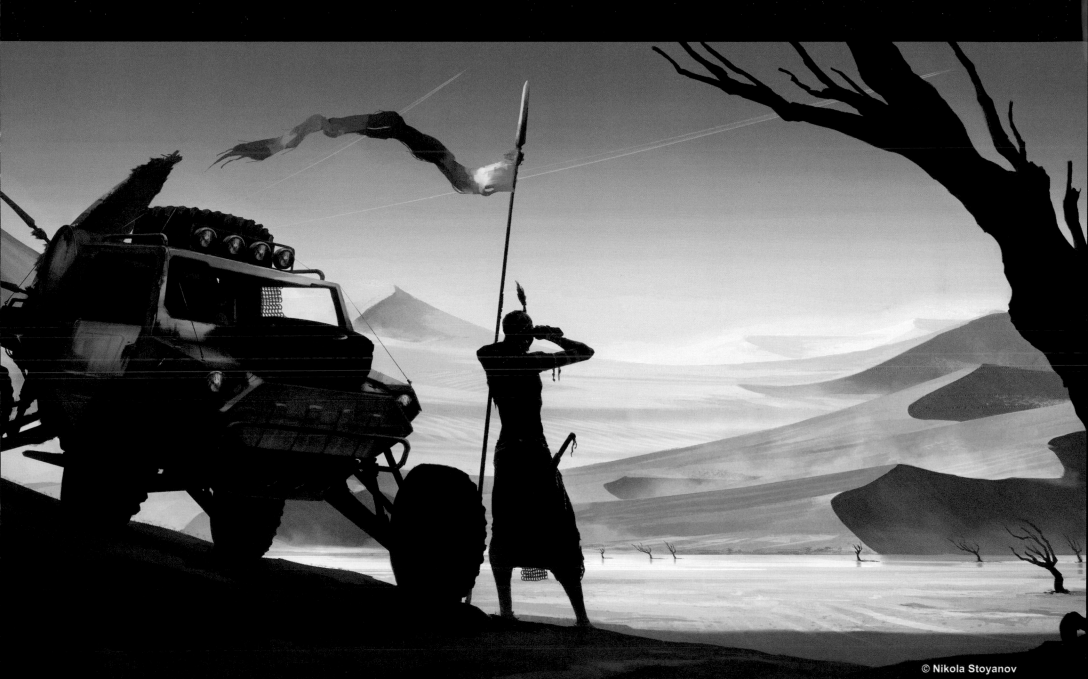

Mountainous coastlines

by Juhani Jokinen

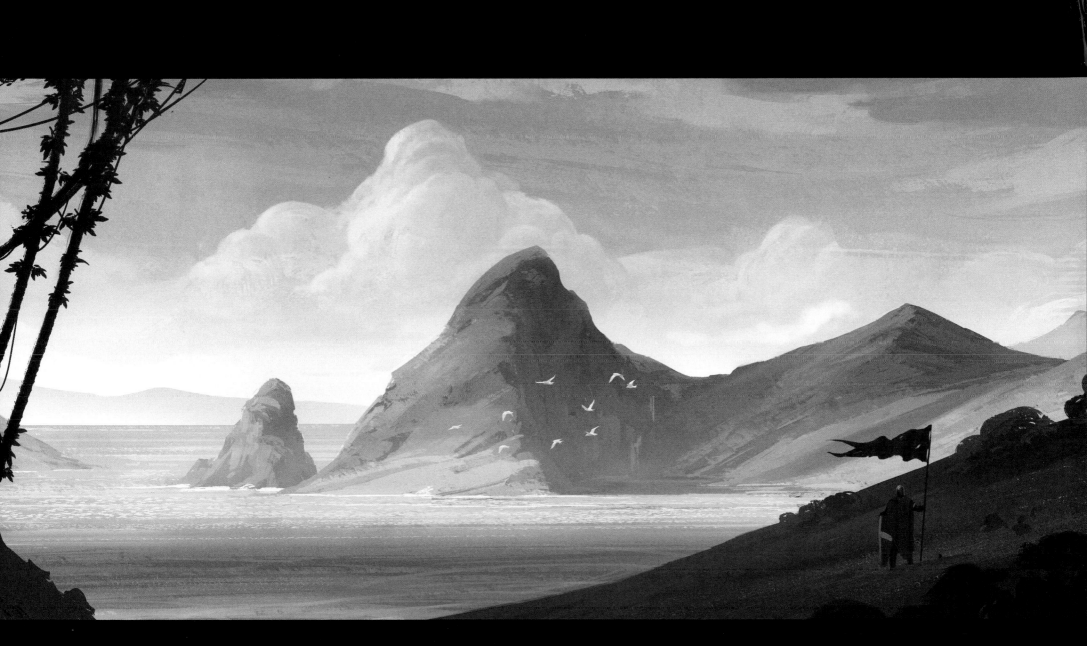

Dramatic events

by Abe Taraky

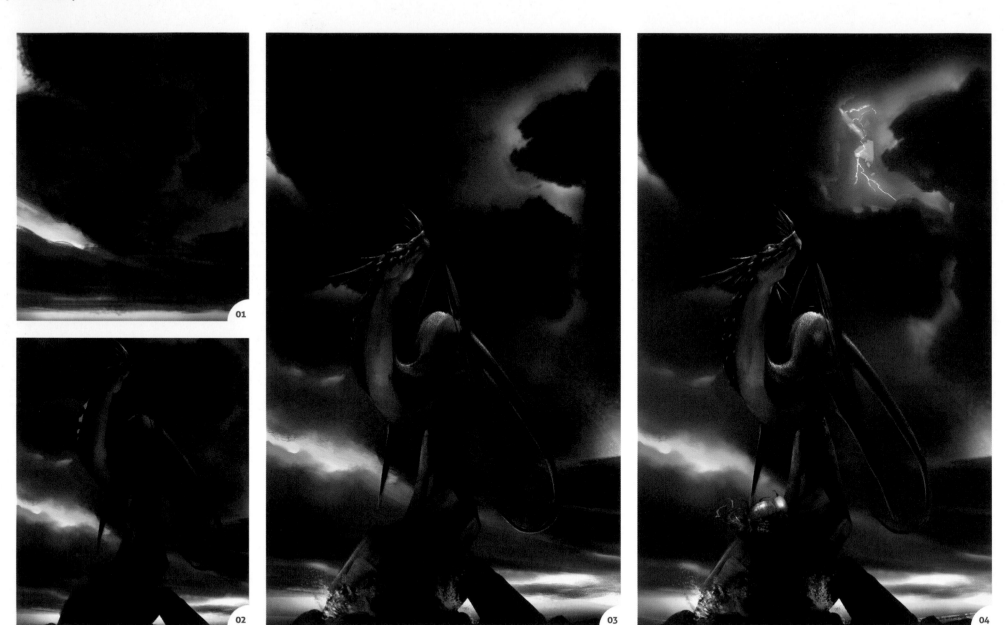

Cartoon capers
by Tommy Kinnerup

Index

Index

Featured artists

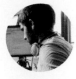

David Alvarez
Concept & 3D artist
www.davidalvarez.fr

Sara Biddle
Freelance digital illustrator
www.salizabeth.net

Bram 'Boco' Sels
Freelance illustrator
www.artofboco.com

Carlos Cabrera
Freelance concept artist
www.artbycarloscabrera.com

José Gómez
Concept & comic artist & character designer
www.chuloillustration.blogspot.co.uk

Takumer Homma
Freelance concept artist & illustrator
www.takumer.com

Juhani Jokinen
Concept designer illustrator
http://artofjokinen.deviantart.com

Tommy Kinnerup
Concept artist & illustrator
www.tommykinnerup.com

Kamil Murzyn
3D artist & freelance illustrator
http://kamilmurzynarts.pl

Dave Neale
Freelance concept artist & illustrator
www.daveneale.com

Christopher Peters
2D artist
http://trejoeeee.deviantart.com

Simon Robert
Freelance concept artist
www.killborngraphics.com

David Smit
Freelance art director & concept artist
www.davidsmit.com

Eric Spray
Concept artist
www.sprayconcepts.blogspot.com

Nikola Stoyanov
Lead 2D artist
http://drawcrowd.com/nikostoyanov

Cyril Tahmassebi
Concept artist
www.serylconcept.com

Abe Taraky
Concept artist
http://abetaraky.blogspot.ca

Rich Tilbury
Freelance concept artist & illustrator
www.richardtilburyart.com

Lindsey Wakefield
Freelance artist
http://lindseywakefield.blogspot.co.uk/

Benita Winckler
Freelance concept artist & illustrator
www.benitawinckler.com

Book Specifications
297 x 210mm | 240 pages
ISBN: 978-0-9568171-6-7

Beginner's Guide to Creating
Manga Art

Learn to Draw, Color and Design Characters

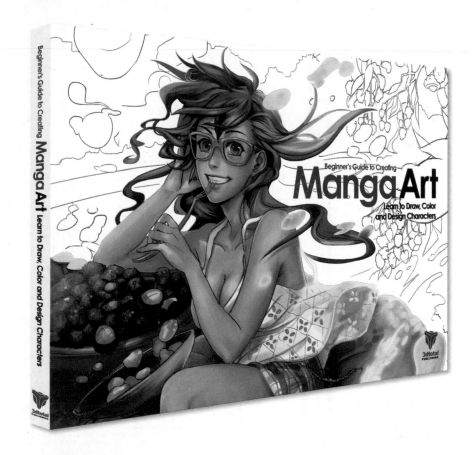

An insight into the creation of manga art, focusing on coloring, drawing and designing characters using traditional and digital methods.

Manga is an increasingly popular art form, particularly with the recent influx of Far Eastern games, anime, and comics into the western world. A term originally describing a Japanese comic art style of the late 19th Century, manga has come to be applied to a variety of mediums in recent years and is receiving more and more mainstream interest and attention.

Beginner's Guide to Creating Manga Art explores the topic of manga art, starting from basic character design and progressing to full-color images. Industry greats including Steven Cummings and Gonzalo Ordoñez open a window into their world and present tutorials covering everything from drawing features, anatomy and expressions to designing clothing, perfecting poses and coloring characters with a variety of traditional and digital artistic tools.

Bursting with knowledge and brilliant artwork, *Beginner's Guide to Creating Manga Art* is an unmissable title for anyone wanting to learn how to capture that classic manga style.

• Artists looking to learn about a new art form
• Hobbyists who want to learn useful tips and tricks from the best manga artists in the industry
• Lecturers and students teaching or studying fine art courses
• The massive comic and manga anime fan-base

Available from www.3dtotal.com/shop

3dtotal.com
Visit 3dtotalpublishing.com to learn more about our book range